# THE DIVORCE MEDIATION ANSWER BOOK

D0112619

# THE DIVORCE MEDIATION ANSWER BOOK

*Save Time, Money,
and Emotional Energy
with a Mediated
Separation or Divorce*

∽∘∾

CAROL A. BUTLER, PH.D., AND
DOLORES D. WALKER, M.S.W., J.D.

Kodansha International
New York • Tokyo • London

Kodansha America, Inc.
114 Fifth Avenue
New York, NY 10011
U.S.A.

Kodansha International Ltd.
17-14 Otowa 1-chrome
Bunkyo-ku, Tokyo 112, Japan

Published in 1999 by Kodansha America, Inc.

Copyright © 1999 Carol A. Butler and Dolores D. Walker.
All rights reserved.

Library of Congress Cataloging-in-Publication Data

Butler, Carol A.
   The divorce mediation answer book / Carol A. Butler and Dolores D. Walker.
      p.  cm.
   Includes bibliographical references and index.
   ISBN 1-56836-252-8 (acid-free paper)
      1. Divorce—law and legislation—United States—Popular works.
   2. Divorce mediation—United States.   I. Walker, Dolores D.   II. Title

KF535.Z9B85                                                     1999
346.7301 66—dc21                                          98-34008

Book design by Christine Weathersbee

Manufactured in the United States of America on acid-free paper

98  99  00  01       10  9  8  7  6  5  4  3  2  1

346.7301
B

# Contents

# Introduction

This book is intended to provide you with immediate, accessible, straightforward answers to the many questions that will come to mind as you think about separation or divorce. In the seminars we teach and in our individual, private mediation and psychotherapy practices, we work with couples in conflict both married and unmarried, straight and gay/lesbian, and even with couples already divorced. We have tried to consolidate our knowledge and experience into this book so that you can use it for support and guidance. Our goal is to help you negotiate cooperatively and make educated decisions throughout this emotionally and legally confusing period, not only in the context of divorce mediation but also along whatever path you choose.

Divorce mediation has been steadily increasing in popularity all over the United States. A majority of states now have some form of court-ordered divorce mediation, and many couples seek out private mediators to help them move on with their lives in a constructive way. In divorce mediation, your mediator helps you keep focused on the future rather than on the past, and if you have children, their needs and feelings are kept in the foreground.

As parents, you can establish a working relationship during the process of mediation. This is an important accomplishment that will have a positive impact on your children's adjustment to your separation, and will also make it easier in the future for you as parents to discuss and come to agreement about the many issues that will arise as your children grow.

We hope this book will answer some of your questions and offer some guidance on where to turn. It is not meant to serve as legal advice, and since laws vary from state to state, we strongly recommend that you speak directly to a mediator, attorney, or accountant in your state about your specific circumstances.

# Acknowledgments

We would like to thank the people who helped us and supported us during the preparation of this book. Special thanks to our families and friends for their encouragement and help, and to our literary agent, Andrea Pedolsky at the Altair Literary Agency, who got us into this and provided wise counsel. Thanks also to our editor, Nancy Cooperman Su, for her enthusiasm and support throughout the process.

Others we would like to acknowledge for their generosity with advice and answers are Patricia Ballner, Esq.; Maria Carola; Susan Costello; Kathy Fazzalaro; Ericka Gray; Kenneth Milford; Stephen Payne, M.D.; Phil Pollak, C.P.A.; and Alan Suchman, C.P.A.

# CHAPTER 1
## How the Mediation Process Works

Overview
1: What is divorce mediation?
2: What are the advantages of mediation?
3: Are there drawbacks to mediation?
4: What is the difference between mediation and arbitration?
5: Do we need mediation if we have no joint property and no children? Why can't we just buy a do-it-yourself book?
6: How do I know if mediation is right for us?
7: What happens during the mediation process?
8: Will the mediator try to get us back together?
9: How do we choose a mediator?
10: Where can we get a referral to a qualified mediator?
11: How can I be sure the mediator won't side with my spouse?
12: How are mediation fees set?
13: Who pays for mediation?
14: How long does mediation take?
15: My spouse wants to continue the marriage and won't discuss separation or divorce. Can a mediator help us?
16: Once we have chosen a mediator, how will we proceed?
17: I want to move out immediately because things are so difficult at home. What happens if I move out before I begin mediation?
18: Can I talk to the mediator privately? There are things I don't want to say in front of my spouse.
19: Can we be assured that our mediation is private and confidential?
20: I don't want my spouse to know all about my finances. Can I avoid revealing that information in mediation?
21: Should we bring our child to mediation sessions?
22: Can I bring a relative with me to the mediation sessions?
23: If I use a mediator, will I need to go to court?

1

24: Are there guidelines for what must be included in a mediated memorandum of understanding or in a separation agreement?
25: Even though I have a lawyer, I want to use a mediator. Can my lawyer and the mediator work together?
26: When should I refuse to mediate?
27: Are women at a disadvantage in mediation?
28: What is co-mediation?
29: What if I change my mind about getting divorced during mediation, or after the separation agreement has been signed?
30: What if circumstances change after we're divorced and the separation agreement needs to be changed? Can the mediator help?

Y ou and your spouse may be on speaking terms—at best— or confrontational terms—at worst—as you begin the process leading to a separation agreement and divorce. You need to know whether the mediation process will actually work for you, and that is the purpose of this part of the book.

There are many benefits to mediation. Mediation works because you make decisions *together*, unlike the adversarial process where you each hire a lawyer to negotiate and argue for you. In mediation you remain in control of the process, instead of taking the risk of fighting in a courtroom where a judge may make decisions neither of you wants. There are no court-imposed delays, no depositions, no stenographers, no cross-examinations. Just you, your spouse, and the mediator.

The mediator is the key to this process, helping you make your own decisions by providing support, clarification, and a nonjudgmental atmosphere. In this setting, you and your spouse will explore your feelings about the issues to be resolved and you will make your own decisions. The mediator knows what decisions must be made and ensures that they are made in an orderly fashion. Arguments are minimized, and an atmosphere of cooperation is encouraged so that you can focus on your future lives and the best interests of your children.

This chapter will familiarize you with the *private* divorce mediation process. We clarify when mediation is appropriate and when it is not. We give you criteria for choosing a mediator, help you plan for the first meeting, anticipate your concerns, and describe the roles of lawyers, consultants, family, and friends.

Court-ordered mediation is an option in some states, and it differs in some fundamental ways from private mediation. If you are considering court-ordered mediation, be sure also to review Chapter 10 where we discuss that process.

## Question 1

### What is divorce mediation?

Divorce mediation is a process by which you and your spouse can negotiate the terms of your separation or divorce in a cooperative, nonadversarial setting, with a minimal investment of time, money, *and* emotional energy. The mediation process results in a settlement that becomes the basis for your legally binding separation or divorce agreement.

You will meet with a professional mediator who is impartial and nonjudgmental. The mediator will help you create a unique separation agreement so that you can plan for the future, and if you have children, so that you can develop or continue a good relationship with them.

In the process of the mediation, you and your spouse or partner will learn how to recognize and overcome impasses and reach decisions regarding support, division of property, and parenting arrangements—without court-imposed delays *and* without becoming enemies.

## Question 2

### What are the advantages of mediation?

Mediation saves time, money, and emotional energy. It avoids the cost and time of adversarial litigation. Because the mediator is in control of the process, anger does not escalate and real communication can begin. As you and your spouse deal directly and openly with each other, you gain negotiation and communication skills that will help your future relationship to be less angry. If you have children, this can be a tremendous advantage. Mediation emphasizes the future and provides closure to painful and angry conflict of the past.

Let's take a look at some specific advantages:

*1. Cost- and time-efficient:* Mediation is a cost- and time-efficient way to obtain a divorce. Because you know the fee involved,

and because you can decide how quickly you want to proceed, you can control the total cost; there are no surprises. Unlike divorce litigation, you are in control of the process, and you don't have to wait for space on the court calendar in order to proceed. Attorneys' visits are minimized.

**2. *Future-focused:*** In mediation, as contrasted to litigation, each of you is empowered to control your own future, and since you have shared in the negotiation process, you are more likely to abide by the agreement.

**3. *Child's best interests:*** Divorce mediation provides a *neutral* setting in which to come to an agreement that meets each partner's and child's unique needs. Mediation allows you to truly focus on your child's best interests rather than becoming embroiled in a win/lose battle that litigation often results in. Mediation reassures your child that the two of you can still work together to care for him or her.

**4. *Open communication:*** Unlike divorce litigation, mediation encourages open communication. Mediators help couples learn new ways to resolve conflicts and develop a better understanding of each other's realistic needs.

**5. *Creative parenting arrangements:*** Instead of having to adopt an arbitrary, court-ordered schedule, you can thoughtfully develop your own parenting arrangements, taking into account all the scheduling demands each of you must accommodate.

**6. *Agreement where state law doesn't recognize the relationship:*** In the event of an invalid or "common-law" marriage, which is not recognized in many states, your mediated contract will be enforceable in court. If you are ending a same-sex committed relationship, a mediated contract is *sometimes* enforceable in court. More about this in Chapter 9: Unmarried and Gay/Lesbian Relationships.

**7. *Privacy:*** Issues you would prefer kept out of court—for example, financial details or custody issues—can be resolved in a private, neutral setting.

*8. Closure:* Mediation helps heal the pain of loss and lessens anger and bitterness. As you work together to forge better individual futures, there is a lessening of conflict, an emotional processing of separation and loss, and the beginning of acceptance and closure.

## Question 3

### Are there drawbacks to mediation?

We don't think so, but we are aware that there are a few areas where concerns have been expressed.

Because mediators do not subpoena documents and examine witnesses, some people have expressed concern about the lack of full disclosure of financial information. As mediators, we *always* insist on full disclosure, and we make clear in the first session that the mediation will be terminated if information is withheld. Also, we remind the couple that any agreement will be nullified by the court if important financial information has been withheld.

Another criticism that has been made is that mediation is not appropriate when there is too much of a power imbalance, when in some way one of the spouses might be stronger than the other. A good mediator will recognize if one spouse lacks assertiveness or knowledge, and will empower or inform him or her in a variety of ways.

There are a few extreme circumstances where private mediation would not be an appropriate way to negotiate a fair settlement:

- If there is intimidation or fear of violence
- If there is a recent history of domestic violence or child abuse
- If one of the parties has severe intellectual or emotional limitations

See also Question 26 in this chapter: When should I refuse to mediate?

## Question 4

### What is the difference between mediation and arbitration?

Both mediation and arbitration are alternative ways to avoid litigation. In mediation, *you* make the decisions with the help of the mediator. In arbitration, a third person or persons, after listening to both of you, makes the decision *for* you.

Whether decisions are made through litigation, mediation, or arbitration, most states insist that a judge review and approve all decisions that affect children, since the state is responsible for protecting the best interests of the child.

A mediator provides relevant information, assists in developing settlement options, and helps you and your spouse work together, but you and your spouse make all the decisions. Judges seldom reject what nonabusive parents, in good faith, have created in mediation.

In arbitration, depending on your prior agreement, the arbitrator's decisions may or may not be binding with respect to property. States vary significantly as to whether arbitrated decisions regarding custody, child support, and visitation may be binding.

Sometimes the mediated agreement includes a clause providing that if certain problems arise, the couple will return to mediation to work out the details, and if they cannot agree in mediation, they will submit to binding arbitration. Dolores encourages couples to *limit* what can be arbitrated and to include guidelines regarding what the arbitrator should consider.

## Question 5

### Do we need mediation if we have no joint property and no children? Why can't we just buy a do-it-yourself book?

Not only can you buy a do-it-yourself divorce book, but in Arizona and Utah you can file for your divorce at an automated kiosk at

the courthouse, similar to a bank's ATM machine! However, there are often important legal issues that can be overlooked if you go it alone.

If you work with a mediator, you will be certain that your agreement is complete and legally binding, and you will still keep your expenses to a minimum. In our experience, there are always details to be reviewed that are easily overlooked and that can cause problems later, such as debts, apartment leases, title complications regarding property, taxes (who pays, who gets the refund, who is liable if there's an audit), health benefits, or even the timing of the divorce.

Finally, a mediator can help you through any tough spots, and a book or an ATM machine can't do that.

## Question 6

### How do I know if mediation is right for us?

If you are interested in mediating your divorce but unsure if it's the right way for you to proceed, the best course of action is to participate in a mediation session or two and see how you feel about the experience. You can ask questions about your situation during these sessions, and you will get useful answers from the mediator. Since you pay only for an hour or two of the mediator's time, this is an inexpensive way to make your decision, and you will obtain some information that will prove useful no matter how you proceed.

See also Question 2: What are the advantages of mediation?; Question 3: Are there drawbacks to mediation?; and Question 26: When should I refuse to mediate? in this chapter.

## Question 7

### What happens during the mediation process?

Your mediator will provide information, establish ground rules, help you develop choices, and keep you future-focused as you

negotiate the terms of your separation agreement. The mediator will stress that you can make any settlement you choose, and, as needed, will explain how the laws, guidelines, and norms of where you live have an impact on your decisions.

If you need a consultation to help you clarify your position in the course of the negotiations—with an accountant, an appraiser, a child psychologist, a psychotherapist, or some other expert— your mediator can help you make those arrangements.

Your mediator will outline the decisions you need to make in order to create a separation agreement. This will help you structure your mediation, deciding on the terms of the agreement item by item.

These terms will be written up by the mediator as an unsigned document called a *memorandum of understanding*. Based on the memorandum, a separation agreement will then be drafted.

You will be encouraged to go over the agreement with a *review* attorney, who will give you feedback from the point of view of an advocate for *you* alone. You can use this opinion to evaluate and possibly modify the settlement through an additional mediation session before you sign the final agreement. Then your state's procedures for filing for divorce will be followed, the court will process the documents, and you will be notified that you are officially divorced.

## Question 8

### Will the mediator try to get us back together?

No. Recovering a relationship is the goal of couples therapy, not mediation. Neither those mediators who are psychotherapists nor those who are attorneys will try to get you back together. Mediators are focused *solely* on making the process of separating as amiable as possible. We are neutral and concrete, concerned with defining issues and facilitating reasonable solutions so that you can put closure to the marriage and move on to separate futures.

If you are not sure you are really ready to get a divorce, consider meeting jointly with a couples therapist for a few sessions to

see if you and your spouse can make progress toward resolving your problems.

## Question 9

### How do we choose a mediator?

A mediator should have relevant experience and appropriate training for *your* particular situation. You should be comfortable with the mediator and you should feel that the mediator will be neutral, open, informative, and capable of helping you make your own decisions.

- Is she a good listener?
- Does he easily convey his ideas to you?
- Does she keep the session focused on the task at hand?
- Does she seem to be objective?
- Does he jump to conclusions?

Any competent divorce mediator should be able to answer questions about your state's legal requirements, especially about property distribution, custody, and support. We suggest that you interview more than one mediator in order to get an idea how different mediators work and to find a person you feel comfortable working with. Feeling good about your choice is important so that you will have confidence in your mediator and won't become discouraged if you hit some rough spots in the negotiations.

Some of the key questions you'll want to ask each mediator you meet with are:

- How much training do you have as a mediator?
  In addition to graduate degrees in the law or the mental health professions, your mediator should have a minimum of 60 hours of mediation training. The more the better.
- How much experience do you have in mediating family cases?

There are many kinds of mediators. A mediator who specializes in international mediation or labor disputes is unlikely to have sufficient divorce mediation experience.

- What training do you have that's related to our particular situation?

  Anticipate what you will especially need from your mediator. Is your situation financially very complex? Emotionally intense? In other words, does the mediator have relevant financial, legal, or family psychology training?

- How long have you practiced as a mediator?

  This will vary since mediation is new in some states. Your mediator should be an experienced person. If mediation is new in your area, the mediator should be experienced in the law or in a mental health profession in addition to having completed mediation training.

- How many cases do you mediate in an average year?

  Again, this will vary with the use of voluntary and mandated mediation in your area. We would like to see the mediator have a minimum of 15 cases a year. In states with court-mandated mediation, we feel the number should be closer to 25 cases.

- What is your fee? What does it include? (See Question 12 in this chapter.)

- Who drafts the separation agreement and files the divorce papers?

### Question 10

**Where can we get a referral to a qualified mediator?**

A good place to seek a referral is through the Academy of Family Mediators. In addition to their expertise in other fields such as mental health or law, Practitioner Members of the Academy have

met extensive training and experience requirements. We offer a list of available AFM mediators in the Resources section at the end of this book, and an updated list is available on AFM's web site. Many mediators on our list include their professional titles, such as Esq. or J.D. (attorneys) or Ph.D., M.A., or M.S.W. (psychotherapists or psychologists) or M.Div. (pastoral counselors), so that you can have some idea of the additional areas in which they are trained.

In states where no Practitioner Member is listed, contacts for local mediation organizations are provided. There is also a list of web sites in the Resources where you can find resources about mediation.

Other referral sources are state and local mediation organizations, the American Arbitration Association, the American Bar Association, the Society of Professionals in Dispute Resolution, and, sometimes, local bar associations. In some cities, you will find mediators listed in the classified section of the local telephone directory.

## Question 11

### How can I be sure the mediator won't side with my spouse?

Mediators are *ethically* bound to be impartial, neutral, and unbiased. In 1994, a set of Model Standards of Conduct for Mediators was prepared by a joint committee of the American Arbitration Association, the American Bar Association, and the Society of Professionals in Dispute Resolution. The Academy of Family Mediators has prepared similar standards. Copies are available from the organizations.

Both sets of standards include ethical requirements that the mediator be impartial and neutral, disclose any conflicts of interest, clearly explain fees, and maintain confidentiality.

During your consultations with different mediators, think about whether that person seems fair. Ask yourself: Does the mediator encourage each of us to discuss our concerns? Is he listening to

both of us? Does she respond similarly to my concerns and those of my spouse? Does he seem to be making every effort to be unbiased?

Remember, the mediator's role is to facilitate *each of you* in making decisions by creating a safe, informative atmosphere in which both you and your spouse can negotiate. If you have any concerns or misgivings, address them openly and see if you can't clear the air. Your mediator should respond positively to your expression of discomfort and should work with you to increase your confidence in the process.

## Question 12

### How are mediation fees set?

Generally, fees are set on an hourly basis and vary according to location. In private practice, in addition to charges for sessions with the couple, additional charges usually include phone calls with clients that last more than ten minutes, preapproved consultations with experts, and time for review and preparation of documents.

Recently, the American Arbitration Association, the American Bar Association, and the Society of Professionals in Dispute Resolution formalized what had been general practice for most mediators and, in conformance with the Standards of Practice of the Academy of Family Mediators, mandated that the standards for fees should be fair and reasonable and should be fully disclosed. We recommend that the fees your mediator charges be fully disclosed in writing. According to the Standards, contingency fees and commissions or rebates for referrals are prohibited.

## Question 13

### Who pays for mediation?

While you can negotiate with each other about who will *actually* pay, the mediator will usually ask that the two of you sign an agreement so that you will be *equally* responsible for the fees. If your spouse agrees to pay for the sessions, you may want to

be sure the sessions are paid in full, so you don't have to be concerned about making up the difference if your spouse fails to pay.

The timing of payment will be discussed when you begin the mediation. Ordinarily, payment is expected at the end of each session, but some attorney/mediators ask for a retainer, which is a deposit in advance for a specific number of sessions.

## Question 14

### How long does mediation take?

This depends on you and your spouse. The more decisions you have already made before coming to mediation regarding property, children, and finances, the more quickly the mediation will proceed. If you are very emotional and negative, it will take longer because you will need to spend some time expressing your feelings before you are able to focus on the practical issues.

We prefer to have sessions that last no longer than one and a half hours, but some other mediators schedule longer sessions, especially when couples have traveled long distances to get to the mediator's office. Carol has completed mediations in one session for couples with no children who have had a financial settlement in mind when they came to mediation. But other couples can take longer, especially if there are children or complicated property or financial situations. Mediators vary to some degree in the way they work, but we believe a mediation should be completed in less than ten hours, usually considerably less.

Couples sometimes return to mediation to renegotiate a point that arises after they've consulted with review attorneys, or even after the divorce, if circumstances change. This is fairly rare, and whatever adjustments are needed usually can be accomplished in one session.

Also see Question 30: What if circumstances change after we're divorced and the separation agreement needs to be changed?

## Question 15

### My spouse wants to continue the marriage and won't discuss separation or divorce. Can a mediator help us?

Suggest that your spouse phone the mediator, and perhaps the mediator can help him or her consider a mediation consultation so that the three of you can evaluate the situation

Your spouse may be more hurt than angry, and argumentativeness may be a way of hiding the hurt. Depending on the specific circumstances of your situation, we might proceed cautiously, evaluating each session with both of you before committing to the next.

Eventually, your reluctant spouse may feel more comfortable attending mediation, knowing that the commitment is only for one session at a time. It is not unusual, through this process, for the spouse who is reluctant to end the marriage to come to terms with the separation and to participate in piecing together an agreement.

In the meantime, in mediation you may be able to negotiate temporary financial arrangements so it will be easier to live separately. Some-

It is not unusual for couples to come to one of us for mediation after living separately for some time, and we find that these mediations often go more smoothly than with newly separated couples. Our theory is that when negotiations are easier after time has passed, it is because the experience of living apart has allowed the unknown to become known.

- The emotional turmoil of separating has subsided, and an individual identity is being established by each former partner.
- Each person is more focused on his or her individual future than on their joint past.
- Many financial issues have been settled by necessity.
- Couples have developed confidence, through experience, in their solo parenting ability.
- The remaining issues that need to be resolved in the final agreement are very clear.

15

times—particularly if you live separately—the passage of time facilitates negotiation because reality intervenes.

If your spouse still refuses to discuss divorce and you want to proceed immediately, you will need to retain a lawyer. Although in most no-fault states a resident spouse can file for divorce and the other spouse has no legal right to insist on staying married, in order for the court to make any financial or parental decisions, the other spouse must be properly served with legal papers. This is sometimes difficult to do, particularly if the absent spouse is not a resident of the state.

Also see Question 8: Will the mediator try to get us back together? and Question 5 in Chapter 2: Why is it so difficult to separate or divorce?

## Question 16

**Once we have chosen a mediator, how will we proceed?**

Most mediators will begin in a similar fashion. You will be given a questionnaire to complete asking for information about you individually and as a couple—and about your children. The mediator will explain the mediation process, discuss confidentiality and privacy, disclose any conflicts of interest, and answer your questions. He or she will provide you with a written agreement to be signed by you and the mediator agreeing to the confidentiality of the negotiations and to fee arrangements.

You may or may not begin actual negotiations at your first meeting. Couples vary considerably with regard to what they have already settled between themselves. If there is time, you may begin exploring issues that need to be resolved, or you may begin negotiations on an urgent issue such as temporary financial arrangements or temporary parenting arrangements.

## Question 17

**I want to move out immediately because things are so difficult at home. What happens if I move out before I begin mediation?**

Many spouses do this, but generally it's a mistake, particularly if there are children involved.

If you have children, you need to mediate temporary terms for your parenting arrangements *before* you move out. If you don't, the court could interpret your leaving as indicating a disinterest in your children. This could have an impact on your future custody or visitation rights.

Also, be aware that if you move out, and for some reason you aren't able to work together in mediation and you end up in court, you may have created a problem. Moving out could give your spouse grounds for divorce, such as abandonment, and that could, in some states, affect your financial settlement.

Another potential problem is that, in some jurisdictions, if you change your mind after having left, you may find yourself unable to move back in. In North Carolina, for instance, if you move out without having a written agreement, the court could find that you deserted your family, and your spouse has the right to refuse to allow you to return.

There are exceptions, however. We have both mediated agreements with some couples without children who have lived apart for significant periods of time. They had been able to settle most issues amicably between themselves before coming to mediation, and the time apart had helped them determine what remained to be negotiated in mediation.

## Question 18

### Can I talk to the mediator privately? There are things I don't want to say in front of my spouse.

Meeting with the mediator privately is called a *caucus*; not all mediators think doing this is useful. If you think you need a caucus, ask your mediator how she'd like to handle it.

Some mediators will caucus with each partner at the beginning of mediation to determine whether there are problems that make their situation inappropriate for mediation. Many mediators caucus as a way to reach a settlement on difficult issues. Some media-

tors refuse to caucus at all because they are concerned that one of the spouses will feel that secrets are being kept, and that the mediator has become biased.

The tricky part about having a caucus is to get the rules clear before you do it. In terms of confidentiality, there are two types of caucuses, and most mediators have a preference for one or the other.

In the first type, you agree that everything you say in the caucus is confidential, and only *you* can reveal material from the caucus in the subsequent sessions with your spouse. The mediator may encourage you to discuss a particular point she believes would be useful in the negotiations, but you have the final say.

The alternative is that you agree in advance that *nothing* is off limits. The mediator will be discreet, but she has your permission to introduce anything from the caucus that she thinks will help the negotiations along. Many mediators will only agree to this type of caucus because it minimizes their vulnerability to manipulation by the parties.

All mediators we know take phone calls from clients, and often a relatively brief phone call is an opportunity to discuss something privately with the mediator in a less formal, off-the-record manner. If the mediator sees the conversation as moving the negotiations along, she will probably permit it.

## Question 19

### Can we be assured that our mediation is private and confidential?

When we talk about mediation, "private" and "confidential" are two separate concepts. *Privacy* here means nonpublic, since mediation takes place in the privacy of the mediator's office. In mediation, the two of you can keep your negotiations and the details of your personal and financial business private.

This is in contrast to a court proceeding for a divorce, which takes place in public, with witnesses who may be testifying about financial, property, or personal matters. Only under very special circumstances are portions of court proceedings kept private.

*Confidentiality* means that the details you provide in mediation cannot be disclosed elsewhere. When you begin mediation, your mediator will ask you each to sign an agreement stating that your negotiations are confidential and that neither of you will subpoena your mediator as a witness in any future court action.

This agreement is a contract between the two of you and the mediator, but if you live in a state that does not protect the confidentiality of mediation, and you get involved in litigation, the court may *order* you to reveal facts that you agreed were confidential in mediation.

States differ in what aspects of mediation they protect.

- Communications made during mediation sessions about the subject matter being discussed may be confidential, but not, for example, if the information is needed to prevent a crime.
- Facts about the mediation, such as that you failed to appear for a mediation session, may not be confidential in court-ordered mediation.
- The mediation agreement itself may or may not be confidential.

In Oregon, for example, the confidentiality of communication during the mediation is protected by law, but the agreement is not considered confidential unless the parties specifically agree otherwise. Moreover, the court has an overriding interest in protecting children in all states, so information about child abuse is *never* confidential.

## Question 20

**I don't want my spouse to know all about my finances. Can I avoid revealing that information in mediation?**

Only if both of you disclose the necessary information will the process work. Remember, in divorce proceedings financial information is *never* confidential. In a litigated divorce, your attorney or the judge would order full disclosure of *all* financial records. In

mediation, we insist on full disclosure as well, and will not proceed if either spouse is unwilling to comply. It should therefore not concern you that your spouse will have knowledge of financial information that you have disclosed in mediation.

## Question 21

### Should we bring our child to mediation sessions?

Mediators vary in their views about whether children should come to any of the mediation sessions. In court-ordered mediation, children are usually seen separately by the mediator. In private mediation, children are sometimes involved after the settlement to help them understand and cooperate with the new parenting arrangements.

Neither of us encourages bringing children to sessions, but we do look at this question if it comes up and proceed cautiously because we don't want the child to feel pressured to choose between parents. We consider the child's age and emotional state, and sometimes we recommend a consultation with a child psychologist as the best way of attending to the child's needs.

If you both agree it would be useful to involve your child in the process of developing future plans, you need to think about these issues:

- What impact would it have on your child to be involved in the process?
- Would attending a session increase your child's feeling of responsibility for the divorce?
- What could your child actually contribute to the process?
- Is your child old enough that he or she needs to provide input for future parenting arrangements?
- What is your motive for involving your child? Do you want your child to take sides?
- Would either of you be tempted to manipulate your child prior to the mediation session?

- What effect would your child's presence have on you and your spouse?

Carol recently began a mediation with a couple who have a 15-year-old son, and they asked about involving him in the mediation. Since he is old enough to participate to some degree in planning his future, and perhaps might be more cooperative if he had input into the visitation schedule, Carol didn't rule out the possibility if it seemed appropriate as the mediation progressed.

She did suggest, however, that it might be easier for her to see their son alone so he wouldn't feel put in the middle. Because she is a very experienced psychotherapist, she was comfortable making this suggestion. The parents agreed that their son would probably find it easier to discuss his preferences and feelings in a private setting.

Another alternative might be to arrange a consultation for your child with a child psychologist or child therapist, who would then communicate your child's concerns and present an independent evaluation.

## Question 22

### Can I bring a relative with me to the mediation sessions?

Both of us on occasion have been asked if a relative can accompany one or both parties to the mediation sessions. While we understand the need for support, it is important to proceed cautiously. Will it help or hurt mediation? If family interference has been a problem throughout the marriage, it may not be advisable. Are the relatives going to bring conflict into the session because of their own anger? Do they desire an outcome—revenge, for example, or humiliation of your spouse—that differs from the goals of mediation?

Carol had a consultation with an orthodox Jewish woman whose first words were, "I want a divorce but my father is a rabbi and he would kill me." After some discussion of that dramatic

statement, Carol invited the client to bring her parents to the next session so that her parents' religious and personal viewpoints could be clearly understood. The rabbi and his wife gladly attended the next session and explained that they supported their daughter completely and felt she was entitled to the divorce based on the extensive history of problems in the marriage. The mediation proceeded smoothly after that clarification, with no additional need for family involvement.

We recommend that you meet with your mediator to explore the reasons you want someone to join you. We suggest a session or two with just you and your spouse and then a reevaluation of whether you still feel you need the additional person. Another possibility might be a single session with you, the mediator, and your family member to assure the family that the mediator is aware of their concerns.

Also see Question 11 in Chapter 2: My spouse discusses every detail of our separation with her family and close friends, and everyone gives her advice. How can we negotiate under these circumstances?

## Question 23

### If I use a mediator, will I need to go to court?

In all states, divorce papers must be filed with the court, whether you have mediated a fault or no-fault agreement. In New York City where we practice, you do not have to appear in court if you and your spouse make a settlement out of court. Across the river in New Jersey, you must make an appearance no matter what the circumstances.

In most states, if you are seeking a no-fault divorce, and your spouse is not contesting it, it is unlikely that you will need to personally appear in court. If you use fault grounds, however, it is more likely that you will need to appear.

Check with your mediator for the rules in your area.

## Question 24

### Are there guidelines for what must be included in a mediated memorandum of understanding or in a separation agreement?

A memorandum of understanding includes, in plain language, everything that must be included in the separation agreement. The separation agreement is an enforceable contract, based on the memorandum of agreement, which resolves all legal issues relating to your relationship.

Both the memorandum of agreement and the separation agreement may include sections concerning property, children, debts, bankruptcy, income, maintenance or alimony, and taxes. The content of these sections depends on your particular situation.

The property section, for example, may include designations of what is marital and what is separate property; it may divide pensions; it may define property rights or right to future income related to licenses, professional practices, and businesses; and it may define ownership of real estate and personal property such as furniture, cars, art work, investments, and pets.

If you have children, all terms related to the children will be in the agreement. These will include parenting arrangements, visitation, grandparents' visitation, provisions for relocation, child care, medical expenses, schooling, college education, travel, and emancipation.

Other areas of the agreement will be similarly detailed. You'll find both a comprehensive list of decisions to be included in the separation agreement and a sample Memorandum of Understanding in the Resources section at the end of the book.

౼౦౼

## Question 25

**Even though I have a lawyer, I want to use a mediator. Can my lawyer and the mediator work together?**

You may consult with your lawyer before, during, and after the mediation—whenever you think it would be helpful. You might want to use your lawyer as a consultant to help you negotiate more effectively. And your mediator should be willing to consult with your lawyer at your request. Once the settlement agreement is written by a neutral attorney, you can use your attorney to review it and to advise you whether further mediation is necessary to clarify or to resolve additional issues.

We know that some mediators allow both clients to bring their lawyers to mediation sessions, although they do encourage the lawyers to take an observing, advisory role, rather than their more usual adversarial one. Frankly, we can't imagine doing this. We can't picture two New York litigators being in this situation and not being confrontational! But if you think it might work for you, by all means discuss it with your mediator during the consultation.

In many jurisdictions, court-ordered mediation differs considerably from private mediation on this issue.

See Chapter 10 for a discussion of court-ordered mediation.

## Question 26

**When should I refuse to mediate?**

There are circumstances where mediation is not suitable.

Are you afraid of your spouse? You should not attempt mediation if there is a recent history of *domestic violence* or *child abuse* or where an atmosphere of *intimidation and fear* is clearly present, because you might feel forced to agree to terms that would not be in your best interests. For an exception to this rule, see Chapter 10, Question 12, for a description of certain court-ordered mediation programs in which special procedures are used to facilitate mediation in selected cases where there is a history of domestic violence.

In some circumstances, it is appropriate to delay mediation until both of you are emotionally ready to focus on the very detailed process of mediation. Separation is usually a highly emotional experience, and if you are so severely depressed or in such an extreme emotional state that you cannot focus, you may need a little time to stabilize. Sometimes a therapeutic experience or a support group is helpful at this point.

An experienced mediator recognizes if you are not suitable or ready for mediation, and advises you accordingly.

Also see Chapter 2, Questions 13–16.

## Question 27

### Are women at a disadvantage in mediation?

We don't think so. There are two stereotypical attitudes about women that lead to this question. One is that women don't know and are unwilling or unable to learn about financial issues. The other is that women will give in to keep the peace. In our experience, this is generally not what happens in reality.

Women often handle household accounts and work in jobs where they are required to be knowledgeable about finances. If they are inexperienced with financial matters, we find that they learn as well as men do when provided with information by the mediator.

In one of Dolores's mediations, the wife handled all household and business accounts for her husband's business. In fact, only the wife had consulted with the accountant. Dolores had to insist that the husband visit the accountant so he could better understand his own finances.

Women *and* men are diverse in their knowledge and bargaining skills. There is no telling who will be the best informed about financial details or in better emotional control, but it is our job as mediators to be certain that both parties have all the information they need and to make sure it's understood.

It is the mediator's responsibility to generate various choices and to explore trade-offs so that there is no intimidating, black-or-

white choice to be made. In clarifying whether the solution seems fair to both parties, we make certain that both voices are heard.

## Question 28

### What is co-mediation?

Co-mediation involves two mediators working together with the couple. Sometimes they have different areas of expertise; one may be a mental health professional and the other may be an attorney. Sometimes a more experienced mediator is teamed with someone in training. Some mediators like to use a male-female team.

The advantages of having two professionals to help develop the agreement are: more ideas, more expertise in the room, different points of view to create more options.

Possible disadvantages are: two mediators may cost extra; a trainee is less experienced; it may take longer to get an agreement; and additional issues are created by having two mediators who may have different approaches.

In court-ordered mediation, there is a lot of variation from place to place in the use of co-mediation. For example, in certain Connecticut courts, all mediations are conducted using male-female co-mediation teams. See Chapter 10 for more about court-ordered mediation.

Recently, Dolores, a lawyer/mediator, co-mediated a session at the request of a therapist/mediator. The spouse had requested that a single session be arranged in this way because he wanted to move out of the house before the separation agreement was completed. Usually, it's important that a temporary move agreement include detailed information to protect the legal rights of the spouse who is moving out. This type of co-mediation allowed for more options to be explored and for the arrangements for moving to be finalized legally and efficiently.

∽∞∾

## Question 29

### What if I change my mind about getting divorced during mediation, or after the separation agreement has been signed?

You can always change your mind during mediation and negotiation of an agreement. Mediation allows time to examine all documents and financial records, to consult with attorneys and other experts if necessary, and to understand the agreement in its totality.

Once signed, most agreements provide that changes must be made in writing and signed by both parties. If you have signed the agreement, but now you both agree that you want to resume the marriage, together you can sign a document voiding the agreement.

If only one of you decides against divorce after the separation agreement is signed, you *might* be able to block the divorce by contesting the grounds for divorce or by arguing that the terms of the agreement have not been followed. However, the separation agreement may remain in effect as an enforceable contract. As always, the child-related provisions of the contract are subject to court review to be certain they are in the best interests of your child.

If your spouse has failed to reveal significant financial information prior to the signing of the agreement, you can, of course, go to court and ask that the agreement be invalidated. Parties in mediation are advised of this early in the process.

To avoid any problems, think through your decisions carefully and discuss concerns early in the process. If you have misgivings about divorce, you may want to speak with a therapist or couples counselor.

See also Question 15: My spouse wants to continue the marriage and won't discuss separation or divorce. Can a mediator help us?

∽∾∽

## Question 30

### What if circumstances change after we're divorced and the separation agreement needs to be changed? Can the mediator help?

A mediator tries to plan for anticipated changes as much as possible when writing the separation agreement and to provide for alternative ways to resolve issues related to future unexpected events. You may want to make changes in the agreement, for example, if you or your former spouse have a significant increase or decrease in income, or if one of you has unanticipated and costly medical expenses, or if one of you wants to move to another state. Any of these circumstances may result in a need to make changes.

Carol helped one couple change their parenting arrangements. The agreement worked out in court after several years of bitter litigation involved such a detailed parenting plan that the couple were forced to have contact with each other for the slightest adjustment. The frequent conversations usually developed into arguments, and they were exhausted by the arrangement. In the mediation session, they examined the sources of the tension between them and revised their agreement, so that much less consultation was required. See also Question 9 in Chapter 4: Can child support be increased or decreased after the agreement is signed?

Couples often agree to a clause in the separation agreement stating that mediation will be attempted if a specific problem arises. If mediation fails, arbitration is usually the next step. See Question 4: What is the difference between mediation and arbitration?

We would encourage you to discuss the changes with one another, and then to schedule a mediation session. In the session, we would help you to renegotiate the issue in question, and then a rider incorporating agreed-upon changes would be properly executed and attached to the original agreement.

# CHAPTER 2
## Emotional Issues and Negotiation Skills

Overview

1: How is negotiating my divorce agreement different from other types of negotiations?

2: How do I get what I want? Are there rules for negotiating?

3: How can I negotiate when I don't want to compromise?

4: If my spouse and I are at an impasse on a particular issue, how will mediation help us resolve it?

5: Why is it so difficult to separate or divorce?

6: We disagree on so many things. How will we ever negotiate a settlement?

7: When we argue, my spouse always wins. How will I be able to negotiate under these circumstances?

8: I'm concerned my spouse won't be an adequate parent without my help. How can I negotiate a parenting arrangement?

9: How can we negotiate when different people give us contradictory information?

10: I feel immobilized although I know a divorce is inevitable. What can I do?

11: My spouse discusses every detail of our separation with her family and close friends, and everyone gives her advice. How can we negotiate under these circumstances?

12: We tried to work the marriage out but couldn't. I know divorce is the only answer, so why am I depressed?

13: My affair broke up our marriage. If I mediate, I'll have to be in the same room with my spouse. I don't know if I can do that.

14: I've become very suspicious of my spouse. How can I trust her in mediation?

15: I decided, for my own protection, to open a separate bank account, and now my spouse refuses to attend the mediation session. Can a mediator help get him to cooperate?

16: I'm frightened. My spouse has been very abusive. Can we mediate our divorce?

**M**arriage was an organizing factor in your lives. You and your spouse together made many decisions in particular ways *because* you were married and shared certain values and expectations. Now those expectations have been turned upside down. You will be negotiating a separation agreement at an emotionally difficult point in your life, and you will be required to make decisions without your accustomed underlying rationale. This can be frustrating and confusing.

You or your spouse may find that feelings of anxiety over the potential loss of financial security, extended family, home, and friends have a quality more like childhood panic than adult concern, because these losses represent a temporary loss of the "self" with which you have become comfortable. There may be feelings of betrayal, rage, or helplessness. If the two of you become involved in an adversarial process, these feelings may be intensified because you will be dependent on your lawyers' strategizing.

A mediator understands this state of mind and will keep the negotiations nonconfrontational and structured. With your mediator's assistance, you will both be able to speak for yourselves and plan your individual futures.

The negotiation techniques we discuss will be helpful with this process. We will answer questions about how to overcome emotions that interfere with negotiations: how to make trade-offs so that you get what you really want; how to get a reluctant spouse to mediate; how to overcome impasses; and how to develop better ways to communicate so that you can have future discussions concerning such issues as parenting arrangements with less conflict.

31

## Question 1

### How is negotiating my divorce agreement different from other types of negotiations?

Because you are negotiating something very complex and personal, the stakes are higher than if you were negotiating a business matter. Your relationship has probably been quite emotional, both affectionate and angry, and facing separation may elicit some painful and perhaps unanticipated responses from both of you.

If you have children, you cannot walk away and never see each other again. You will be negotiating the terms of an ongoing relationship that will affect both you and your children for many years to come. Under these circumstances a win/lose approach cannot work.

## Question 2

### How do I get what I want? Are there rules for negotiating?

Negotiation is about problem solving. There are no absolute rules, but there are techniques to be used thoughtfully.

You are more familiar with the process of resolving conflicts through negotiation and compromise than you may think. You have negotiated with friends and family about all sorts of choices affecting more than one person. Think about what you have learned about yourself as a negotiator in your prior experiences resolving such common conflicts as scheduling, meals, curfews, hairstyles, holidays.

These are some of the basic ideas to keep in mind when you negotiate:

*Before mediation sessions begin*
- Do your homework in advance so that you are prepared with information and questions about the issues that concern you.

- Think about what is really important to you, and think about trade-offs. Don't get greedy, but don't fail to recognize if you are in a poor bargaining position on some issues. Keep in mind that it is unlikely you will get everything you want, whether you use mediation or litigation. If you remember this, you will have a much easier time considering alternative proposals.
- Prioritize what is important to you. Look at the whole picture. Don't limit yourself to one issue. Be aware of what you value most.
- Assess and strategize, anticipating what your spouse may want or must have.
- Plan some concession points. You may be willing to give up money for some other benefit, or some other benefit for money.

### During mediation sessions
- Be patient. Negotiation is a process that takes time.
- Focus on the future. Don't dwell on past issues that won't continue once you are divorced.
- Begin with a reasonable position. If you are unreasonable at the outset, you risk an impasse.
- Stay with the agenda. Don't get stuck on irrelevant issues.
- Don't formulate a reply without listening carefully. Take notes. Be certain you understand what is said. Clarify by asking questions of *both* the mediator and your spouse.
- Don't be confrontational, and avoid verbal put-downs. Focus on the problem instead of on who's to blame.
- Do not escalate. If your spouse attacks you verbally, don't take the bait. Stay focused on your future goals and on resolving the problems that stand in the way.
- Avoid treating everything as equally important. Probably, the antique clock and the pension plan are not of equal value to you.
- Generate solutions. When you say no, try to suggest another solution. You don't have to agree to anything that you think is unfair, but you should *consider* every proposal seriously—

33

and seriously consider how it can be modified. Is there something else that might make the proposal more appealing to you?

• Review any documents or information provided during mediation. Be certain they are clear and complete.

Remember, mediation goes through stages. Often when your easier issues are settled and the end is in sight, there will be more motivation to compromise. As mediation sessions end, continue your homework. Review the proposed agreement, making sure that you have read it carefully and that you understand it.

Be certain that your final agreement is clear and enforceable. An agreement to negotiate about an issue at a future date is not enforceable unless there are clear guidelines about who will make the final decision and what criteria will be used.

Negotiation is a process of making trade-offs, but you must keep in mind as you negotiate that there can be legal or tax consequences of certain decisions you make. The general idea is that in order to get something you want, you give up something, perhaps even something to which you are legally entitled.

Some examples:

• The pension in exchange for the house
• Furniture in exchange for the computer
• Heirlooms in exchange for more furniture
• Payment of less child support (non-tax-deductible) in exchange for payment of more alimony (tax deductible)
• Payment of ex-spouse's college or graduate school education in exchange for no alimony
• Payment of ex-spouse's education in exchange for fewer years of alimony
• Payment of more alimony in exchange for the tax deduction
• Payment of more support to the parent with primary physical custody who agrees not to relocate
• Relocation of the parent with primary physical custody in exchange for less child support (since the noncustodial parent will pay more for frequent visitation and transportation costs)

- Relocation of the child in exchange for more and longer visitation and payment by the custodial parent of certain travel costs
- Fewer overnight visits during the week in exchange for more weekend visits.
- Payment of all unreimbursed medical expenses in return for the children's dependency deductions and child credits
- Dependency exemption and child credits in return for payment of more college tuition
- Payment of ex-spouse's interest on a second mortgage in exchange for delaying the sale of a home and remaining in the home for a specified period of time
- Remaining in the home for a period of time in exchange for little or no alimony
- Remaining in the home for a period of time in exchange for not including overtime income as part of calculation for child support
- Additional payments from a business when it nets a specific sum in exchange for not dividing the business
- Share of a pension in exchange for payment of educational expenses
- Share of a pension in exchange for start-up business expenses

## Question 3

### How can I negotiate when I don't want to compromise?

We can understand that winning it all—particularly if you feel you are in the right—is very satisfying. Winning feels good.

The problem is, decisions made by you and your spouse in mediation or by a judge seldom give everything to one person and nothing to the other. So, even if you're in the right, if you are unwilling to compromise, you run the risk of losing what is most important to you, and probably at great cost in terms of time, money, and emotion.

Instead of worrying about compromises, think about options. How many different ways can you have it your way? What don't you really want or need that you can consider trading for what you really must have? And most important, think about what you *really* want.

Dolores worked with one couple in mediation where the father insisted on being the "school-night parent" (the one with whom the child spent school nights) and was prepared to put up quite a fight to get that access. But when Dolores asked exactly what hours he wanted to spend with his daughter, it turned out he had only two weeknights available, and one of those evenings he was only available after 7 P.M. Once the father explored the options with the mediator, he decided it was more important to have more quality time than busy evenings with his daughter, and he agreed to lengthy weekend visits instead.

## Question 4

### If my spouse and I are at an impasse on a particular issue, how will mediation help us resolve it?

We need to look closely at the reasons you can't agree. Are there emotional issues? Is there a fear of committing to a different way of doing things? Are you concerned that you may waive some legal rights? Or do you lack sufficient information?

People often have a period of extreme emotional upset when a marriage is ending. Severe anxiety and depression are not abnormal at this time. If you are at a stalemate because of an emotional reaction, a few sessions with a therapist may help you to clarify and moderate your feelings so that you can think more objectively.

Are you afraid to commit to a change that might not work out? Are you afraid to formalize changes in your relationship with your children? We might recommend that you experiment; try something for a month or two. Agree that you may do something totally different if the trial plan doesn't work out. For example, you can try out a parenting plan and then, in a mediation session, you can make adjustments that are an outgrowth of having some real experience with shared parenting.

Sometimes people are afraid they will permanently waive their legal rights if they make a decision, and as a consequence they become immobilized. In such a situation, you might try to negotiate a temporary arrangement, with a clear understanding that this will not set a precedent for the future.

In one of Dolores's cases, although the husband wanted to move out, he was afraid to do so for fear that he would be accused of abandonment and that he would lose any right to the house and to shared custody. The wife agreed to sign a temporary agreement stating that his move would not waive any of his rights.

Sometimes lack of sufficient information creates the impasse. Often the mediator can provide the needed information. If not, the mediator may recommend an opinion from someone both parties agree upon as an expert. This expert might be a child psychologist, a financial planner, a neutral attorney, or an appraiser. And you both can agree in advance that the expert's opinion will either be simply *advisory* (you will take it into consideration) or that it will be *binding* (you agree to accept the expert opinion to break the impasse).

The mediator's role is to help the couple think through their respective positions regarding each issue. We help to generate options, and we take an active role in eliminating an impasse if it occurs.

## Question 5

### Why is it so difficult to separate or divorce?

Do *both* of you find it difficult? If so, you may want to try couples counseling before proceeding with divorce. However, if only one of you is interested in counseling, then it is probably time to come to terms with the separation.

We recognize that there is often ambivalence about saying good-bye. This is usually a factor when couples in mediation have difficulty agreeing on minor issues, seem to connect intensely through anger, or, when the agreement is almost complete, seek to change some of the terms.

During the process of mediating the separation agreement, your fears will begin to subside as you learn to negotiate con-

structively and to resist your impulses to engage in emotional arguments. Mediation will restore a sense of your own power and autonomy. You will learn not only to assert your needs but to plan for and develop control over your future.

## Question 6

### We disagree on so many things. How will we ever negotiate a settlement?

Being unable to agree is probably a major reason you are planning to separate or divorce. Throughout your marriage, you may have been disagreeing openly and feeling hostile to each other, or you may have been holding back your hostility to avoid a confrontation, but you were probably having those disagreements silently in your own mind.

If communication has broken down but you want to make a settlement, you will find mediation extremely helpful. The mediator will help you communicate about the necessary issues and will stop both of you from rehashing past disagreements. She will keep you focused on your individual and separate future plans and will strongly encourage you to let go of the argumentative habits that didn't work in the past.

## Question 7

### When we argue, my spouse always wins. How will I be able to negotiate under these circumstances?

If you feel overpowered by your spouse, you need to really examine why your spouse always wins arguments with you.

- Does your spouse win because you're uncomfortable arguing?
- Do you feel guilty?
- Are you afraid of confrontation?
- Are you afraid of losing control?

Your mediator's role is to keep the discussions calm, to help you both assert yourselves without losing control. Remember, the purpose of divorce mediation is to negotiate a settlement of the practical issues, *not* to win an argument or to place blame.

- Are you afraid things will get violent?
- Does your spouse threaten you?

Don't agree to mediate under these circumstances. The only exception is in some court-ordered mediation programs in which they have special protective arrangements (security guards, separate waiting rooms, controlled departures, etc.) for couples where violence is an issue This is obviously not possible in a private mediator's office, which is why we don't recommend it.

- Do you stop arguing because you believe your spouse knows more about an issue?

Here mediation can be helpful. Your mediator will assist you with negotiating techniques and with information. Mediators have many ways to empower the weaker party at any point in a negotiation, and remember, each couple relates differently on different topics. In some areas you may feel less knowledgeable, but in other areas you will feel confident and your spouse will be the one who is unsure.

Your mediator will remain in control of the process and keep the focus on the future. Clarification will be encouraged, confrontation discouraged. We support the expression of ideas, but we do not permit disruptive behavior.

## Question 8

### I'm concerned my spouse won't be an adequate parent without my help. How can I negotiate a parenting arrangement?

Mediators often work with parents who have been responsible for most of the decision making for the children and who voice

serious doubts about the other parent's ability to care for the children alone. Will the other parent pay enough attention to the children, feed them adequately, see that they're bathed and put to bed on time? Will they provide enough consistency and discipline?

Sometimes these are realistic concerns that the two of you can talk about when you negotiate your separation agreement. Your parenting plan may need to be more specific and comprehensive. In order to encourage your spouse to be open to your proposals, it is important to try to make concrete suggestions during the negotiations, without blaming your spouse or making angry references to the past.

In other instances, concerns about the other parent's inadequacy may really be underlying feelings of anger. Do you identify with any of these feelings?

- You rejected me, now you want to take my child away.

- You didn't have time for me, and you don't have time to be a parent; you want joint custody to punish me.

- You were a lousy spouse and you're a lousy parent.

- I don't want anything to do with you, and I don't want to deal with you about the child.

- I'm the only good parent, and without you causing problems, everything will be fine.

Take a few minutes and think about whether any of these feelings apply to you. Is your anger getting in the way of accepting your spouse's different style of parenting? See also Question 20 in Chapter 3: My spouse and I have different attitudes about parenting.

Try talking over your feelings with your mediator. You may need to be more objective about these issues, and, if possible, move them out of the foreground so that you can work out a reasonable arrangement in mediation. Remember, if you are unsure about the parenting arrangements, try them for a while before

signing the agreement. That way, if you need to, you can come back to mediation and work out appropriate modifications.

> Dolores mediated a separation in which the wife, who was a licensed nutritionist, would not agree to joint custody until her fears about adequate care for the children were addressed. Although her husband felt that he could quite adequately take care of their children, he agreed to include in their agreement that she could mail information about nutrition to him every other week, and that he would read it upon receipt.

## Question 9

### How can we negotiate when different people give us contradictory information?

One possible reason for the confusion is that the law is unclear or not specific enough about your particular issues. Although there are guidelines in every state regarding child support, there are many legal concepts that apply to divorce but are open to various interpretations.

If you go to court, the decision about your issue may depend on the latest case or on the judge's opinion. In mediation you will explore various alternatives and will develop a solution that makes the most sense for your situation.

*Some of the more puzzling concepts are:*

- What exactly is equitable distribution?
- What is the value of a professional license? Does it make a difference that I've been in practice for several years?
- Who is entitled to alimony or maintenance? How much? For how long?
- What are the rules about out-of-state relocation?

There are many other questions that individual states may or may not address by way of guidelines, but your mediator will be

knowledgeable about the issues involved, and there is almost always plenty of room for a range of outcomes.

By the way, we address all the questions raised above in various places in this book—but that doesn't mean we have all the answers!

## Question 10

### I feel immobilized although I know a divorce is inevitable. What can I do?

Immobilization is often a symptom of fear, like being caught in the headlights of a car while crossing a road at night and being unable to move. The inability to act may be fear of telling your spouse you want a divorce, or fear of your children's or your family's reactions, or fear about surviving financially. It may be guilt or shame about wanting the divorce. It may be a sign of resistance to accepting the fact that a divorce is inevitable.

We suggest you talk to a good friend or family member about how you are feeling. Just try to open up a little. You'll be surprised at how your feelings and thoughts shift around and things begin to make more sense. If you have been talking and still feel immobilized, consider a few sessions with a therapist.

Once you begin the process of moving toward divorce, you will feel energized. When you settle some anxiety-producing issues, you'll begin to feel more comfortable about your future. Taking action leads to further action, and you'll become focused on the future rather than the past.

Also see Question 12: We tried to work the marriage out but couldn't. I know divorce is the only answer, so why am I depressed?

∽०∾

42

## Question 11

**My spouse discusses every detail of our separation with her family and close friends, and everyone gives her advice. How can we negotiate under these circumstances?**

In many families—and indeed in many cultures—marriage is a joining of families, and there is a strong tradition of family involvement even before the marriage. In that context, it isn't surprising that families often are very involved if the marriage is in trouble. It may be appropriate to discuss the point of view of the involved family members at the beginning of mediation so that their feelings are clear to the mediator. If close friends play an important role in your spouse's life, it may be necessary to allow your spouse to state their viewpoints once, and then establish some ground rules about their involvement. Also see Question 22 in Chapter 1: Can I bring a relative with me to the mediation sessions?

An attempt can be made to experiment with realistic limits about with whom you may discuss the separation while you are engaged in the mediation process, how frequently you may speak with them, and what topics are off limits for the moment. Both you and your spouse probably suffer additional stress as a result of the confusion and misunderstandings caused by all that cross-talk, and couples often find that these limits are a relief.

## Question 12

**We tried to work the marriage out but couldn't. I know divorce is the only answer, so why am I depressed?**

The depression may be in anticipation of the losses you fear, and you may be grieving.

The end of your marriage, and the possible loss of significant relationships, familiar surroundings, and financial security often lead to feelings of sadness and worthlessness. Insomnia and an inability to concentrate are not unusual in this period.

43

If you have had other significant losses earlier in life, or if you have a history of depression, your upcoming divorce may trigger a deeper, more serious reaction. It is important that you see a therapist to determine the extent of your depression and to obtain appropriate help.

It helps to know that feeling very sad about divorce is normal. There are different phases, or stages, that people who are grieving commonly pass through. Elisabeth Kübler-Ross described these stages as shock and denial, anger, bargaining, depression, and acceptance (in that order). Try thinking about your present experience in terms of where you have been and where you are in these stages. Remember, it takes time to work your way through these phases, but it doesn't take forever.

Some of your sadness may be linked to anxiety about the future. You will be helped by working through the details of your divorce in a calm, supportive setting where you can plan for the future. While some sadness may remain, you will experience relief as each issue falls into place, and you will gradually be able to accept the changes that your divorce will bring.

## Question 13

**My affair broke up our marriage. If I mediate,
I'll have to be in the same room with my spouse.
I don't know if I can do that.**

It can be difficult to face your spouse under these circumstances, and anxiety about asserting your needs when you feel at fault for your spouse's distress is understandable. It may help to keep in mind that the purpose of divorce mediation is to create a settlement, not to discuss why the marriage failed. In our practices, we sometimes complete a mediation and have no idea why the marriage ended; it has never even been mentioned.

While it's important to take responsibility for your actions, try to remember that a failed marriage is *never* the fault of just one party. Think about all of the issues that were problems in the mar-

riage, and try not to put *all* the blame on yourself. As for facing your hurt or angry spouse, the mediator can help by keeping the focus on negotiating the settlement, and de-escalating feelings or conflicts that may arise.

If you are uncomfortable being assertive about the things you need, be reassured that the mediator will help you express your views and needs. The reality is that the marriage is over, and you both need to move on with your lives.

## Question 14

### I've become very suspicious of my spouse. How can I trust her in mediation?

Are these feelings that you had during the marriage, or are they directly related to the decision to divorce?

- Have you caught your spouse in lies throughout the marriage? If your spouse has been dishonest during the marriage, you will undoubtedly convey that to your mediator early in the process so that she will be alert to any possible deception that might affect the settlement.
- Is it only now that you are suspicious? If you express doubt about anything your spouse says with regard to the settlement, the mediator can make sure that all the facts are fully disclosed so that the settlement will be fair. If full disclosure is not made, the mediation cannot proceed.

There is another possibility: the divorce process itself can bring up feelings of mistrust, suspicion, betrayal, and even paranoia. And the friends and relatives you turn to for advice may increase your fears; they may want to be protective, give advice, or tell war stories about divorce. If you've visited any litigators, they may have increased your suspiciousness because it's their duty to tell you about the worst that can happen and to formulate a plan of attack.

In contrast, mediation is helpful in building trust. Your mediator will be emotionally supportive and will require that all neces-

sary information be shared. Since you will be in the room together throughout the mediation, you can observe your spouse's reactions to all the issues. This atmosphere encourages candid discussion, and you will find that it decreases your feelings of distrust.

## Question 15

**I decided, for my own protection, to open a separate bank account, and now my spouse refuses to attend the mediation session. Can a mediator help get him to cooperate?**

Just before divorce there are often cycles of hostility: disagreement, confrontation, silence, more hostility, and finally, as communication breaks down, some unilateral action, such as taking money out of a joint bank account and opening a new account. These actions lead to further anger and suspicion.

Encourage your spouse to contact the mediator. She will clarify that a commitment will be made that no unilateral actions will be taken during mediation. She can help the two of you work out a temporary agreement about what will remain marital assets and what will be kept separately, until the details of the final agreement can be resolved.

## Question 16

**I'm frightened. My spouse has been very abusive. Can we mediate our divorce?**

If your spouse has recently been physically abusive or has frequently been intimidating or threatening, we would generally not recommend private mediation.

- Has there been physical abuse?
  We feel strongly that if there is a recent history of *physical* abuse of you or of your children, the relationship is too threatening for you to be able to negotiate effectively—even with the help of a mediator. You may be too fearful to be

appropriately assertive about what you want in the mediation session, and you may be in danger after the session if your spouse has been upset in the session.

- Has the abuse been verbal or emotional?

  If the abuse has been exclusively verbal or emotional, here are some questions you should ask yourself to help decide if mediation is possible:

  Has my spouse frequently tried to intimidate me with insults, accusations, or threats of violence? Even though things have never gotten physical, does this behavior make discussion impossible? Does it make me feel powerless?

  Am I afraid my spouse will threaten me after each session?

  Will I be afraid to speak up in the session, even with the mediator's help?

  Was my spouse's abusive behavior linked to alcohol or drug use? If so, is my spouse in recovery? For how long? Is there a strong enough support system in place so that a relapse is unlikely?

If you are fearful, it is probably better that you not deal directly with your spouse. We suggest you hire a lawyer to represent you and to argue on your behalf.

See also Question 3 in Chapter 1: Are there drawbacks to mediation? Question 26 in Chapter 1: When should I refuse to mediate? And Question 12 in Chapter 10: My spouse gets violent and I'm afraid to go to court-ordered mediation. Can I get out of it?

# CHAPTER 3
## Decisions about the Children

Overview

1: What are the best ways to help children "survive" the divorce?

2: What can we negotiate in mediation to ensure that my relationship with my children won't be affected by my moving out?

3: How will the type of relationship we have influence our parenting agreement?

4: How do we decide about parenting arrangements (custody and visitation)?

5: Our children will have different needs as they mature. What changes can we expect and how can we anticipate these changes in our parenting plan?

6: Will it be hard on our children if we agree on joint custody?

7: Does the child's age affect which parent gets custody?

8: Should we let the children decide which parent they want to stay with?

9: I adopted my stepchild when I married her mother. Must I give her up now that we're getting a divorce? What can I negotiate in mediation?

10: How should we arrange where our children spend birthdays, holidays, and school vacations?

11: Although my spouse has moved out, he drops by unexpectedly almost every evening. The children get upset if we argue about it, but I want him to stop. What can I do?

12: Our baby is still nursing. How does that affect custody and visitation?

13: My parents want to be sure they see their grandchildren. Since I'm going to be out of the country, and my children will be living with my ex-spouse, how am I going to arrange this?

14: If one of us remarries, how does that affect custody and visitation?

15: What if my spouse wants to move away with our children?

16: Our child will be traveling between coasts for visitation with my former spouse. What do we need in the agreement?

17: I'm worried that my spouse will leave town with our child without my permission. What can I negotiate in our agreement to prevent this?

18: We have a special-needs child. How does this affect the agreement?

19: My spouse and I are from different religious backgrounds, and this creates special problems for us in bringing up our child. How can the mediator help us with this?

20: My spouse and I have different attitudes about parenting. This has been a source of conflict during the marriage, and it seems inevitable that it will be a bigger problem after the divorce. How can the mediator help us address this in our agreement?

21: I have a live-in lover, and my spouse isn't comfortable with us having joint custody or visitation. How can we work this out?

22: What if my former spouse never keeps promises about visiting the children or paying child support?

23: Can I refuse to let my children visit if my ex-spouse is late with child support?

24: What if I don't feel it's safe for my children to visit my former spouse? Can I ever refuse to let them visit?

25: I have spent time in jail. How will that affect my rights to custody and visitation when we mediate?

# Overview

In mediation, we think in terms of *parenting arrangements* rather than *awarding custody* and *allowing visitation*. In this section we will clarify the legal terms used to describe the various parent-child relationships in divorce, but our emphasis will be on helping you develop the best plan for becoming cooperative co-parents.

It's not unusual for one or both parents to enter divorce mediation with the fear that their spouse will somehow manage to deny them access to the children. You will be reassured to know you both are *entitled* to ample time with your children, and only if you are prepared to prove that your spouse has engaged in behavior that has been harmful to the children, can visitation or custody be affected.

Engaging in the mediation process is a good way to establish a civilized postdivorce relationship. Mediation avoids much of the lasting bitterness commonly resulting from a protracted and costly adversarial struggle. If you and your former spouse can cooperate in making decisions about your children, the process of moving on with your lives will go more smoothly. If, on the other hand, after the divorce you continue to act out your emotional conflicts, everyone suffers and no one wins.

Your children will experience much less trauma as a result of the divorce if both of you are able to be cordial and relaxed with them and with each other. Remember, there will be many occasions for years to come—school visits and graduations, recitals, christenings, bar mitzvahs, weddings—when you will be together because of your shared interest in your children.

In this section we will explore the ways in which you can create your new parental roles. We suggest you also read the chapters about alimony and child support (Chapter 4), taxes (Chapter 7), and additional issues (Chapter 11) for more information related to your children.

## Question 1

### What are the best ways to help children "survive" the divorce?

There are certain basic principles that must be kept in mind in order to limit the negative effects of your divorce on your children:

- Tell your children together in a gentle, nonargumentative way that you are separating.
- Reassure them that they are not the reason for the breakup.
- Don't express your anger at your spouse to your children; they can be hurt and confused when they hear their parents criticized.

Remember, the most important factor in your children's adjustment to your divorce is not the type of parenting arrangements you have chosen but the way you as parents conduct yourselves during and after the divorce.

Keep in mind that change is often difficult. We usually adjust to new situations in time, and transitional difficulties are often due primarily to the experience of change rather than to the new situation itself. Think about simple transitions like falling asleep or waking up, or more complex ones like the first day of a vacation or a new job.

- If you have made parenting arrangements that you and your spouse feel are in the best interests of your children, stick to the arrangements for a while, even if your children voice objections. Give them time to adjust to the changes.
- Don't discuss every detail with the children; rather, explain how things will work in a simple, direct way. Don't present everything at once, especially to a younger child. Be specific rather than explaining the overall, long-term plan. For example, say, "On Friday, Daddy is picking you up from school and you'll spend the weekend at his house, and I'll pick you up from school on Monday."

- Most children will ask questions that will guide you regarding what else it is necessary to address: "How will I get to my music lesson on Saturday?" "What will you do while I'm at Dad's?" "But I need you to help me with my homework!"

- Encourage your children to give the new arrangements a try for a specific period of time—a week or even a month—depending on their ages and the nature of their objections. Reassure them that you hear their objections and that you will try to modify the plans if they remain unhappy after the trial period.

- Allow your children to express their feelings about the divorce. Don't expect your kids to support your decisions immediately. They probably didn't want you to separate, so don't expect them to be happy about it or not to object at first when familiar routines are disrupted.

- If you are moving to a new residence, help your children adjust to the change by letting them assist in choosing the furnishings for an area they will occupy—their bedroom or a special place where they can study. It will make it easier for them to feel at home.

- If there is a lot of hostility and conflict between you and your partner, the children are more likely to have a difficult time. In that case, the parenting arrangements should be simple, minimizing the contact between the two of you and thus minimizing the exposure of your children to the conflict.

- If you need to make adjustments due to changes in circumstances, discuss them out of your children's presence. Then present the new plan calmly and reassuringly to the children.

- Try to think positively about your future; you will reassure your children by being focused on the future. Make simple plans about things you and your children can do on your own, rather than lamenting and dwelling on what you could have done if the marriage had remained intact.

If after a month or two your children are still very unhappy and voicing difficulties, you may want to consider a consultation with a

professional who specializes in working with children therapeutically. An experienced therapist can help you evaluate whether your children's reactions are normal or extreme, and whether some type of intervention is a good idea. Short-term therapy, for example, can help children (and of course a parent as well) through this difficult period.

## Question 2

### What can we negotiate in mediation to ensure that my relationship with my children won't be affected by my moving out?

Mediators often hear this concern expressed by noncustodial parents, who fear they will no longer be able to have a close relationship with their children.

Actually, your future relationship with your children will depend on how you continue to relate to them *and* on how you relate to your former spouse. Your parenting arrangements will assist you in making a smooth transition.

If you and your spouse tend to argue whenever you meet, you will want to minimize contact with one another. Perhaps you can agree to pick your children up at school or at the babysitter's, and return them there. Create parenting arrangements that are clear and detailed, with alternatives spelled out in the agreement for unexpected situations so that you can minimize the reasons to argue over the children's changing needs. Also see Question 3 in this chapter.

We advise you not to move out without a temporary letter of agreement stating that the move won't be used as a ground for divorce or for any other purpose. Be certain that your temporary agreement provides sufficient details for visitation to establish your ongoing, continuous, and frequent involvement with your children. See also Question 17 in Chapter 1.

It is important to negotiate a visiting schedule that allows sufficient time to do more than entertain your children. You need

time to do normal activities around your home so that your children will feel they belong there. Plan age-appropriate household tasks and shared activities that you enjoy doing together, and make every effort to remain involved in *their* activities whenever possible.

## Question 3

### How will the type of relationship we have influence our parenting agreement?

*Think about these questions:*

- Realistically, knowing each other, what kind of future relationship is possible?

- How frequently do I want to be in contact about the day-to-day details of our children's lives?

- Can I comfortably meet my ex-spouse at parties, school conferences, and other functions important to my children?

- What if one of us remarries?

How you feel about these questions will help you decide how detailed you want the agreement to be. Your relationship with your former spouse will change over time. You may get along well now because you are focused on the children, but you may be less cordial once the parenting arrangements are working smoothly— or you may both be more relaxed. Sometimes it's difficult to predict how things will work out.

If you can get along with each other calmly, most issues can probably be resolved as needed in the future. If you are very argumentative—a high-conflict couple—most of the details should be clearly spelled out in the agreement, with plenty of alternatives built in to handle irregular situations (illness, business trips, special events, for example) so that you will have minimal need for discussion and decision making.

In one of Dolores's mediations, the father traveled a lot and wanted to move into the apartment next to his ex-wife's so he could drop by to see the children whenever he was in town. He thought his wife was being selfish in objecting to this arrangement. When Dolores explored his ex-wife's feelings, she explained that she didn't want their children to meet his new girlfriends accidentally, that it would create unnecessary stress for them and for her. The father became more understanding, and agreed to move to another building in the neighborhood so they could all have more privacy.

In contrast, Carol worked with a couple who decided to divide their large apartment into two apartments with separate entrance doors, so that their teenage daughter could spend time with each of them when convenient. Since these parents remained quite friendly, they agreed to talk regularly so they could present a united front about discipline and rules. For them, this was an ideal way to remain in daily contact with their daughter even though they were divorced.

## Question 4

### How do we decide about parenting arrangements (custody and visitation)?

In working out your parenting arrangement in mediation, you will plan how much time your children will spend with each of you and whether both of you will provide a complete household for your children or just a comfortable visiting situation. Equally important, you will plan how decisions affecting your children will be made after the divorce.

Some of the factors you'll want to consider when negotiating about how your postdivorce family will function include:

- The best interests of your children

- Minimal disruption of your children's routine

- Relocation of one of you to another state

- Any special or health-related needs of your children

- The age and sex of your children

- Your children's preferences

- The past relationship of your children with each of you

- Your ability to cooperate with each other, which determines how flexible the arrangements can be

Since mediation focuses on creating the best parenting arrangements, you should become familiar with some of the legal terms the courts may use to describe the elements of your arrangements with your children. Within these categories, each specific issue (such as decisions about school, the timing of visits, for example) can be negotiated in mediation:

- ***Joint custody***—you share both physical custody and legal custody (decision making). Joint physical custody doesn't necessarily mean equal time. Your children may spend as little as one-third of their time with you and two-thirds with your former spouse, depending on your schedules, the ages of your children, and the location of your home.

- ***Sole physical custody and joint legal custody***—one of you has sole physical custody, and you share custody for the purpose of decision making.

- ***Sole custody***—one of you has sole physical and legal custody and the other has specific times for visits. You may agree to share certain decisions, such as those about schooling, religious training, and medical care.

- ***Split custody***—each parent has physical custody of at least one of the children.

Also, different states have different practices. For example, in Texas, parents are usually "Joint Managing Conservators" of their child, and instead of ordering "visitation," Texas issues a "Standard Possession Order," which describes "periods of possession." The child visits the "possessory conservator." In Ohio, the term "shared parenting" is used instead of "joint custody." In Pennsylvania, the courts use the words "partial custody" to

describe overnight visitation. In New Jersey, visitation is now called "parenting time."

## Question 5

**Our children will have different needs as they mature. What changes can we expect and how can we anticipate these changes in our parenting plan?**

The details of your parenting plan will vary over time in order to accommodate your children's developmental changes. Revisions may be necessary and can be made formally in your mediation agreement, informally as needed, or through occasional meetings with your mediator during which the changes are decided and formalized.

These are some basic developmental principles to keep in mind that will help you formulate a written agreement that meets your family's unique needs:

- *Infants* need to get to know both of you as intimately as possible. Physical contact is important—bathing them, holding them, talking to them. They need you to be attuned to their needs, and you can only develop that attunement by taking care of them and learning their special ways. They will show you the way if you give them your attention and really interact with them.

- *Preschoolers* can talk, so it is easier to know what they want, but they are still very fragile and dependent. They do better with relatively brief visits, and they need safety and routines. Transitions cannot be rushed, from one of you to the other, or even from situation to situation with the same parent (for example, going out to the park or going to bed). In these situations the preschooler may feel insecure and may cry or become resistant unless you take your time.

- *School-age children* need a lot of respect and consideration for their interests and activities. They can make changes more easily, but they need time to rest, to focus on their

activities, to ask questions, and to be affectionate and loving with you.

- *Preteens* are generally more independent, but they still are very much in need of your cooperation, guidance, and support.
- *Adolescents* want to be very independent, but they need consistent parenting from both of you. They need you to be flexible concerning visitation schedules if they have special activities that are important to them, though they may have difficulty giving you the same consideration. They need privacy and access to their friends, and they need you to provide the time and structure for them to attend to their schoolwork and responsibilities.

See also Question 1: What are the best ways to help children "survive" the divorce?

## Question 6

### Will it be hard on our children if we agree on joint custody?

This depends a lot on your relationship with each other. If you can minimize the conflict between yourselves, you will be able to make transitions smoother for your children. Although a united front may not be possible, you should both make an effort not to criticize the other parent in front of the children.

Ideally, although basic routines (bedtime, study time, etc.) should be relatively similar with each parent, your child will learn that in reality there are different rules about some things at each parent's home. This is quite normal.

At first, any change will be somewhat difficult for your children and may lead to some resistance. That's because most children want their parents together, and as they visit each parent, they may feel disloyal toward the other. They may even feel somehow responsible for the breakup. The two of you will want to emphasize that the divorce is not their responsibility, and that it's acceptable to enjoy seeing each parent in separate surroundings.

In all likelihood, as your children adjust to the idea of having a relationship with each of you in separate surroundings, they will be just fine. Most children will generally get comfortable in both places and will quickly discover the advantages (and disadvantages) of each home.

Each of you probably has different ways of parenting, but you need to be predictable and fair, and not be drawn into competition with the other parent. When your children stay with you, try to include ordinary routines, privacy, shared activities, and time to talk quietly and to make plans.

## Question 7

### Does the child's age affect which parent gets custody?

At one time the courts automatically granted custody to the mother if the child was under five years old. This is no longer true, although some states and some judges still take the age of the child into consideration as one factor in determining the best interests of the child. For instance, if your child is a teenager, some judges might determine that it is in his or her best interests to be with the same sex parent. You and your spouse know your child best, and you will be able to make the best plan for your child.

That's why mediation is a better choice. Neither parent has to worry about the inclinations of a particular judge. The parents work out the best arrangement based on their own preferences and unique circumstances.

## Question 8

### Should we let the children decide which parent they want to stay with?

While some courts do take the children's preferences into consideration (in Pennsylvania and Texas as early as age 12, Oregon at

14, in some other states at age 16), it is never advisable to ask your children to take sides. In our individual psychotherapy practices, we have worked with adults who suffered severe shame and anger as children because their parents put them in the middle. It is important that you present a united front under these difficult circumstances.

The age of your children will affect your agreement, but no matter what you agree on, it is not unusual for teenagers to want to have a say about where they spend their time. Talking to your teenager objectively about how she prefers to schedule her time is very different from asking her which parent she prefers.

This is where a flexible attitude on your part in creating the separation agreement comes in handy. Include a paragraph in the agreement to mediate any changes in the parenting plan if modifications are needed that can't be made amicably.

See also Question 21 in Chapter 1: Should we bring our child to mediation sessions?

## Question 9

### I adopted my stepchild when I married her mother. Must I give her up now that we're getting a divorce? What can I negotiate in mediation?

This comes up often with us since about half of adoptions are stepparent adoptions. If there was a legal proceeding in which you adopted your stepchild, you have all the rights and obligations of a biological parent. Like any other parent, you will negotiate parenting arrangements in mediation that will include custody, visitation, and child support.

In contrast, if the "adoption" was unofficial, very few states will require you to support your stepchild, and most states will not recognize your right to visit. In mediation, however, you may be able to arrive at a mutual understanding for future visitation with your stepchild, perhaps in exchange for helping with ongoing expenses.

## Question 10

### How should we arrange where our children spend birthdays, holidays, and school vacations?

There is no rule. In mediation, the two of you can work out your own unique schedule. As with all parenting arrangements, each of you should be realistic about the time you have available and the events that are important to you.

If you and your ex-spouse have a relaxed relationship, you may be comfortable with a more general plan about special occasions, since changes will be easy for you to work out. In the event you are a high-conflict couple, we encourage you to work out all the details in advance.

Some of the possible arrangements that can be made in mediation and described in detail in your written agreement include the following:

### Birthdays

*Children's Birthdays.* Some parents share their children's birthdays. They agree that both can attend the party, and that each year they will consult with each other about party arrangements. Since this plan may not be appropriate for a high-conflict couple, another approach is to alternate years, so each year one parent individually holds the birthday party and has the main physical access. In this case, the other parent would have a definite number of hours to visit with the birthday child, or the parents could agree to split the birthday weekend and perhaps make plans with each extended family. Another option would be for the parent who didn't hold the party to take the child out for a special birthday treat after the party, or for that parent to have an extra weekend with the child.

*Parents' Birthdays.* Usually the child spends some or all of the day with the birthday parent. If the birthday falls on the other parent's visitation day, the parent with the birthday should take precedence.

## Holidays

Some parents have favorite holidays or important religious holidays that they negotiate to keep. Other parents simply alternate the holidays year by year, that is, one year the children spend Thanksgiving with the father, and the next year they spend it with the mother. It is important to work out the schedule ahead of time so that important days can be planned and that no one feels unfairly treated.

## School Vacations

Each parenting arrangement is unique. This is an area in which you can be really creative.

Dolores had one couple with children of significantly different ages. The parents decided to split visitation. Each parent would alternate weeks with each of their two children during school vacations so that each child would get a full week's attention from one of the parents.

In the event your children are living far away from one of you, school vacations may be the one time they can spend long periods with you. This would allow each of you to spend almost equal time with the children.

But you need to ask yourself:

- Do you want to continue with the same visitation schedule during school vacation as during the rest of the year, or do you want to split this extra time and each take the children for a longer period?

- If you have to work during your child's vacation, do you have child care available? If not, do you want to agree that your children will spend more time with you as they grow older? At what age? For what period of time?

- Does your spouse have more time to spend with the children during vacations? Easier access to child care? Are you willing to work it out so you have more time with them at another time?

- Do your children attend camp or engage in other vacation activities? Where will they need to stay to be able to participate?

Your final agreement will address each of these questions.

## Question 11

**Although my spouse has moved out, he drops by unexpectedly almost every evening. The children get upset if we argue about it, but I want him to stop. What can I do?**

The two of you need to work out a specific visitation schedule in mediation. If your children don't know from one night to the next when their other parent will be there, they are set up for disappointment. "Dropping by" leads to confusion, and it may encourage your children to believe that your relationship will continue although you have told them it's over. In the event that an unscheduled visit is necessary, the visiting parent should phone first and both parents should agree on specific beginning and ending times for the visit.

A visitation schedule is important so that each of you can plan for your time alone with your children, and so that your children will know when they can count on seeing you. It's also important so that each of you knows when you can be free to make other plans while your ex-spouse is responsible for the children.

## Question 12

**Our baby is still nursing. How does that affect custody and visitation?**

With an infant, making a parenting plan is especially difficult. It gets easier as the baby becomes a toddler.

Obviously you both want to be sensitive to your baby's needs. You can try prepared formula as an occasional alternative to nursing, and if your baby accepts a bottle, the father can provide himself with the proper supplies and he should be fine—for brief visits at first, and for longer ones as the baby grows.

You may need to renegotiate custody and visitation several times during the early years. If you can't work things out together, you can always use mediation from time to time to make needed adjustments until your child is old enough for you to create a parenting arrangement that lasts for a longer period of time.

## Question 13

**My parents want to be sure they see their grandchildren. Since I'm going to be out of the country, and my children will be living with my ex-spouse, how am I going to arrange for this?**

You are referring to *grandparents' visitation*. Since most states have some form of visitation rights for grandparents, we recommend that you provide for grandparents' visitation in your agreement.

### *The areas for mediation include:*

- Whether visitation should be at a definite time each year
- How long visitation should last (this may vary with the age of your child)
- Where the visits should take place
- Who pays for transportation, and whether it will be included as part of the visitation period

If you become concerned that these visits are harmful to your children, or if either set of grandparents attempts to sabotage the relationship between your children and one of their parents, you can return to mediation to have the visitation arrangement changed.

## Question 14

**If one of us remarries, how does that affect custody and visitation?**

Spouses often worry about each other's ability to be a good parent, and they wonder what it would be like for the children

in the event a new partner appears on the scene. Custody and visitation should not be affected by the remarriage unless you can prove that the new spouse is abusive or harmful to your children, or unless you and your former spouse decide to mediate new arrangements.

## Question 15

### What if my spouse wants to move away with our children?

This is a difficult problem because both of you want to spend time with your children. In mediation we try to help you arrive at a fair solution.

Each of you has legitimate concerns. If your former spouse wants to relocate and you rely on a weekly visitation schedule, you may be concerned about having significantly less contact with your children, a loss of bonding, and less opportunity to be involved in your children's development.

If your children live with you and you want to relocate, you may not be totally free to do so. Unless your former spouse agrees, you may be restricted from moving to take a better job, improve your quality of life, or join your new spouse.

If you don't use mediation, you will find that most judges limit the custodial parent's freedom to move to a specific in-state area. States vary considerably regarding circumstances that would permit out-of-state moves.

Your agreement should include a description of the possible circumstances under which you would agree to an out-of-state move (see box).

Here are some options you may want to specify in your agreement whereby you would be willing to allow your former spouse to relocate with the children:

- After your children reach a certain age
- If he or she remarries someone who lives or works in another state

- If he or she has an opportunity for a significant increase in income, with a definition of the percentage increase considered significant
- If he or she agrees to pay for most of the transportation for visitation
- If the move is limited to a specific region such as the East or West Coast
- If you are compensated with more visitation time (summers, holidays, school vacations)
- If you move outside the area
- If you agree to the move for any other reason

To keep in touch: If your children are moving across country, negotiate to E-mail them daily, so they hear from you on return from school, or to have an 800 number or a cellular phone so they can contact you easily.

## Question 16

### Our child will be traveling between coasts for visitation with my former spouse. What do we need in the agreement?

Agreements vary on these details, but a variety of commonsense issues need to be thought out and anticipated, depending on the age of your child, your personal preferences, and on airline rules. Let's take a look at some of them:

- Will someone have to travel with your child?
- Who will meet your child upon his or her arrival?
- Who will pay for traveling and other arrangements?
- Who makes the travel arrangements?

As your child matures, you may agree to longer visits to your former spouse. Parents frequently agree that short visits may begin after age five or six, and by age eight or nine, the child may stay away for the summer or other long school vacations.

## Question 17

### I'm worried that my spouse will leave town with our child without my permission. What can I negotiate in our agreement to prevent this?

Most couples who live in the same community agree in mediation that out-of-town visits are planned well in advance, and are limited to short periods of time. Requirements for advance notice and permission are written into the agreement, and out-of-country visits require *more* advance notice and more details about the plans. Arrangements are made in advance about regular communication between the stay-at-home parent and the child to alleviate anxiety for everyone—phone calls, e-mail, contacts with relatives in the area where the child is visiting.

But if you're concerned that your spouse has the potential to take your child to live elsewhere without permission, then you need to ask yourself the following questions:

- Does your spouse have the resources to manage financially in a different city?

- Are there family members or other sources of support in another city or country that offer the additional attraction of emotional and social support?

- Does your spouse seem vague and noncommittal when you try to discuss parenting arrangements, as though he might have a different agenda?

Under these circumstances, you should both meet with a mediator to discuss your concerns, explore potential problems, and find ways to provide reassurance.

Parents may feel more comfortable under these circumstances by providing for the following:

- Older children can be taught to recognize signs of trouble and to take appropriate action.

68

- Your child's passport can be kept in a safe place.

- Visits can be supervised, or the presence of a third party can be required.

- You can add a condition in your settlement agreement requiring family or couples counseling where your former spouse and involved friends and relatives can be educated about the abduction laws and the consequences of aiding a custody violation.

- Your former spouse can be required to arrange a substantial financial guarantee if he or she wishes to leave the immediate area with your child.

You may agree not to allow visits out of the country without both parents' approval, and the child's passport can be kept by the parent who is concerned about the possible custody violation.

If your spouse is emotionally disturbed and, in your opinion, poses a danger to your child, mediation is not the place to start. You need to have a psychiatric or psychological evaluation of your spouse and, using the information from the evaluation, develop a plan to protect your child, using the authority of the court to assist you. See also Question 15: What if my spouse wants to move away with our children?

Your fears about your former spouse taking away the children may be partially an expression of your anxiety about separating from them. Some anxiety is normal, but it may be heightened because of the emotional stress of the divorce. You can arrange regular contact with your children when they are away, such as daily e-mail or a prearranged maximum number of hours between phone calls. Get the phone numbers of nearby relatives and friends, if possible, so that you have the resources to help you locate and make contact with your children without having to wait for them to contact you.

∽o∾

## Question 18

**We have a special-needs child. How does this affect
the agreement?**

If your child has special needs because of an illness or a disability,
you need to consider the following in mediation:

- Do both of you have adequate child care arrange-
ments for when your child is living with you or
visiting?
- Which of you will escort or arrange for a caretaker
to escort your child to medical appointments and
to therapy?
- How will decisions be made concerning education,
tutoring, and schools?
- How will decisions be made concerning medical
procedures?
- Who will pay what percentage of the additional
costs of education, therapy, or medical proce-
dures?
- What public funding or scholarships will be
affected by your financial arrangements and by
any agreement you make concerning your will or
life insurance?
- Do you need additional medical insurance for your
child and additional life insurance for both of you?

## Question 19

**My spouse and I are from different religious backgrounds,
and this creates special problems for us in bringing up our
child. How can the mediator help us with this?**

Your mediator should be sensitive and respectful about religious
differences. You should present the relevant issues clearly early in

mediation so your mediator can consider them when appropriate.

Plans can be made for your children's religious upbringing based on the wishes of both of you and taking into consideration the relative importance of religion to each of you. Some couples agree to expose the children to both religions and allow the children to make their own choices when they reach an appropriate age.

In a case Carol worked on, one parent was more religious than the other. Although the wife was Christian, she agreed to her husband's request that he be permitted to supervise the children's religious education in his (Jewish) faith.

If you can't resolve your religious differences about the children, you can mediate the rest of the settlement and agree to return to mediation or counseling after a specified time has passed in order to work on resolving the issue. Once you both settle down after the divorce, it may be easier to agree on a plan.

## Question 20

**My spouse and I have different attitudes about parenting. This has been a source of conflict during the marriage, and it seems inevitable that it will be a bigger problem after the divorce. How can the mediator help us address this in our agreement?**

Balancing different parenting values requires careful planning in mediation. One parent may have been raised in the "spare the rod and spoil the child" school, while the other spouse may not believe in physical punishment of any kind. When couples with different attitudes are living together, they can try to moderate their differences when parenting conflicts arise. Anxiety understandably arises when the parenting plan provides that the children will be alone with the more restrictive or the more permissive parent.

In one of Carol's cases, the father came from a culture where girls were very restricted in their social activities, especially during adolescence. The wife was more liberal, and in fact, this had been an ongoing source of conflict during their marriage. In medi-

ation, they discussed their feelings about their daughter's socializing in detail and agreed on very specific rules, with changes spelled out as their daughter got older. They agreed to return to mediation if they had future conflicts that they couldn't resolve themselves.

If you have conflicts about different parental standards about discipline, money, proper behavior, proper dress, or anything else, your mediator will help you include specific conditions in the agreement, about how these matters are to be handled with your children.

## Question 21

### I have a live-in lover, and my spouse isn't comfortable with us having joint custody or visitation. How can we work this out?

Here is a good example of how mediation lets both of you keep control of the process. You and your former spouse can work with the mediator to establish ground rules about cohabitation so that both of you can be satisfied that your children are receiving proper care.

In negotiating the details of custody or visitation, it's important to keep in mind that the courts are very concerned that your children see *both* of you regularly. Unless your spouse can prove that your live-in lover is harmful to your children, it is unlikely that the courts would approve an agreement that severely limits your right to see the children, so there's no point in your spouse trying to establish extreme limits in mediation.

If your spouse goes to court and raises the issue of your live-in lover, the decision about when you see your children is being put in the judge's hands. Judges' opinions and laws on the subject of cohabitation vary widely from court to court and state to state, and you may end up with a decision that is far from what either of you wanted. So it's clearly best to work this out in mediation.

Dolores worked with a couple who divorced because the wife felt that the husband was too impulsive and chaotic to live with. At first the wife did not want their child visiting when his new live-in lover was present, but by the time the mediation was over, she had decided that the new person kept the former husband's household running smoothly and would be a good influence in keeping their child's routine consistent during visits. Instead of trying to limit visitation, the wife negotiated language in their agreement that they would return to mediation to revise the visiting plan if at any time she became uncomfortable about his living situation.

## Question 22

### What if my former spouse never keeps promises about visiting the children or paying child support?

Promises are more likely to be kept if your former spouse has participated in creating the parenting arrangements and negotiating child support. Planning together is one of the advantages of mediation.

You can provide in the agreement that if either of you fails to honor obligations, there will be penalties with serious legal or financial consequences. This should keep your ex-spouse in line. For example:

*Visitation*

- If child care is required, the spouse who fails to keep the visitation schedule will pay for child care.

- If 14 days' notice is required to prepare your child for vacation away from home, vacation will be postponed in the event the notice isn't provided, or the parent who fails to provide timely notice will be responsible for all trans-portation costs.

*Child Support*

- If all child support payments have not been paid, the parent will not be able to claim tax deductions.

- If the parent owes over a certain amount, the other parent will go to court to enforce the agreement through *income execution* (deduction from earnings by the ex-spouse's employer).

- If the parent owes above a specified amount, the other parent will receive additional property.

## Question 23

### Can I refuse to let my children visit if my ex-spouse is late with child support?

Visitation is independent of child support. If your ex-spouse stops paying child support, you may not deny visitation. If your spouse has custody of the child and does not permit you to have your normal visits, you may not reduce child support payments. The answer in these situations is to try to resolve the child support problem through mediation, or through enforcing your agreement in court.

## Question 24

### What if I don't feel it's safe for my children to visit my former spouse. Can I ever refuse to let them visit?

If there has been a history of child abuse or, if because of changes in your ex-spouse's circumstances, a potential for physical harm exists, talk to your spouse about visitation at a safe location, such as in a relative's home or, if necessary, in the relative's presence. If your former spouse refuses, by all means seek court protection for your children. Refusing to allow your children visitation without seeking court intervention is not advisable because the court may find you in contempt, and you may be severely penalized.

If you believe your former spouse's way of living has become harmful to your children, you could come to mediation with your ex-spouse and negotiate a temporary change in the visitation

74

arrangement until the harmful situation can be eliminated. The only alternative is to go to court to try to modify the visitation arrangement, but you will have to convince a judge of the danger to your children.

## Question 25

### I have spent time in jail. How will that affect my rights to custody and visitation when we mediate?

In some states, going to jail for a significant period of time (years rather than months) is one of the fault grounds for divorce. Depending on the offense, however, the fact that you have spent time in jail does not by itself affect your right to spend time with your children.

If you were in jail for a nonviolent crime, unrelated to personal or family matters, and unrelated to children, there is no reason *because of this alone* that your negotiated agreement concerning custody or visitation would be affected. However, there may be other factors that, in combination with the fact that you have served time in jail, could cause concern and might lead to some modifications when the agreement is reviewed by a judge.

If you have been convicted of a violent offense or an offense of a sexual nature, even if it was not violent, your spouse may fear that you might harm the children. If these types of offenses are at issue, you could negotiate in mediation to develop a plan that would allow you to see your children, perhaps with supervision.

For example, another adult whom both of you designate could join you on the visits with the children, and the visits could be very specific regarding time and place. Your visits could be limited and/or supervised for a specific period of time, at which point the visitation plan could be reevaluated. Based on everyone's feelings, the plan might be modified and then reevaluated again periodically.

# CHAPTER 4
## Alimony and Child Support

Overview

1: Under what circumstances can I get alimony?
2: What role does fault play in negotiating for alimony?
3: How do we determine how much alimony is fair?
4: Do alimony payments stop if I live with a new partner (cohabit) or remarry?
5: Will my alimony payments be affected if my spouse's income changes drastically? Under any circumstances?
6: How can I be certain that alimony payments will continue if my ex-spouse dies or becomes disabled?
7: Who decides how much child support is necessary, and what does it include?
8: What are some of the reasons the court will accept if we negotiate an agreement where I pay less than the child support guidelines?
9: Can child support be increased or decreased after the agreement is signed?
10: Until what age do we have to support our children?
11: Does child support have to be spent directly on my children?
12: Must I pay child support to my ex-spouse when our child leaves home for lengthy periods for summer camp or school?
13: Who pays the children's medical bills? Health insurance?
14: Who pays for child care?
15: Must we pay for college?
16: I will be the custodial parent, but my spouse tells me that I'm responsible for child support too. Is that possible?
17: If our child spends more or less equal time with me, why should I pay child support?

18: How can I be sure that child support will continue if something happens to my ex-spouse?

19: I have child support obligations to children by a prior marriage. How will that affect the child support payments I will be negotiating in this divorce?

20: If one of us remarries, how does that affect child support?

21: My spouse intends to change careers, and the new career will pay much less. Is that allowed, and how will it affect child support?

22: My spouse gets paid in cash. How can child support be calculated fairly?

23: My spouse takes so many business deductions that very little income shows up on our personal tax return. How can we figure out the right amount for child support?

24: How will the child support part of our agreement be enforced? I want to be generous when I negotiate my child support payments, but will I get in trouble if I can't pay?

25: My spouse is a musician, and his income varies significantly from year to year. How can I be definite about financial arrangements?

26: Will my spouse's deferred payment arrangement affect our support and property agreement?

## Overview

In many divorces, alimony and child support create the most anxiety for couples about to begin negotiating a settlement, but in reality they are often the easiest issues to resolve. Expectations or fears about alimony are usually unrealistic, and the minimum amounts required for child support are quite specific and easy to calculate for most families.

In this section we will explain what goes into making a decision about alimony, and we will define the three types of alimony (permanent, temporary, or rehabilitative). We will also explain the role of the child support guidelines provided by every state, and how you can make your own decisions in mediation about child support.

The word *alimony* describes support payments made by one ex-spouse to the other. In some states this is called *maintenance* or *spousal support*. Few states have legal guidelines about alimony. Some states continue to grant long-term alimony if there has been a long marriage and there will be a significant disparity in earning capacity, but in recent years the trend has been away from providing lifelong income for the former spouse. In most states alimony is paid if there is a significant imbalance in income, and only to allow the less-moneyed person to become self-supporting over a specific period of time through education or special training. Spousal support is also sometimes provided for a specific period of time so that a parent can stay home to care for a very young child. In Questions 1 and 2, we will explore some of the common-sense factors you will want to consider in deciding whether alimony is right for your situation.

Unlike alimony, each state does have guidelines describing what child support must include. In this section, we answer several questions about how child support payments are calculated. Your own agreement may vary from the guidelines in your state, but only in rare circumstances is it permissible for the total

amount spent on your child to be lower than the guidelines' minimum. In most situations, couples find that the minimum amounts described in the guidelines are affordable, and we have found in many of the divorces we have mediated that parents were willing to commit more than the state requires so that they could provide "extras" for their children.

If there is very little money or income, child support will be considered first. The *best interests of the child* is an important principle in divorce law, so alimony can only be discussed after provisions have been made for the children's needs. The IRS treats child support and alimony very differently. The differences will be discussed in this chapter and in Chapter 7: Taxes.

## Question 1

### Under what circumstances can I get alimony?

Wherever you live, you are unlikely to get permanent alimony unless one of the following applies:

- You have been married for many years, you are a senior citizen, and you are unable to work or gain the skills necessary to obtain a job that will support you
- You have been married to a wealthy person and cannot keep up the standard of living to which you've become accustomed
- You live in a state, such as New Hampshire, New Jersey, Michigan, Virginia, Oregon, or Washington State, for example, where permanent alimony is granted more liberally.

Alimony, also called *maintenance* in some states, is money paid by one spouse to the other after a divorce for the purpose of support. Husbands as well as wives are sometimes appropriate candidates for alimony.

Mention of the word *alimony* often elicits strong emotional responses. In the past, before so many women worked outside the home, the husband was the one who paid, and he paid more if he was at fault in the divorce. Sometimes, if the wife was at fault, she was not granted alimony.

At the present time, a very small percentage of divorces or separations even involve the

payment of alimony; of those that do, an even smaller number receive alimony for more than a brief period of time. Fault is no longer a factor in granting or limiting alimony in more than half of the states. Ask your mediator about the alimony situation in your state (in Texas, for example, you must be married for more than 10 years to receive alimony) since it's important to understand the factors to be considered in your specific situation.

*Permanent* alimony is generally reserved for an elderly, unskilled spouse and a marriage of lengthy duration, or the long-term spouse of a wealthy person who would be unable to maintain the standard of living the wealthy spouse had been providing. Dolores worked with a couple, for example, where the wife had supported her older artist husband for many years. Although she wasn't wealthy, she earned four times her husband's income. In this case the wife agreed to pay long-term alimony.

If you successfully negotiate for any alimony, it will probably be *rehabilitative*, to be paid for a specific period of time so that you can develop a way to earn a satisfactory living or qualify for a promotion. The other option is *temporary* alimony, which is intended to compensate you for time spent in the past helping your spouse with his or her business or career, or in some circumstances, for time you will spend without full-time employment until your child reaches a certain age.

You will need to negotiate about whether you will receive any payments, and if so, how much and for how long. You will want to be sure there is enough

Sometimes when one spouse has been the main provider, he begins negotiations with an expressed or unexpressed desire to continue providing everything. In one of Dolores's cases, the husband, a teacher, offered generous alimony and child support payments in the first session. Although there would soon be two households, he wanted to support both households to the extent that he had supported the family prior to the divorce.

Dolores encouraged the couple to draw up a realistic budget for each home, including rent, utilities, transportation, cleaning, food, and all the other necessary day-to-day expenditures. Once they realized what living separately would actually cost, the husband was able to focus more realistically on what he could provide.

money available, in accordance with the child support guidelines, for child support and child-related expenses *before* alimony is negotiated. Then the income and expenses of both you and your spouse must be considered to determine if alimony is appropriate. Take a realistic look at your personal financial situation, have a complete physical examination, and try to make the best possible assessment of your present and future needs, especially with regard to when and under what circumstances you *can* become self-sufficient. These considerations will help you negotiate for an appropriate amount of alimony.

You will probably want to include in your agreement some events that would result in the termination of alimony (for instance, if circumstances change for the spouse who's paying, or if you remarry or live continuously with a lover who is contributing to the household income). See also Question 4: Do alimony payments stop if I live with a new partner (cohabit) or remarry?

If you don't have alimony in your agreement, generally you can't add it once you're divorced, even if circumstances change. If, however, you are negotiating for alimony and you think circumstances may change, you can spell out terms for adjusting the payments in the future.

## Question 2

### What role does fault play in negotiating for alimony?

You can always try to negotiate for alimony if you feel alimony is necessary for your future survival—whether or not you're at fault in the divorce. Don't hesitate to bring it up in mediation so that the mediator can help you explore the possibility of including alimony in your settlement. Even if your spouse is angry, he or she may be willing to focus on the future and make tradeoffs for something else he or she wants. You will need to consider your spouse's ability to pay; the length of the marriage; your earning potential, age, and general health; and any other pertinent factors.

Historically, fault might have resulted in the loss of alimony, but today, although most states *have* fault grounds, few states *require*

fault grounds for divorce. If you litigate in some states, however, fault may play a part in determining alimony, as well as custody and property rights (see box).

> In Georgia, a person who has committed adultery and might otherwise be entitled to alimony may lose out if the facts show that the adultery was the cause of the separation.
>
> In North Carolina, abandonment or marital misconduct, such as "illicit sexual behavior" may be factors in granting alimony. There are very specific rules:
> - If the dependent spouse has committed acts of illicit sexual behavior, the supporting spouse is not required to pay alimony.
> - If the supporting spouse has <u>also</u> committed acts of illicit sexual behavior, the court may award alimony.
> - If <u>only</u> the supporting spouse has committed such acts, the court <u>must</u> award alimony.

## Question 3

### How do we determine how much alimony is fair?

A key factor for the two of you to consider is the ability of the moneyed spouse to pay. If one of you is considerably more prosperous than the other, it is more likely that alimony will be a possibility. The actual amount must be negotiated.

Some of the factors you will want to think about in the course of agreeing on alimony include:
- The assets, debts, and income of each of you:
  Does the person seeking alimony have other assets that can provide significant income, such as investments, trusts, pensions? Are there marital debts that either of you will be paying after the divorce?
- The future earning capacity of each of you:
  Did one of you put the other through school? As a result, does one of you have a greater future earning capacity?
- The length of the marriage:
  Have you established a standard of living during a long

marriage that the less moneyed spouse will be unable to maintain?

- A prenuptial agreement, if any:
  Is there a valid prenuptial agreement, and does it prohibit or limit the amount of alimony? Have circumstances changed? Would it be fair to mediate a change in the arrangement?
- Age of children:
  Are there very young children at home? Will one of you need to stay home to care for them? Can you afford child care, or do you need to pick up your children after school? How will that affect your future career? Your retirement savings?
- Special circumstances such as advanced age, disability:
  Are there reasons one of you cannot be self-supporting?
- The tax advantages and disadvantages to each of you:
  Alimony is tax-deductible to the payer and taxable to the recipient. There are various ways to pay alimony that have different tax consequences. See Chapter 7 for more information on taxes.

## Question 4

### Do alimony payments stop if I live with a new partner (cohabit) or remarry?

These are some limits you may negotiate for ending alimony:
- Remarriage
- Graduation from college
- Earning more than a certain amount
- Moving in with someone else
- A specific date
- When children reach a certain age
- The paying spouse's retirement

You and your spouse must discuss when and under what circumstances you will be able to support yourself. In your mediated agreement, you can agree to include specific circumstances under which alimony will stop or be reduced. For example, couples often agree that continuously living with someone who can share expenses, whether you remarry or

cohabit, is a circumstance under which alimony will terminate.

If you litigate, and there is no provision in a signed separation agreement that stating the terms for ending alimony, some states will terminate alimony if you are cohabiting or remarried. Other states may assume that you need less alimony if you cohabit, and if you don't feel your alimony should be

> In some states, such as Virginia, even if you agree with your spouse to separate, cohabiting while waiting for your divorce will give your spouse grounds to end alimony. Before cohabiting, always discuss with your mediator or attorney what you need to put in writing in your temporary agreement or separation agreement so that you can protect yourself.

reduced under these circumstances, the burden of proof will be on you to show that your economic situation has not changed.

## Question 5

### Will my alimony payments be affected if my spouse's income changes drastically? Under any circumstances?

When you mediate your agreement, you can agree in writing about the specific circumstances that would lead to changes in alimony payments.

Since couples can't know in advance what might occur, they often agree to a cost of living adjustment (COLA) or agree that, if a certain event occurs, such as a significant change in income, alimony may be revised upward or downward.

Many couples build in events that will provide a reason for the termination of alimony, for instance, cohabitation or remarriage.

If you have an agreement and one of you seeks a modification of alimony through the court, for the most part the court will not intervene or change the alimony described in your agreement. There are exceptions:

- Courts do recognize agreements in which couples modify the terms of alimony on their own. If the two of you agree, you can always return to media-

tion to work out a new alimony arrangement—and put it in writing.

- Some courts will change the alimony arrangement if you go on welfare or are in dire financial need.

## Question 6

### How can I be certain that alimony payments will continue if my ex-spouse dies or becomes disabled?

You can't. Unless there is a specific arrangement in your signed agreement, alimony payments terminate with your death or the death of your ex-spouse. Usually, an annuity or life insurance policy is an alternative way to provide some future income for you if your spouse dies. Your mediator will know what is permitted in your state.

If it seems likely that your ex-spouse may not be able to continue to pay support, may become disabled, retire, or die, you may prefer to negotiate for more marital property and little or no alimony.

See also Chapter 6: Retirement Plans and Social Security.

## Question 7

### Who decides how much child support is necessary, and what does it include?

Your negotiations will begin with a consideration of the child support guidelines in your state. These are the minimum standards for child support based on specific factors such as income (including overtime, contracts, investments, pensions, annuities, trusts and estates, capital gains, social security), number of minor children, and which expenses are included under your state's guidelines. Your mediator will go over these with you and will help you tailor them to meet the needs of your family.

The guidelines and your individual child support agreement are intended to cover your child's ongoing daily expenses, including food and shelter. In addition to that amount, other costs that

may be included in the guidelines, and, in any event, must be considered by you, are health insurance, unreimbursed medical expenses, child care, education, summer camp, and travel expenses. You will negotiate a way to pay for them, which may be the same or different from the basic child support expenses: one of you may pay all additional expenses, you may share equally or in proportion to your income, or you may agree to pay for certain expenses and your spouse for others.

Although your mediated agreement will be subject to review by the court to determine if it is in the best interests of your children, the court is unlikely to invalidate your customized child support plan as long as it is fair, the reasons for departing from the guidelines are clear, and your children's interests are protected.

## Question 8

**What are some of the reasons the courts will accept if we negotiate an agreement where I pay less than the child support guidelines?**

Often courts accept an agreement where parents pay less than required by the child support guidelines because they share almost equal time with their child and there's not much difference in their earnings. They may also pay a significant amount for other child-related expenses such as special tutors, medical expenses, private school, or travel expenses to visit their children at distant locations.

If you are paying less than the guidelines, you will want to establish in your agreement that your children's best interests are being served, that the support is sufficient, and that your children's standard of living remains as close as possible to the standard they had prior to divorce.

∽∘∾

## Question 9

### Can child support be increased or decreased after the agreement is signed?

In mediation, we try to be realistic about how far into the future we can plan. As children get older, they tend to require more financial support—their clothes cost more, and they engage in a variety of new activities, most of which entail some expense. Other questions in this chapter discuss how specific child-related expenses can be handled.

A child support agreement is established for a few years, and we build into the agreement that it will be reviewed at specific times and adjusted according to an agreed-upon formula. This formula may be spelled out in the child support guidelines, it may be a cost of living adjustment based on the consumer price index (CPI), or it may be based on some other factor.

You can also provide in the agreement that you will mediate new child support arrangements in the event of specified events, such as significantly lower or higher income or significantly higher expenses for the child. If mediation fails, you may either opt to strictly follow the child support guidelines or seek a modification in court.

## Question 10

### Until what age do we have to support our children?

The age until which you are obligated to support your children (emancipation) varies from state to state. For example:

- In Colorado, emancipation occurs at age 19.
- In Pennsylvania, it's 18 or graduation from high school, whichever comes later.
- In Georgia, it's 18 or graduation from high school,

whichever comes earlier, or age 20 if the child is still in high school at that age.

- In New York, it's 21.

You may choose to support your children for a longer period, or you may link your extended support to a specific purpose, such as completing college or graduate school.

Other events that could lead to ending child support and that you may want in your agreement include:

- Active military service
- Marriage
- Independent employment coupled with living away from home (if this occurs before your state's age of emancipation, you may need a court order declaring your child emancipated).

Many couples specify in their agreements that their child will be emancipated upon graduation from college or at age 22, whichever occurs first.

## Question 11

### Does child support have to be spent directly on my children?

Child support is intended to help pay for any expenses involved in taking proper care of your children. This would include household expenses (food, rent, electricity), and other general expenses (transportation, laundry, repairs).

You don't have to account for how the money has been spent, but it's a good idea to keep records, since that will help you keep track of whether the amount you are receiving is enough to cover the necessary expenses.

∽o∽

## Question 12

### Must I pay child support to my ex-spouse when our child leaves home for lengthy periods for summer camp or school?

Unless you make other arrangements in mediation, you are required to pay child support until your child is emancipated, even if your child is away from home at summer camp or school. Generally, the costs of housing continue, be it for rent and utilities or mortgage payments, since your child will return from camp or school and continue to reside with your ex-spouse.

Sometimes couples mediate alternative ways of paying support once the child leaves home for college. You could, for example, negotiate to pay a greater portion of the tuition and boarding expenses and less to your ex-spouse for cost of living once your child is in college.

## Question 13

### Who pays the children's medical bills? Health insurance?

Unreimbursed medical expenses (not covered by health insurance) may not be included in the child support guidelines in your state. Who pays for these expenses will need to be negotiated.

Who pays for health insurance may also have to be negotiated if it isn't in your guidelines. If your children were covered under your or your spouse's health insurance policy, this coverage would usually be continued.

You and your spouse will decide what constitutes medical expenses. Are psychiatrists, psychotherapists, orthodontists included? Dolores mediated an agreement in which the parents decided that costs for orthodontia and psychotherapy would not be shared unless both parents agreed. Otherwise, the parent arranging the treatment would be solely responsible.

You could provide in your agreement that if your child has medical expenses above a specific amount, a different formula for payment would be used, or you would return to mediation to negotiate new terms.

## Question 14

### Who pays for child care?

You negotiate this obligation in mediation. Child care expenses may or may not be an add-on to your state's child support guidelines. If child care is an add-on, it would cover the time the custodial parent is working and cannot care for the child or if, for instance, the custodial parent is in school preparing for future employment.

If the state guidelines do not cover the expense of child care, but the noncustodial parent can afford it, that parent may agree to pay for all or part of the costs so that there will be less responsibility for child or spousal support in the future when the former spouse's income increases or when the former spouse becomes self-supporting.

Child care for purposes other than employment, such as evenings out, is the individual parent's expense.

## Question 15

### Must we pay for college?

The answer to this question depends on several factors:

- Do the child support guidelines in your state terminate at age 18 or 21?
- Do those guidelines include a requirement that you pay for college?
- Do you have the ability to pay?

If your obligation to support your child ends when your child reaches the age of 18, you are not be obligated to pay for anything

91

beyond that point whether you are married or divorced, so even if some college expenses are included in your state guidelines, your obligation would be minimal.

Regardless of the guidelines, parents often want to provide some money for college if they have the ability to pay. There are several ways this can be written into the agreement:

- You may have already saved some money for college, and you can specify in the agreement how it is to be used.

- You can create a college fund to which each of you contributes on a regular basis.

- You can agree to share the costs for state college, or to pay proportionately according to your income for private college.

- If your child is young and you are uncertain whether you will be able to afford college, you could agree to return to mediation closer to college enrollment to plan for college costs.

- The custodial parent may be willing to agree that child support will be spent on room and board. Also see Question 12: Must I pay child support to my ex-spouse when our child leaves home for lengthy periods for summer camp or school?

- If one parent has limited funds, the other parent may simply agree to pay for college.

This is an area where you can work out a creative solution, because college expenses can vary greatly depending on the type of college and your willingness and ability to pay. For example, Carol worked with a couple who agreed that each would pay one-third of the college costs and that the child would have to pay one-third.

## Question 16

### I will be the custodial parent, but my spouse tells me that I'm responsible for child support too. Is that possible?

While you may mediate any arrangement you want as long as you include sufficient child support as defined by your state guidelines, your mediator will tell you whether the child support guidelines in your state require both parents to be responsible for the obligation.

In one way or another, each parent contributes to child support. Sometimes both parents are required by the guidelines to contribute money; in other states, one parent contributes money and the other provides child support by maintaining the child's home.

Some guidelines require that the income of both parents be added together, and the proportionate share each parent must contribute is then calculated. The noncustodial parent's share is then paid monthly to the parent with custody. This is true even if the parent with whom the child lives earns considerably more income.

In some states, expenses such as child care, school activities, education, and medical expenses are not included and need to be calculated in addition to the basic amount.

Confused? Your mediator will provide you with information about your state so that you can create a tailor-made agreement that suits you.

See also Question 17: If our child spends more or less equal time with me, why should I pay child support?

Illinois is one of the few states where the custodial parent may have to pay child support to the noncustodial parent. If you live in Illinois and have a significantly larger income than your former spouse, even though you are the custodial parent, you may have to pay support to your ex-spouse for child care during visitation.

93

## Question 17

### If our child spends more or less equal time with me, why should I pay child support?

Even if the amount of time you both spend with your child is almost equal, in the majority of states your children are considered to have a primary residence with one of you, and you are required to pay child support to the parent maintaining that primary residence. That parent requires the support to maintain the child's residence and to take the responsibility of buying clothes and other necessities for the child. Most states emphasize that your child's standard of living should be altered as little as possible, so the primary residence must, where feasible, resemble the residence your child had prior to the divorce. This costs more than if the custodial parent lived alone.

In some states, the guidelines base child support on a percentage of gross income and adjust that amount according to the time your child spends with each of you. It is important to be aware that if you make significantly more money than your spouse and use these guidelines, even if you both spend equal time with your child, you would still owe child support based on your higher income.

Of course, if you agree to do so in mediation, you can opt out of the guidelines and explain in your separation agreement that, since you are spending equal time with the children, you will share expenses equally.

In some states, significant visitation time with the noncustodial parent results in a reduction of that parent's child support obligation, and you may want to take this into consideration when you mediate your agreement.

For example, a 1997 New Jersey law provides that if the noncustodial parent provides two or more overnights per week, the child support obligation will be reduced.

In California, the child support guidelines take into account which parent has the higher earnings as well as the amount of time each parent has physical responsibility for their child.

In Michigan and Maryland, if the child spends more than approximately 35 percent of overnights with the noncustodial parent, the amount of child support will be reduced.

## Question 18

### How can I be sure that child support will continue if something happens to my ex-spouse?

In mediation, you both will be encouraged to include in the agreement an obligation to purchase life insurance and disability insurance to provide for child support payments, and for future educational expenses in the event something happens to you or your former spouse. The value of the life insurance can remain the same for the full term of the policy, or can decline in value as the children grow older and become emancipated.

## Question 19

### I have child support obligations to children by a prior marriage. How will that affect the child support payments I will be negotiating in this divorce?

In mediation, we take into consideration the child support agreement you made when your prior marriage ended, in addition to your local child support guidelines, when we negotiate support obligations for children from your current marriage. In most states, child support for children from a prior marriage or where there's an existing court order for support must be deducted from gross income before calculating child support for subsequent children.

However, if one of your children from either marriage needs additional support because of some special situation, you will

have to review your financial plans carefully so that the additional costs can be paid. Although we could make special arrangements in mediation for future adjustments to your planned child support payments, remember that the court will review the arrangements with the best interests of *all* your children in mind.

## Question 20

### If one of us remarries, how does that affect child support?

Remarriage is frequently a concern during mediation negotiations, and your mediator will help you plan for changed circumstances. You can negotiate a parenting arrangement with an alternative plan in the event of remarriage, or you may agree to return to mediation if one of you decides to remarry. So long as your children's standard of living can be protected, the courts are likely to go along with your agreement.

If your child support agreement is based on your state's child support guidelines, child support may be subject to modification. If your agreement requires periodic modification based on the guidelines, this is what might occur in some states:

- If you are receiving child support and your ex-spouse has a child in the new marriage, that event could reduce the child support payments because the court takes into account the best interests of *all* children.

- If your ex-spouse pays you child support, and his new spouse's income is available to help pay his living expenses, you may be able to get an increase in child support on the principle that he now has a greater share of personal income available for his own use.

- If you are receiving child support and *you* remarry, in some states your ex-spouse may be able to get a reduction in child support on the same basis—that you and the children have the benefit of your new spouse's income for your personal living expenses.

Some couples write into their agreement what the financial arrangements will be if they remarry. These arrangements are permissible so long as the post-remarriage support meets the guidelines' minimums.

## Question 21

### My spouse intends to change careers, and the new career will pay much less. Is that allowed, and how will it affect child support?

If your spouse has lost his or her job and must change careers to remain employed, your child support may be lowered, just as your standard of living would be lowered if you were still married. We would suggest a mediation session where you try to plan together so that the impact of the career change would be minimized.

If your spouse is choosing to change careers or take a lower-paying job, perhaps you could persuade him or her to wait a few years to make the change, for example, until your child graduates from high school. You should think about whether you are willing to trade something to make that prospect attractive. Perhaps in exchange for your spouse postponing the career change, you would be willing to pay a larger share of your child's future college expenses.

If you feel your spouse is making this change irresponsibly or punitively, you may be able to argue against it effectively. Courts vary significantly, but most courts would *not* limit your spouse's choice to change careers. If, however, the reason for the change appeared to be punitive, some judges would order that support payments must continue at the same level.

Sometimes a job change can be beneficial, even if the parent earns less money. Carol worked with a couple who had joint custody and equal time with the children. The father had never had full responsibility for the children, and although he was anxious about it, he wanted to give it a try. He liked the parenting role so much that, since things were slow at his job, he agreed with his wife that he would work part time so he could spend more time

with the children. He assumed a larger share of the child care responsibilities, which they agreed would decrease the mother's child support obligation.

## Question 22

### My spouse gets paid in cash. How can child support be calculated fairly?

In this type of situation, mediation can be a big advantage. Discussions about finances in mediation are private, and as such, do not require documentation of income if both you and your spouse agree on what is fair. You probably have an idea of what your spouse's earnings are, and you can agree on an amount of child support that will meet your child's needs and provide the standard of living to which your child is accustomed.

If your spouse refuses to agree on an amount of child support that you think is in line with his or her income, you may be forced to litigate. If you litigate, you both will be required to produce all financial records. Then, you may choose to have a forensic accountant reconstruct more realistic income figures from additional information based on a detailed analysis of checking accounts and charge accounts (to look for items that may have been partially or fully paid for in cash), and a similar evaluation of other personal expenditures, assets, and standard of living.

Mediation allows you to agree on a legally enforceable amount, without having to divulge finances in public court, and without the hassle of complex calculations based on your spending patterns.

## Question 23

### My spouse takes so many business deductions that very little income shows up on our personal tax return. How can we figure out the right amount for child support?

Many state child support guidelines provide ways to add back in tax deductions which may be acceptable for income tax purposes but

not for computing child support. If the guidelines don't do so, you can agree to additional guidelines in your mediated agreement.

For example, often the guidelines require that deductions for depreciation of such items as computers and cars, which may have been deducted as depreciation over several years or all in one year, should be added back into the income figure. Similarly, those entertainment and parking expenses that may have been deducted for business but were also personal expenses can be added in as income. There are many such examples.

Your accountant, mediator, or valuation expert can assist the two of you in determining the appropriate income figure to be used in computing child support.

## Question 24

**How will the child support part of our agreement be enforced? I want to be generous when I negotiate my child support payments, but will I get in trouble if I can't pay?**

If your child support payments are not made, you *could* get into trouble. For that reason, prior to agreeing to an amount, it is important that you review your budget, income, and liabilities with the mediator so that any child support payments you agree to make, in addition to the amount required by the child support guidelines, are payments you will be able to make.

As of October 1, 1997, the federal government established a computerized directory (the National Directory of New Hires), which traces parents who owe child support—even if they have moved to another state. This program is expected to substantially increase the collection of past-due child support. Depending on state enforcement laws, the child support obligation may be enforced, for example, through income execution (deduction from your paycheck, unemployment check, or other benefits), or attachment of a tax refund. In New Jersey, for example, a 1998 law allows the state to track child support evaders through cable television bills and bank accounts. Penalties for nonpayment may include revocation of your driver's license, denial of

federal loans for your business or property, fines, or possible time in jail.

In the event your circumstances change, rather than failing to pay, you should return to mediation and try to renegotiate the payments. If your ex-spouse is unwilling to renegotiate, you can seek court approval to lower the payments.

In mediation, you may prefer to agree to be responsible for a larger proportion of college expenses or for some of your child's activities not directly considered child support by your state's guidelines. That way, while these obligations would be enforceable as part of a contractual agreement if you couldn't pay them, they wouldn't carry the same penalties as failure to pay child support.

See also Question 22 in Chapter 3: What if my former spouse never keeps promises about visiting the children or paying child support?

## Question 25

### My spouse is a musician, and his income varies significantly from year to year. How can I be definite about financial arrangements?

You can only be definite about two things: your current marital assets and the specific method you agree to use for determining future support payments. You may be negotiating alimony so that you can become financially independent, but you can't be sure that your former spouse will earn enough in the future to regularly pay a set amount. In this situation, your alternative may be to give up part or all claim to alimony in exchange for a larger share of current assets, such as a house or savings. Remember, alimony depends on the ability to pay, and if earnings are marginal and there are no assets, alimony is not a realistic expectation.

On the other hand, child support is a requirement, sometimes for *both* of you. Mediators suggest several ways to determine what will be paid for child support, with the goal of establishing a realistic amount so that appropriate plans can be made to meet the child's needs with as much stability as possible.

With an unpredictable future income, you need to agree on an

amount to use as a basis for calculations using the child support guidelines. You could agree either to average the last two or three years of net income or to use only the net income for the prior or current year. Your former spouse would agree to pay a fixed amount based on those earnings, either for one year or for a specified number of years. If it becomes impossible for him to meet these obligations, you could agree to return to mediation to review the situation.

When future income is unpredictable, creativity is necessary to provide appropriate flexibility. In one of Carol's mediations, the couple agreed to exchange tax returns each year to calculate future child support payments. In one of Dolores's mediations, the couple agreed that if the former spouse earned more than a set amount annually, instead of using the guidelines, child support would be increased for that year according to a specific alternate formula.

### Question 26

### Will my spouse's deferred payment arrangement affect our support and property agreement?

You should discuss deferred salary or other kinds of deferred payment arrangements as part of your negotiations in mediation.

Occasionally for tax or other purposes, some employees arrange to defer part of their salary until the following year. You can agree that this deferred sum will be treated as part of the current year's income, or that the calculation of the following year's support obligation include the deferred salary. Deferred income of any kind is always considered for purposes of child support and is subject to the child support guidelines or to whatever child support formula you agree on. In mediation, you can negotiate whatever terms you choose regarding this money.

Similarly, prior to divorce, some authors, movie stars, sports figures, and corporate executives sign contracts for significant sums in which payment is made over a lengthy period of time, or deferred until retirement. In many instances this money is treated as marital property to be divided or future income to be shared.

## CHAPTER 5
### Decisions about Property and Business Interests

Overview
1: What is the difference between community property and equitable distribution?
2: What is the difference between marital property, separate property, and transmuted property?
3: I had my own bank account before we were married. Is that still my money now that we're getting divorced?
4: How can we put a value on an intangible asset?
5: Who gets Grandmother's silver?
6: Who gets the frequent-flier miles?
7: Who gets the lottery winnings?
8: Who gets the dining room furniture?
9: Who gets the dog?
10: How do we value our stocks?
11: Shouldn't I be compensated for helping put my spouse through medical school? Now he has a professional license and a successful career and I earn very little.
12: Who gets the house I owned before we were married?
13: If we sell our home, how do we divide the proceeds?
14: If I have custody of the children, do I have a right to continue living in the house we bought together?
15: I want to live in our co-op for three years until our children are out of school, but my husband says that will leave him without money for a place to live. What can we do?
16: I would like to buy out my spouse's interest in our home, but I don't have much money. Is there a way I can do that?
17: We both want to move, but the market is down and we don't want to sell the condo right now and lose money. Are there any alternatives we can negotiate in mediation?

18: If we don't sell our house for the next few years, how can I agree on other financial terms? I don't know what the house will be worth in the future.

19: In order to negotiate, I need to determine the value of my spouse's business. How do I do that?

20: Should we negotiate an agreement to remain business partners after we get divorced?

21: I supported my spouse and paid most of the business expenses when he started a new business. Now we're getting a divorce. Do I get any payback?

22: My spouse's partnership contract has a buyout provision that provides for a very low price if she wishes to leave the partnership. In mediating our agreement, must we use this figure in computing the worth of her partnership as a marital asset?

23: What exactly is "goodwill" and how is that a factor in negotiating the value of my business?

# Overview

$O$ne of the questions that always comes up in mediation is, "Who gets what?" You'll be happy to know that in mediation, as long as you agree, you can make any property settlement you want.

Remember that *property* includes many things: real property (a house, a condominium, a car), personal property (jewelry, stocks, pensions—we discuss pensions in Chapter 6), even the increase in value of something you own. The terms describing the distribution of the different types of property will be defined in Questions 1 and 2 in this chapter: *separate property, marital property, transmuted property, community property*, and *equitable distribution*.

For many couples who own their own home, the home is their largest asset. In Questions 12–18 we discuss the factors you are likely to consider in negotiating decisions related to your home: whether your home is marital property, how to value it, which of you will keep the home, or how you will divide the equity if it is sold. If you choose not to sell your home at the time of the divorce, see the questions that discuss how to determine future value, and the concept of trading off your share of the equity in the house for other assets.

Just as with your home, when you negotiate your agreement, you may need to assess a family business in order to share its value as a marital asset or receive future income. Businesses are organized in different ways—sole proprietors, partnerships, and different types of corporations—and each form of ownership has different operating rules and a different financial structure. Questions 19–23 concern negotiations related to the family business.

If you or your spouse has a small business, you may be able to value the business yourself, based on a review of the relevant documents. If you are evaluating a large business with significant

income and assets, an expert may be necessary to determine the actual value. Even with a small business, mediators find that if one spouse distrusts the other, a valuation by a neutral expert whom the couple consults *together* can be useful. Question 20 addresses the issue of whether you should continue as business partners after the divorce.

If you have financial questions that are not answered in this section, see Chapters 4, 6, 7, and 8, which discuss alimony and child support (4), retirement plans, and social security (6), taxes (7), and other financial issues (8).

## Question 1

### What is the difference between community property and equitable distribution?

State laws differ as to how assets and debts acquired during the marriage are to be divided when a divorce occurs. You can make trade-offs in mediation—and you may end up with a very unorthodox distribution—but your starting point is the law in your state.

*Community property states* divide most property and income acquired *during* marriage equally: fifty-fifty. For example, the value of a home acquired during marriage is determined, and that sum divided equally between husband and wife. Usually, personal gifts and sole inheritances that have not been used for marital purposes are not subject to community property distribution and remain the sole possession of the recipient. If you owned your home before marriage and you've kept the title in your name, but it has been improved or increased in value, the *increase*

**Community Property States***
**1996**

Arizona
California
Idaho
Nevada
New Mexico
Texas
Washington State
Wisconsin

*Note: All other states use Equitable Distribution standards

in value is community property, but the value of the home itself generally is not. See also Question 12: Who gets the house I owned before we were married?

*Equitable distribution states* divide property and income acquired during marriage according to factors defined as "fair," which does not necessarily mean sharing equally. States vary in what they include as marital property. In the majority of states, only the property acquired during marriage is considered for equitable distribution; gifts and inheritances are kept separate. In a few states, gifts and inheritances are included as marital property, and in even fewer states, everything ever owned may be included as marital property to be considered for distribution.

Once you determine which property is to be distributed, there is the question of how to do it so that the division is fair. Factors determining how the property is shared can include the contributions of each spouse, both monetary and nonmonetary. If, for example, your spouse is an artist and you entertain gallery owners, potential buyers, or agents, or

Dolores met with an angry New Yorker who just wanted to know what the law required him to give his spouse in their divorce settlement. He had difficulty accepting that in New York, an equitable distribution state, there is no absolute answer. Dolores explained that the couple would have to negotiate their own settlement. If they couldn't agree, the court would decide using various factors such as:

- What each person earned during the marriage
- Nonmonetary contributions to the marriage, including performing tasks that freed the other spouse to concentrate on his or her work
- Any existing prenuptial agreement
- Length of the marriage
- Age and health of each spouse
- The comparative future earning capacity of both spouses
- Individually owned property (if one spouse has significant nonmarital assets, the court will be inclined to give more of the marital assets to the less wealthy spouse)
- Spending patterns of both spouses, such as excessive or irresponsible amounts spent on people or activities outside the marriage (gambling, drugs, and the like)

keep the artwork protected, or do the majority of household tasks so that your spouse can be free to teach art, you have made a significant nonmonetary contribution toward your spouse's career. If that career is valued as a marital asset, your contribution to its value would be considered in the negotiations for property distribution.

## Question 2

### What is the difference between marital property, separate property, and transmuted property?

The first step in mediating the distribution of property is to identify the proper owner of each item listed as an asset. The definition of ownership differs from state to state, but there are certain basic principles you can think about as a starting point. Your mediator will advise you about any special circumstances that apply to your particular assets.

In most states, *marital property* is property and income you have accumulated after marriage, with the exception of sole inheritances, sole gifts, and sometimes personal injury awards. *Gain or interest* earned on separate property, particularly if the nonowner spouse contributed to the gain, is sometimes treated as marital property.

A court in Montana found that the gain in value on a baseball-card collection owned by the husband before marriage, and that increased in value by more than $100,000 during marriage, was marital property. The wife's contribution included participating in collecting additional cards, protecting the cards from a flood, and straining the family budget to increase the collection.

*Separate property* is property you acquired before marriage, or in some states, after marriage but that you solely inherited, received as a gift, or received as a personal injury award. Separate property usually remains separate unless it is *"transmuted."*

*Transmuted property* is marital property. That is, it is property that originally was separate, but during marriage was commingled

108

in some way with marital property and, as a result, became marital property. For example, if you accumulated money in a separate bank account prior to marriage, and you deposited money earned during the marriage into that account, then the original money is transmuted into marital property. Also, if you ever wrote a check on the separate account for marital purposes, such as rent, this action could transmute all the money in the bank account into marital property.

## Question 3

### I had my own bank account before we were married. Is that still my money now that we're getting divorced?

In the majority of states, the answer depends on what you did with the money. If you converted the account to a joint account, transferred the balance into a joint account, or deposited money earned during marriage into your separate account, the account may no longer be considered your separate property.

If you withdrew some of the money and invested it in a marital asset (a jointly owned house, for instance) that portion of the money may no longer be considered your separate property because you have *transmuted* it. If you kept the account in your name, only used it for your personal expenses, and didn't deposit funds earned during marriage, you need to examine how you have used the money. If you spent money from this account to make mortgage payments or for other marital expenses, you may also have transmuted the money you spent into marital property. (See Question 2 for more on transmuted property.)

Check with your mediator, since in some states such as New Hampshire, Massachusetts, and Connecticut, even separate property from before the marriage goes into the marital pot. It may be some consolation to know that even if all assets are considered marital property, premarital assets are not usually split *equally* between the spouses when the final settlement is made.

## Question 4

### How can we put a value on an intangible asset?

There are sometimes assets that have been accrued during a marriage that, unlike a bank account or a share of stock, do not have a specific dollar value. These are intangible assets. Although state laws vary, intangible assets like a medical or legal practice, the worth of celebrity, or the goodwill aspects of a business may need to be valued and taken into account in the financial settlement of a divorce. For example, if one person has become a celebrity in the course of a long marriage, it is not unusual to give the spouse a significant financial settlement to balance out the difference in earning potential.

In mediation, you and your spouse may be able to negotiate compensation for an intangible asset in a way that satisfies both of you.

The standards for calculating the value of assets may be dictated by the laws or rulings in your state, or you may be able to choose the method of valuation you wish to apply. The following standards of value are commonly used:

- **Fair market value:** This is the price that a buyer would pay to a seller when neither is being forced to buy or sell. Both are assumed to be willing and able to make the deal and informed about the property and the market for similar property. In a divorce, neither the seller nor the buyer may be particularly willing, so this standard may not be the best type of valuation to use in a divorce negotiation.
- **Investment value:** In this case, you are calculating a value that the property has for a particular buyer. For example, this method takes into account criteria such as how much the business earns, or if there are outstanding debts that affect profitability.
- **Fair value:** This is a value that will fairly compensate an owner who would prefer not to sell but is being forced to sell, or, in the case of divorce, is reluctantly considering negotiating a sale as part of the overall settlement. Fair value may include a discount if the property would be difficult to sell under ordinary circumstances, or if the seller is a minority owner without full control over business decisions.

This might be in addition to any alimony or maintenance to which you might be entitled under normal circumstances.

See also Question 23: What exactly is "goodwill," and how is that a factor in negotiating the value of my business?

If you are unable to agree on value and compensation for a business or other complex asset, an expert—in this case a forensic accountant—can be retained whose specialty is to examine all of its elements (tangible and intangible), compare them with known statistics, and make a professional estimate of the value. The report of the forensic accountant will be reviewed in the mediation and used to facilitate the development of your settlement.

## Question 5

### Who gets Grandmother's silver?

Probably you, if you inherited it or she gave it to you as a gift. If Grandmother gave the silver or bequeathed it to *both* of you, then it belongs to both of you. It may not be desirable or possible to actually divide it. In the course of negotiations, one of you will trade your share for something else of value.

## Question 6

### Who gets the frequent-flier miles?

In many instances, this question is negotiated in mediation. If the miles were earned during marriage, they are marital property and are valued as an asset. If they are nontransferable, they may have to be traded for something else. In one of Dolores's mediations, the frequent-flier miles were part of a trade-off, so the noncustodial parent could visit his child more often.

## Question 7

### Who gets the lottery winnings?

If the lottery ticket was purchased during the marriage but prior to the divorce, even if one of you purchased it alone, generally the

winnings are marital property to be shared by both of you. If the ticket was purchased before marriage, the answer depends on the laws in your state about separate property.

## Question 8

### Who gets the dining room furniture?

If you obtained the furniture after marriage, it belongs to both of you, and unless it's worth an enormous sum, it's not worth fighting about.

There was a couple who spent a year fighting in court over the dining room furniture. Finally, the judge ordered the furniture put out on the courthouse lawn, and the couple was ordered to alternate choosing pieces of the set. Can you imagine the cost? The time? The question is, what were they really arguing about?

(See Chapter 2 for a discussion of some of the emotional issues that often arise in these situations.)

## Question 9

### Who gets the dog?

This is a difficult question, because you can't divide the dog. If you owned the dog before marriage, it's probably yours. If you purchased it together, you'll have to negotiate, perhaps give up something else you want in order to get the dog. If it's your show dog and your spouse has shared in its care, then your spouse has contributed to any gain in the dog's value. The gain in value is a marital asset.

Often this is an emotional question rather than a legal one. Before commencing mediation with Dolores, a couple had arranged to share custody of their dog, Lydia, during their four-month separation. There had been difficulties. The husband wouldn't return the dog on time; the wife wouldn't give him a key to return Lydia when she wasn't home. Dolores recognized that the real issue was that the couple was working out attachment

and separation issues through the dog. Once this was acknowledged, she was able to help the couple talk about their grief and anger concerning the divorce. Afterward, they agreed that the husband would get Lydia and the wife would get the car.

## Question 10

### How do we value our stocks?

If the stock is publicly traded, your mediator will help you agree on a date on which the stock will be valued, such as the date the separation agreement is signed, or the date the divorce is actually granted. Then you may either contact your broker or check your local newspaper or the *Wall Street Journal* to determine the value of the stock on that date. Remember, when the stock is sold, it may be subject to capital gains tax.

In the event that the company in which you own stock is a small corporation whose shares are not traded, it will be more difficult to determine the value. Your mediator can help you find an appropriate valuation expert.

## Question 11

### Shouldn't I be compensated for helping put my spouse through medical school? Now he has a professional license and a successful career and I earn very little.

The degree, the license, and the professional practice are perfect examples of intangible assets without a specific dollar value. As we discussed in the Overview section of this chapter, knowing your legal rights may inform you about possible trade-offs when you are negotiating a divorce settlement, but how to proceed may still be far from clear.

State laws vary considerably as to whether a degree, license, or professional practice is a separate or a marital asset and whether the license has a separate value if your spouse has an established

practice. States that do not recognize the license or degree as a marital asset for property distribution purposes may still value one or both of them as a consideration for some form of alimony or, if you paid for tuition, for reimbursement.

There are many ways you can *negotiate* this issue in mediation. In one mediation, Dolores met with a doctor who had a five-year-old medical practice, and his wife who had been working as his office assistant. While her husband attended medical school, the wife had been the sole breadwinner. She had only completed two years of college at the time of their marriage, and they decided it would be more valuable to the marriage for her to work and her husband to obtain his medical degree.

Since the husband had been in practice for some time, Dolores arranged for an expert to value the practice and, based on a percentage of the value of the practice, they agreed that the doctor would pay for his wife's living expenses and tuition while she returned to school to complete her degree and prepare herself to be self-supporting. Since the husband's potential earning capacity would continue to be significantly higher, they agreed to share their other assets such as the house, bank accounts, and retirement savings, with the wife getting 55 percent and the husband getting 45 percent.

This is an example of a mediated solution. The wife made an informed choice. She knew that if she allowed a judge to make these decisions, she might receive reimbursement, alimony, a portion of future earnings, or nothing for her sacrifice. She knew the value of the professional practice, and she decided that what was most important to her was to increase her own income. Rather than relying on an estimate of what her husband might or might not earn in the future, she negotiated a settlement giving her what she wanted: financial independence.

## Question 12

### Who gets the house I owned before we were married?

As separate property, it's yours, but, if the mortgage was paid with marital funds, or your spouse helped maintain and improve

it, your spouse will have some claim to a portion of the value of the house.

## Question 13

### If we sell our home, how do we divide the proceeds?

If the house is jointly owned, you will negotiate in mediation how the net proceeds will be divided. Net proceeds are determined by deducting mortgage loans, broker's fee, costs of sale and taxes, and any other items you have agreed to deduct in the separation agreement, from the total (gross) proceeds.

If the house is owned by only one of you, you must consider the following in negotiating about whether to share the proceeds:

- When did you buy the house? Before or after the marriage?
- How did you finance its upkeep and improvements?
- Did your spouse do work on the house?
- Were any expenses paid out of marital funds?
- What would be fair?

Whether you live in a community property state or in an equitable distribution state, you can negotiate to divide the net proceeds in any way you wish. It's also possible that you may want to trade part or all of the net proceeds for the amount in your pension account, or for another asset or stream of income.

If you let the court decide in a community property state, and your home was purchased during the marriage, the net proceeds would be divided equally. In an equitable distribution state, the net proceeds would be divided by the court according to your individual monetary and nonmonetary contributions to the marriage.

∽∘∾

115

## Question 14

### If I have custody of the children, do I have a right to continue living in the house we bought together?

Not necessarily. The house is a marital asset. The value of that asset will be shared by the two of you. Usually, you have to negotiate an agreement if you want to continue to live in the house.

In one of Carol's mediations, the couple decided that the custodial parent would live in the house until the youngest child graduated from grade school. A second mortgage was taken out so that the noncustodial parent could afford to buy another house. Once the child graduated and the original house was sold, the second mortgage was paid off out of the profits from the sale of the house, and after expenses for repair and maintenance, closing costs, and broker's fee were deducted, the remaining money was divided equally by the parents.

In one of Dolores's mediations, the wife agreed to buy out her husband's interest so that she could remain in the house and he could move elsewhere. See also Question 16: I would like to buy out my spouse's interest in our home, but I don't have much money. Is there a way I can do that?

It's important to be aware that, although you may agree between you which one will be responsible for any remaining mortgage costs, if the mortgage is in both your names the creditor can continue to hold you both responsible. If your former spouse agrees to be responsible for the payments on your jointly held mortgage, you can include in the written agreement that you will be reimbursed if you make any payments because your former spouse failed to make them. You also can agree to specific compensation, such as some other asset, in case he fails to make the

In Maryland, the parent who has custody of the children is entitled to live in the family home for three years after the divorce. After that, unless there is a separation agreement stating otherwise, the house must be sold.

payments, or you can agree to sell the house if a certain number of payments are missed. See also Question 15: I want to live in our co-op for three years until our children are out of school, but my husband says that will leave him without money for a place to live. What can we do?

## Question 15

**I want to live in our co-op for three years until our children are out of school, but my husband says that will leave him without money for a place to live. What can we do?**

Unfortunately, two households are more expensive than one. However, you may be able to negotiate some trade-offs so that your spouse can afford to get another place.

Depending on your individual circumstances, you could buy your spouse out; or a second mortgage could be arranged so that your spouse would have money to purchase another home; or you could trade part of other marital property worth the same as three years' rent. You might consider forgoing support payments for the period you remain in the co-op so that your former spouse could afford to live elsewhere; or you could agree to be responsible for certain debts in return for staying in the co-op.

As long as the co-op is jointly owned, you must determine who will be responsible for mortgage payments, taxes, insurance, utilities, maintenance, minor and major repairs, and any other related expenses. While agreements vary as to who pays for what, often the spouse remaining in the home pays the ongoing expenses, and both share the costs of major repairs.

Carol had a couple who agreed the house spouse would pay the ongoing expenses, and both would share the costs of major repairs. Dolores had a couple who agreed that the house spouse would pay ongoing expenses and would forgo a portion of alimony. The other spouse would pay the mortgage on their jointly owned home and would be reimbursed for one-half of the payments made when it was sold.

117

If none of these alternatives is feasible, and your spouse cannot afford to live elsewhere, you may have to sell the co-op and, with your share of the profit, rent or purchase a less costly home.

## Question 16

**I would like to buy out my spouse's interest in our home, but I don't have much money. Is there a way I can do that?**

First, consider whether it's realistic to keep your home. Can you afford the future costs of mortgage payments, maintenance, repairs, insurance, and property taxes?

If your answer is yes, you will have to negotiate a settlement, and there are several possible ways you can proceed:

- Your and your spouse might agree that you will assume the mortgage and give up some or all support payments or a portion of your share of marital property.

- If the bank won't allow you to assume the mortgage, you can agree to leave the mortgage in his name but agree to "indemnify" your spouse by guaranteeing repayment of any mortgage payments you might not pay and your spouse might be required to make on your behalf.

- You could give your spouse a second mortgage, which would guarantee the portion of the debt that you are agreeing to pay.

When you calculate how much the house is worth, remember that if you buy out your spouse's interest and the house is sold, you may have the added expense of paying additional taxes.

## Question 17

### We both want to move, but the market is down and we don't want to sell the condo right now and lose money. Are there any alternatives we can negotiate in mediation?

You may agree to move out and rent the condo until the market improves. Before you do this, ask yourselves if you are amicable enough to be business partners. If not, it may be wiser to sell or to arrange for one of you to continue to live in the condo for a set period, at which point you will reevaluate the market.

If you decide to rent the condo, be sure you understand the tax consequences. For example, if after divorce you each wish to take advantage of the $250,000 single-person capital-gain exclusion, you must have retained joint title and one of you must have lived in the condo for two of the last five years before it is sold.

If you decide to sell at a loss, you may prefer to treat the condo as a business property so you can take deductions for capital losses. Your accountant can help you determine which is best so you can make your plan part of the mediated agreement.

Recently, one of Dolores's couples agreed to rent until they could sell profitably. After consulting with their accountant, they agreed that for the entire time their home is to be rented, it will be listed with a broker for sale at a fair price. That way, they will be able to establish that their intent is to sell their residence and not to run a business.

See also Question 7 in Chapter 7: If we agree to sell our home, what are some of the tax consequences we should take into consideration in negotiating our agreement?

Dolores mediated a case in which a couple decided to continue using their vacation home until it could be sold. For a time they argued as though they were deciding custody. Who could use it on weekends? What if the weekends in-cluded a holiday? Who else could be there? Could their dates visit?

Some of the decisions they had to make included:

119

- How would they share occupancy? Every other weekend? Alternate holidays?
- Who would pay to open and close the pool?
- Who would pay for upkeep?
- Who would approve repairs and who would pay for repairs?
- Who would pay the mortgage and interest payments?
- Who would pay the property taxes?
- Who would pay for the phone and utilities?
- How would the proceeds be divided if it were sold immediately?
- How would the proceeds be divided if it were sold in the future?
- How much profit did they want to make? How much of a loss could they accept?
- What price were they willing to sell it for?

After discussing these issues in detail, they added specific language to cover each situation in their final agreement.

## Question 18

**If we don't sell our house for the next few years, how can I agree on other financial terms? I don't know what the house will be worth in the future.**

This is a difficult question, but there are some guidelines that should help you arrive at a reasonable estimate of the value and of what your share should be. For instance, you could determine the *current value*, based on either actual sales of similar houses in your neighborhood or a formal market appraisal. Once you deduct any mortgages owed, you will have a realistic idea of the equity or present worth of the house to you. Although real estate values may fluctuate, this information will help guide you in agreeing to other financial terms. You can include in your agreement the percentage of the equity that each of you will take when the house is sold. One or both of you can agree to be responsible for the ongoing expenses until the sale, in exchange for reimbursement at the time of sale.

Dolores mediated an agreement with a couple who agreed on

the current value of their home based on actual sales in the neighborhood. Since the wife planned to continue living in the home for another two years, she agreed that she would take 45 percent of the net value and that her husband would take 55 percent. In addition, since the husband had to purchase a new home immediately, they agreed that the net value would be calculated by deducting two years' worth of interest on his new mortgage, and that other deductions when the former home was sold would include payment for broker's fee, attorney's fees, and any taxes.

See also Question 13: If we sell our home, how do we divide the proceeds?

## Question 19

### In order to negotiate, I need to determine the value of my spouse's business. How do I do that?

Your mediator will help you determine the best way to value the business. If your spouse owns a large business with significant profits, you will want a CPA or other financial adviser who is experienced in valuing similar businesses to make the valuation. If the two of you can agree on the expert, it will be less costly than if you each hire your own.

If this is a small business, you may want to attempt your own evaluation. Look at income and expenses, assets and debts. What is the average gross income? Are there any long-term contracts for services the company is to provide? What are the expenses (lease payments, loan payments, salaries, taxes, utilities)? What are the assets (such as current value of equipment, accounts payable)? What are the debts (loans, unpaid taxes, unpaid retirement plans)?

Bank statements and tax returns will provide you with some of the information you will need. Sometimes profit and loss statements, loan applica-

In valuing the business, look at the debts that affect the asset. Have there been loans to keep a nursery business afloat during the cold season? Have there been business loans used for personal expenses?

121

tions, or buy/sell agreements may assist you in determining value. The more financial information you have, the easier it will be to determine an actual value.

See also Question 11: Shouldn't I be compensated for helping put my spouse through medical school? and Question 21: I supported my spouse and paid most of the business expenses when he started a new business. Now we're getting a divorce. Do I get any payback?

## Question 20

### Should we negotiate an agreement to remain business partners after we get divorced?

If remaining partners means that both of you will be active in the business, it depends on whether you are a high-conflict couple. Ask yourself these questions with regard to your relationship with your spouse as a business partner:

- Do you trust the business judgment of your spouse/partner?
- Do you argue or disagree frequently?
- Do you regularly feel misunderstood or criticized?
- Do you feel unappreciated or competitive?
- Will you be able to communicate and compromise?
- Do you feel that you too frequently need to explain yourself?
- Are you able to be supportive of each other?

Since both of you may need to rely on the business for future income, it is important that the business not be destroyed by arguments before or after the divorce.

If it is not feasible to sell the business, and the business needs the skills of both of you to survive, you might negotiate a way to work separately, giving you each different schedules or different tasks. While this may not be ideal for either of you, sometimes a

compromise is necessary for a period of time in order to be prudent financially.

If you own a restaurant, for example, one of you could supervise employees in the front of the restaurant, and the other could supervise the kitchen employees. In a consulting business, perhaps one of you could work from home and the other could work from the office.

If you decide to maintain a business relationship, you will need to mediate an agreement that clarifies the roles of each of you, determines the interests and obligations related to profits and debts, and provides a way to resolve conflict, usually through mediation or binding arbitration. You may want a buy/sell agreement, so that if the arrangement doesn't work out, you will have a contract specifying a formal way for one of you to buy the other out while allowing the business to continue running smoothly.

## Question 21

**I supported my spouse and paid most of the business expenses when he started a new business. Now we're getting a divorce. Do I get any payback?**

Since the business was started during the marriage, it is a marital asset, so you can negotiate an arrangement to get some payback. For example, you could agree to a share of the income from the business, a lump-sum payment, or periodic payments as a property settlement.

If the other business owes a lot of debt but there is a foreseeable income stream, you may prefer to negotiate for alimony since that would be payable even if the business went bankrupt. If you believe the business will become successful, you could agree to future payments once it either nets or grosses a specific sum.

If there are other business partners involved, it may not be possible to obtain a share in the business or to take money directly from the business. You may need to trade your interest in the business for another asset, or for future payments from your former spouse's share of the profits.

Also see Question 19: In order to negotiate, I need to determine the value of my spouse's business. How do I do that?

## Question 22

**My spouse's partnership contract has a buyout provision that provides for a very low price if she wishes to leave the partnership. In mediating our agreement, must we use this figure in computing the worth of her partnership as a marital asset?**

The buyout figure may not reflect the actual value of your spouse's interest, and there is no requirement that you use it.

You will want to know what percentage of assets she owns and what percentage of profit and debt she has agreed to. Once you determine the percentage of yearly profit, and the actual profits and debts of the corporation, you may be in a better position to estimate its value. You may also decide to consider simply valuing future income, and basing your negotiations on those figures. If you need an expert to help with the evaluation, your mediator can help you find one.

## Question 23

**What exactly is "goodwill" and how is that a factor in negotiating the value of my business?**

Does your business have a solid reputation and an established, recognized name that brings in customers? This is what is meant by "goodwill," and if your business has it, goodwill would probably be a factor to take into consideration in determining the value of the business. However, putting a dollar value on goodwill is complex, and most people bring in an expert if they can't easily agree with one another on a figure.

For example, if you own a pet-supply store, let's say, Healthy Pets A Plenty, the name of the business is likely to have goodwill associated with it, which will be valuable to a new owner. So good-

will can be worth *money* if it will attract a buyer. If you are a dentist, however, the goodwill in your practice is totally associated with you personally. If you wanted to sell the practice, the value of the goodwill without you would be minimal.

Check with your mediator, since not all businesses have a goodwill valuation component, and states vary as to whether goodwill may be considered a factor in business valuation.

# CHAPTER 6
## Retirement Plans and Social Security

Overview

1: Is there any way I won't be forced to share my pension? I worked for years to accumulate a pension, and I don't want to suffer by sharing it with someone who doesn't want to be with me.

2: What are some of the ways I can negotiate to receive my share of my spouse's pension?

3: I understand that I am entitled to a portion of my spouse's IRA or pension plan as part of our divorce settlement. Must I reinvest the money? Are there any taxes or penalties involved in taking my share?

4: What is a QDRO and how does it affect me if I negotiate to give my spouse a share of my pension?

5: If I'm negotiating the division of my pension, how can I evaluate its worth?

6: When would it be advisable for me to negotiate for another asset instead of a share of my spouse's pension?

7: When would I want to negotiate for future pension income instead of a property settlement, based on my spouse's retirement plan?

8: Is the house a good trade-off for pension assets?

9: My spouse has only worked for one employer, but she seems to have more than one retirement plan. Is that possible?

10: Is my spouse's annuity marital property?

11: Can I negotiate for a portion of my spouse's 401(k)?

12: My spouse has a Keogh plan. Can I ask for part of this plan in our negotiations?

13: My spouse has a military pension. How can we divide it?

14: Am I entitled to a portion of my spouse's Social Security benefits?

## Overview

Pension plans are frequently very sizable marital assets. Couples often ask if Social Security and retirement plans can be treated as income or divided as property in mediation as part of the divorce settlement.

First, let's clarify that Social Security is a government benefit, not an asset for property division. See also Question 14 for more about Social Security issues. As for retirement plans, while they are more frequently treated as marital property than as future income, this decision varies from couple to couple.

There are many types of plans to consider. Some of them are company pension plans such as defined benefit or defined contribution/money purchase plans, profit-sharing plans, ESOPs (Employee Stock Ownership Plans), 401(k)s, 403(b)s, traditional or new "Roth" IRAs (Individual Retirement Accounts), tax-deferred annuities, and Keogh plans (self-employed retirement plans).

If the plans are treated as marital property in a community property state, the value of the portion of the retirement plan that was earned during the marriage would simply be divided in half. In an equitable distribution state, the value earned during marriage can be divided proportionally according to a number of factors.

Whether the particular pension plan itself is divisible depends on the law and the terms of the individual plan. Military and government plans, for instance, may have special rules that limit eligibility and divisibility and that cannot be changed in mediation or by court order. But even if the plan is nondivisible, it can be valued so that part of that value can be paid with another asset.

Often a trade-off for another asset is made in mediation in order to preserve the value of the pension. Alternatively, a portion of the pension might be rolled over into an IRA, or the couple might decide to await retirement and then divide the money as either property or ongoing future income. Sometimes the tax-

deferred growth of a pension fund is preferable to trading for other property because the pension fund may increase far more in value than a taxable investment. These decisions depend on a number of factors, which are discussed in this chapter.

We will answer questions about some of these plans, but be aware that there are many variables, including ways to value the plans and methods of distribution. Before committing yourself to an agreement concerning pensions, we encourage you to speak to your mediator, accountant, and pension valuation expert.

## Question 1

**Is there any way I won't be forced to share my pension? I worked for years to accumulate a pension, and I don't want to suffer by sharing it with someone who doesn't want to be with me.**

In mediation you will not be *forced* to share your pension or any other asset because you will be negotiating your own settlement. However, most state laws do require you to value your pension as a marital asset, so this isn't an issue you can avoid. The state views the money put into the pension during marriage as similar to money put in a joint bank account with your spouse or used to buy a house. But remember, you can negotiate to give your spouse an equivalent amount in the form of some other asset instead of a share of the pension.

Pension assets are both financial and emotional issues. It is understandable that you feel strongly about protecting your right to the pension. You've worked long and hard for it, and you probably see it as your primary security for monetary support when you retire.

Similarly, your spouse may feel that contributions made to the marriage while you earned the pension should be taken into account, and if your spouse has no retirement funds, she may see the pension as the only means available for future support.

129

Familiarize yourself with your state laws concerning the division of pensions when you mediate. Then look at your options and think about what you could offer your spouse in return for keeping all or more of your pension. If you have few other assets, you may offer to provide other financial assistance that your spouse wants, such as payment of educational expenses so that she will be able to develop a new career and build a separate retirement fund.

Some couples trade monetary assets for ones that are non-monetary. Perhaps your spouse seeks more freedom regarding relocation with the children. Always ask yourself, "What can I offer to keep this asset as my own?"

## Question 2

### What are some of the ways I can negotiate to receive my share of my spouse's pension?

The portion of your spouse's pension accumulated during marriage is considered marital property. You can negotiate in mediation to receive your share as future income when your spouse retires, or, if your spouse has vested in the pension, as a lump sum.

There are many ways to divide the pension. Your spouse must be *vested* in the plan, which occurs after a certain number of years at a particular job, at which point the pension cannot be taken away, even if the employee is fired or quits. If your spouse is vested, and if the plan permits it, you may be able to take your share at the time of the divorce or you may roll over your portion into a retirement account.

You may decide to wait until your former spouse retires to receive a share as a lump sum or as income payments over time. Of course, if you decide to wait and take future payments, you may also need to negotiate about the tax consequences. As an inducement to get the arrangement you prefer, you may want to offer to put in the agreement that you will reimburse your spouse for any taxes due on the payments.

Pension and IRA distributions are complex and subject to a variety of tax rules and penalties for early withdrawal. *Never* withdraw money from a pension or IRA account without seeking expert advice.

## Question 3

**I understand that I am entitled to a portion of my spouse's IRA or pension plan as part of our divorce settlement. Must I reinvest the money? Are there any taxes or penalties involved in taking my share?**

It is important that neither you nor your spouse withdraw money directly from any IRA or pension plan before consulting with your mediator or another professional who understands the rules about the various types of retirement accounts and what the tax impact might be, given your specific circumstances at the time of your divorce.

Usually, at the time of divorce, your spouse's retirement account can be *divided* without payment of taxes or penalties. In some cases, it can be *distributed* to you at that time and you can pay the taxes on your share and use it immediately without penalty. Most people prefer, however, to roll over the money directly into their own retirement account so that they will have the pension assets when they retire. If you roll over the money, you will pay income taxes as you receive the money after retirement, when you will probably be in a lower tax bracket.

If your spouse has a pension plan through his or her employer, ask the plan administrator to explain the rules for that particular plan. Also, there are presently three different types of IRA accounts, and each has different rules with regard to taxability and penalties on withdrawals.

See Question 4 for information about QDROs.

∽∘∾

## Question 4

### What is a QDRO and how does it affect me if I negotiate to give my spouse a share of my pension?

Sometimes you are permitted to divide retirement assets earned during marriage by using a Qualified Domestic Relations Order (QDRO). In 1986, a federal law provided that by using a QDRO, a judge may order large employers to divide qualified pension plans between workers and their spouses at the time of divorce. At that time, a QDRO may be entered by a court order.

In mediation, you will negotiate the following:

- The date for valuing your pension
- How your spouse will receive his or her share
  A certain percentage or a specific dollar amount
  If your plan permits, a lump sum distribution at the time of the divorce
  A lump sum distribution when you reach retirement age
  Monthly payments beginning when you retire

Although any money distributed to you before you are $59\frac{1}{2}$ years old is subject to an additional 10 percent tax penalty, if your plan permits early distribution and there is a QDRO, money may be distributed to your former spouse at the time of the divorce, regardless of his or her age, without the tax penalty. Your spouse can choose to roll over his or her share into a separate retirement account or, in some instances, the share can be withdrawn, taxes paid, and the remainder used immediately without payment of tax penalties.

If you agree to share your qualified pension when you retire, and you do not include a provision for a QDRO in your agreement, you may be liable for the income tax on the entire amount. Because tax rules change from time to time, it would be advisable to discuss this part of your negotiations with your accountant before you include the information in your formal separation agreement.

A QDRO will not be available if you are an employee of a small business or of government. However, some employers who are not eligible for a QDRO may have another method by which you and your spouse can make a similar arrangement. Ask your pension administrator about the appropriate procedure.

## Question 5

### If I'm negotiating the division of my pension, how can I evaluate its worth?

In order to successfully negotiate the division of your pension, some of the questions you will want to ask include:

- Am I vested in my pension, or if not, when will that occur?
- What is my pension's current value?
- How much was contributed and earned during my marriage?
- What is the formula for future contributions?
- How is my pension invested?
- How will my pension be computed at the time of distribution?
- What is the earliest distribution date?
- What assumptions have been made in estimating the future distributions (such as age and percentage at which future interest will be earned)?
- What portion of my pension will be taxable?
- Is my pension currently divisible by a QDRO or by some other method?

Pension valuations can be complex because they are subject to so many variables. Some plans are worth the amount currently in the plan, others are valued according to certain assumptions such as the percentage of estimated future interest or earnings.

133

Your employer may provide you with information regarding the future worth of your particular plan. However, depending on the complexity of the plan, your mediator may encourage the use of an independent pension evaluator to determine the value.

## Question 6

**When would it be advisable for me to negotiate for another asset instead of a share of my spouse's pension?**

While you always have the choice to negotiate for other assets, there may be times it is especially prudent to do so.

- Your spouse is young, and it is difficult to forecast what will happen in the future. (Will she continue working for the company providing the pension? Will the company remain in business? What will interest rates be in the future?)
- Your spouse is not vested in the plan, and there is no guarantee that your spouse's contribution will be refunded on leaving the job.
- There is little current value to the pension because of small contributions or poor investment choices.
- The plan does not allow an immediate distribution to you.
- You are not comfortable with the company's investment policy.
- You are seeking retirement income, there is a possibility the employer may not continue the plan, and it is not immediately divisible.

∽∾

## Question 7

**When would I want to negotiate for future pension
income based on my spouse's retirement plan,
instead of making a property settlement at the
time of the divorce?**

If you have earned little income through the years, must rely on limited Social Security, and have few or no other retirement assets that will provide you with an income, you may want to negotiate for future income. There is no question that a tax-deferred pension account will grow faster than ordinary savings. This can make a significant difference over time.

But before you make this decision, you will need to determine how likely it is that the pension income will actually exist in the future when you will need it. Companies have the right to terminate pension plans, and when this occurs, current vested accumulations are protected, but future earnings end.

In addition, your spouse could resign, be fired, or die before retirement age. Find out from the pension plan administrator whether, if your husband dies before retirement, you would be able to receive the benefits described in your separation agreement.

If it's agreed that you will receive a portion of the future income from your spouse's retirement plan, the plan administrator can provide written information about the proper procedures to follow to ensure your entitlement. You may need to set up survivor benefits, and, if allowed, may want to segregate your portion of the pension and have the plan administrator invest it according to your instructions. These are just some of the details you will want to investigate.

If your spouse is healthy, arranging for an insurance policy may be an easier alternative. If you choose this route, be certain that you pay for the policy and have your spouse reimburse you. That way you can be certain it is kept current. But be aware of the downside: sometimes insurance costs increase and you or your spouse may not be able to keep up the payments.

135

## Question 8

**Is the house a good trade-off for pension assets?**

The house is a typical trade-off for the pension. In weighing this exchange, each of you must consider the consequences: the advantage of tax-deferred pension earnings, taxes due when pension payments are received, the need for future income, costs of maintaining the residence, and costs of future sale.

## Question 9

**My spouse has only worked for one employer, but she seems to have more than one retirement plan. Is that possible?**

This frequently occurs. For example, some employees have both 401(k) plans to which they contribute and separate company plans to which the company makes cash or company stock contributions. A combination of plans may provide far more choices for you in negotiating the division of retirement assets. Some of the plans may have current value, your spouse may not be vested in others, or future value may be more difficult to determine, if, for instance, a company only contributes to a plan in years when it is showing a profit.

Information about the value of each plan can usually be obtained from the plan administrator or from a pension valuation firm. Then you can negotiate a settlement based on the actual worth of each plan.

See also Question 5: If I'm negotiating the division of my pension, how can I evaluate its worth?

## Question 10

**Is my spouse's annuity marital property?**

An annuity, which is purchased by an individual from an insurance company, is like any other property asset. In most states, you would

have to determine whether the annuity investment was made with funds received prior to marriage and kept segregated from marital funds or whether the investment was made with marital funds.

Unlike a pension fund, an annuity is not currently divisible. However, in the event it is marital property, during mediation you could negotiate to be named as *joint and surviving beneficiary*. Since this would significantly lower the benefit to be paid to your former spouse, trade-offs for other marital property may be preferable. In making the trade-offs, it's helpful to know that your spouse's annuity has been purchased with *after-tax* dollars, and that only the interest has been tax deferred. So when you value the current worth of the annuity, it means that taxes will only have to be paid on the interest earned.

## Question 11

### Can I negotiate for a portion of my spouse's 401(k)?

Yes. This plan is one of the easiest to determine current value of, since the money is taken directly out of your spouse's pay, according to your spouse's instructions, which then may or may not be matched by the employer's contribution. Its current value will be exactly what is in the plan. If your spouse works for a large employer, you may need a QDRO to divide the 401(k).

See also Question 4 for information about QDROs.

## Question 12

### My spouse has a Keogh plan. Can I ask for part of this in our negotiations?

A Keogh plan, now called a defined benefit or defined contribution plan, is a retirement plan set up by self-employed individuals, and you may negotiate for a portion of your spouse's Keogh as you would for any other plan. Money put into the plan during the years you were married (and earnings accrued during those years) are considered a marital asset.

Contributions to a Keogh plan may be much larger than to an IRA. You will want to determine the amount your spouse has contributed during your marriage, and what earnings have been made on that contribution.

Both of you will want to remember that contributions were made with tax-deferred funds, which means that taxes will eventually be due on the funds. If your share is properly rolled over, there will be no taxes or penalties at that time, even if you are younger than 59½ years of age. If you don't roll over your share, you'll pay taxes but no penalties. Otherwise, the taxes will be due when you retire and/or withdraw the money from your plan after age 59½, so you should consider how the taxes will be paid when you are negotiating the settlement.

It is important that you consult with your mediator and accountant about distributing any money from a retirement account at any time, since the terms under which you can avoid penalties vary from plan to plan.

See also Question 3: I understand that I am entitled to a portion of my spouse's IRA or pension plan as part of our divorce settlement. Must I reinvest the money? Are there any taxes or penalties involved in taking my share?

## Question 13

### My spouse has a military pension. How can we divide it?

Federal law, including the Uniformed Services Former Spouses' Protection Act, supersedes state law and your agreement. There are very specific rules that must be followed or the division of your spouse's military pension can be disallowed.

Before proceeding in mediation, contact the accounting office of your spouse's service to determine whether you meet eligibility requirements and what procedures must be followed.

∽o∾

## Question 14

### Am I entitled to a portion of my spouse's Social Security benefits?

You won't need to mediate for the Social Security benefits because your entitlement is determined by federal law. Currently, even if your former spouse has not retired, if you have been married for at least 10 years, have been divorced for at least 2 years, are 60 years of age (50 if disabled), and either unmarried or have not remarried before 60 (50 if disabled), you will be eligible to collect benefits based on your ex-spouse's work record.

You will receive an amount equal to *either* one-half of your ex-spouse's benefit or an amount based on your own earnings, whichever is higher. Your ex-spouse will still receive the full amount to which he or she is entitled, even if several unmarried former spouses are eligible for benefits based on his or her earnings.

If you outlive your former spouse, whether he or she dies before or after becoming eligible, you will remain eligible for benefits. Under those circumstances, you would receive the *full* benefit that your former spouse was eligible to receive.

# CHAPTER 7
## Taxes

Overview

1: Since our divorce won't be final until after the end of the year, do we file our taxes jointly or separately this year?

2: What does "head of household" tax status mean, and is it an important issue for us in mediation?

3: Who takes the exemption for our dependent child on their tax return?

4: Are there other tax credits related to the children that I can negotiate for in mediation?

5: I am negotiating to pay child support, but how can I make it tax deductible?

6: If I agree in mediation to pay alimony, how will that affect negotiating for purposes of tax planning?

7: If we agree to sell our home, what are some of the tax consequences we should take into consideration in negotiating our agreement?

8: What if some of our tax returns are audited after we divorce?

9: When we were married, I just signed the joint returns without reading them. After the divorce, if those returns are audited and found to be incorrect, am I going to be responsible?

10: We will get a big tax refund next year. Who gets it?

# Overview

There are many tax consequences of divorce that we will explore in this chapter. Some of the tax laws and regulations that will be of particular interest to you include those regarding alimony (it *is* tax deductible), what can be treated as alimony, the tax consequences of selling property, income tax filing status and the consequences of filing joint tax returns, and negotiation pointers related to various tax credits, exemptions, and exclusions.

In addition to reviewing this material, we recommend that you obtain the latest version of IRS publication 504 ("Divorced or Separated Individuals"). Since tax regulations change frequently, this publication will give you some of the latest information.

## Question 1

### Since our divorce won't be final until after the end of this year, do we file our taxes jointly or separately this year?

Your income tax filing status is determined by your marital status on the last day of the calendar year. Since you will still be married, you can decide in mediation how to file—either "married filing jointly" or "married filing separately."

The tax advantage of filing jointly is that you are taxed at a lower rate. However, if you anticipate any tax complications, you may prefer the "married filing separately" status so that you would not be jointly liable for any tax penalties.

If you choose "married filing separately" and, on the last day of the year, you will have been separated for six months or more and you have met certain other criteria, you may be eligible for head-of-household status.

See Question 2: Is head-of-household tax status an important issue for us in mediation?

## Question 2

### What does "head of household" tax status mean, and is it an important issue for us in mediation?

Head-of-household status can be important because it allows a single person or a parent who has been separated for more than six months to file at a lower tax bracket. Part of your mediation will involve determining which of you may be eligible to claim this status. Actually, it may even be possible for *both* you and your spouse to file as head of household if you have at least two children and you have *split* custody.

In order to determine if one or both of you may be able to file as head of household, you must consider the following IRS criteria:

Dolores worked with a couple who thought they had everything figured out before the first mediation session. They said they intended to file in-come taxes separately for the year they planned to live apart (officially living apart for a year is one way of establishing grounds for divorce in New York). The artist wife's income was lower than her husband's, and she would be able to get a refund on her taxes. Dolores suggested another option. Since the husband's income as a consultant was greater than his wife's, it would be to his advantage to file jointly as long as they were married and able to do so. He would pay less in taxes, and he could pay his wife the amount of her refund out of his tax savings.

- Your child has received a minimum of 50 percent of child support from you.
- Your child has lived with you for more than 50 percent of the year.
- You have provided more than 50 percent of the cost of maintaining your household.
- Your spouse has not lived with you for the last six months of the year.

## Question 3

### Who takes the exemption for our dependent child on their tax return?

The dependent exemption for each child, which is an IRS-specified amount not subject to taxation, is a negotiable item that can be allocated to either you or your spouse. Since only one of you can claim it each year, if both of you meet the criteria, you may agree to share the exemption by taking it in alternate years. This exemption has enhanced value as a result of the 1997 tax revisions, since now the parent taking the dependent deduction can also take the new *child credit* (see Question 4) and any college *tuition credit.*

The parent who is paying most of the child-related expenses may opt to take most of the tax benefits. Sometimes, however, there is a reason that the dependent exemption and other credits will be more of an advantage to one parent than the other. For example, one parent may be earning too much to be eligible for these tax advantages. Check with your accountant so you can use the exemption and credits to your advantage in your negotiations.

If you are the noncustodial parent and plan to take the dependent exemption, your former spouse must sign an IRS form, which your accountant will tell you about. If you are the custodial parent, you may want to negotiate an agreement to sign this form year to year on the condition that there are no child support arrears.

## Question 4

### Are there other tax credits related to the children that I can negotiate for in mediation?

If you negotiate to take the exemption on your tax return for your dependent child, you can also take the child credit if he or she is under age 17. This credit is $500 per child in 1999 and thereafter.

In addition, if you are paying for your child's college tuition,

depending on your income, you may be able to receive a tuition credit. This is another credit you can only take if you arrange to take the dependent exemption.

Of course, you and your former spouse could agree to take the exemption and credits in alternate years—or arrange for your accountant to decide on the basis of the most advantageous refund—and then you could split the refund.

## Question 5

### I am negotiating to pay child support, but how can I make it tax deductible?

Child support is an expense that is not tax deductible to the payer because it is not considered taxable income to the recipient. This answer may sound unfair to you, but since it is the government's policy that children must be supported, the Internal Revenue Service does not allow the deduction.

There are, however, other tax benefits related to supporting your children that you will be able to discuss in mediation, including child credits, tuition credits, dependent exemptions, and head-of-household filing status. These are all items up for negotiation.

In addition, you may agree to pay less child support and more alimony, or you may decide to pay for some other item as part of your alimony payments, such as mortgage payments or utilities for your ex-spouse's home, which will help reduce your taxes. These options are discussed elsewhere in this chapter.

## Question 6

### If I agree in mediation to pay alimony, how will that affect negotiating for purposes of tax planning?

At last, an unconditional answer. The IRS allows you to deduct alimony from your taxes and your former spouse to report it as income. If you are in a high tax bracket, this will result in lower taxes since the income is shifted to your former spouse, who will

pay at a lower rate. In order for alimony to qualify as tax deductible, there must be a written separation agreement or court order for support, you must be living apart, and you may not file your taxes jointly.

In mediation, couples often trade off more alimony for less nondeductible child support. This can be especially appealing if the parent receiving alimony earns less money and is in a much lower tax bracket.

If the usual alimony arrangement does not fit your particular tax situation, the IRS even allows couples to agree *in writing* that the alimony will not be treated as either a tax deduction or as taxable income. So, while you have an unconditional legal answer, there are still possibilities for negotiation in mediation.

Check with your accountant to be sure this trade-off is done properly. The IRS looks closely to determine whether money paid out as tax-deductible alimony is actually nondeductible child support or a nondeductible property settlement. For example, alimony must not be significantly higher in the first year, or the IRS may view it as a property settlement in disguise; it must not terminate on your child's 18th birthday, or it will be viewed as child support. There are several other requirements, which your mediator or accountant can clarify.

Dolores conducted a mediation in which the parents agreed that the noncustodial parent, who was in a higher tax bracket, would pay more alimony, and the custodial parent, who was in a lower tax bracket, would pay all the medical and educational expenses of their children. These are expenses that are usually shared by both parents. Instead of paying these child-related costs in the usual way, the noncustodial parent shifted his payments to tax-deductible alimony. This actually meant there was more money available for the children's expenses.

∽o∾

## Question 7

**If we agree to sell our home, what are some of the tax consequences we should take into consideration in negotiating our agreement?**

If you decide to sell your home, you will want to be certain that any profits from the sale meet the requirements for the new (as of 1997) capital gains exclusion of up to $500,000 for a married couple and $250,000 for an individual. If you don't meet the requirements, you will be taxed on the capital gains.

If you sell while filing taxes jointly and you have owned and used your home as your principal residence for two out of the five years prior to selling it, you don't have to pay federal income taxes on the first $500,000 of profit. If you sell when you are no longer filing jointly, and one of you has moved out prior to the sale, be certain that you have done so according to a separation agreement so that each of you can claim a $250,000 exclusion.

In addition, you will want to determine whether your state or locality taxes any of the money you may receive from the sale, and if this is the case, plan in advance who will pay these taxes. These taxes are often called "transfer taxes." Carol got an angry call from a couple with whom she had completed one of her first mediations; she had not included the transfer taxes in the agreement, and they came as a surprise to the couple (and to Carol).

## Question 8

**What if some of our tax returns are audited after we divorce?**

Generally, mediators include in your agreement that you will cooperate with each other in the event of an audit. You can decide in advance who will be responsible if there is an audit, and how any payments or refunds will be apportioned.

In one of Dolores's mediations, the wife had taken large deductions in connection with her consulting job. They agreed that any tax liability due because of disallowed deductions would be her responsibility, and if necessary, she would reimburse her former spouse. Since she was on sound financial footing, her husband did not ask for other guarantees, although in different circumstances he might have negotiated the transfer of a particular asset within a certain amount of time if she failed to reimburse him.

You may feel comfortable including in your written agreement that, if the IRS disallows a deduction, the one who took it will pay any additional taxes, interest, and penalties due, and if the deduction was taken by the two of you, that you will share equally any tax liability.

## Question 9

### When we were married I just signed our joint returns without reading them. After the divorce, if those returns are audited and found to be incorrect, am I going to be responsible?

There is an innocent spouse rule, created to protect you if you signed the joint return without any knowledge of tax mistakes made on the return by your former spouse. It might not be easy, however, to prove that you are innocent. The IRS could question you closely and look at your assets to determine whether or not you had knowledge of fraudulent deductions or of the failure to report income. If you did, you may not be accepted as an "innocent spouse."

If you are worried about an audit, include in your agreement that your spouse will pay for any past due taxes, interest, and penalties. But remember, if your spouse fails to pay, even if it's in the agreement, the IRS may expect you to pick up part or all of the tab. You can negotiate a way for your spouse to reimburse you in the event that this happens, and, so long as your spouse does not go bankrupt, it will be legally binding as part of your settlement contract.

## Question 10

### We will get a big tax refund next year. Who gets it?

If you file joint tax returns this year, then you are both eligible for the refund. This is an item to be resolved in mediation.

Ask yourselves what seems fair. Did one of you incur a large tax-deductible expense? If so, did payment for the expense come out of marital funds or separate funds that were not earned during the marriage? Is it a refund that should be split or does one of you want something else in return?

If the large refund is based on some risky tax maneuver, you may prefer to file separately, so that only the one taking the deduction may later be liable for any penalties.

# CHAPTER 8
## Other Financial Issues

Overview

1: What are my "COBRA" rights to my spouse's health insurance?

2: I signed a prenuptial agreement before marriage. How will that affect what I can get in the divorce settlement?

3: How do we divide our debts?

4: If, in our negotiations, my spouse offers to be responsible for our debts in return for paying less support, what should I consider in deciding whether to accept?

5: My parents loaned us money. Who has to pay it back?

6: Should I file for bankruptcy before or after we mediate the agreement?

7: My spouse plans to file for bankruptcy. How can I be sure the financial arrangements we agree to in mediation will be worth anything?

8: Should I file for bankruptcy when my soon-to-be ex-spouse does?

9: When we complete our separation agreement, do we need new wills or any other new documents?

10: If I agree to certain parenting arrangements now, can I change them in my will?

11: I was in an automobile accident while we were married, and the court may order that they pay me a considerable sum of money for my injuries. My ex-spouse wants part of it. Is that fair?

As you have probably already discovered, many of the issues that must be addressed in divorce mediation are financial ones, some of which may affect your future. Among the topics we explore in this chapter are managing continued health insurance for yourself and your children after the divorce, the applicability of prenuptial agreements, dividing personal injury awards, and determining the responsibility for debts and family loans. We also discuss the importance of making new wills, and the impact of filing for bankruptcy on the nonfiling spouse and on the terms of the separation agreement.

Some of these matters can be quite complex, depending on your circumstances. The more well-informed you are when you negotiate in mediation, the easier it will be for you to create a settlement that meets your needs in as many areas as possible. We encourage you to explore your questions in detail with your mediator and, if necessary, with an appropriate financial expert.

See also Chapters 4, 5, and 7 for other financial topics.

## Question 1

### What are my "COBRA" rights to my spouse's health insurance?

COBRA (Consolidated Omnibus Budget Reconciliation Act) is a federal regulation that currently requires that companies of more than 20 employees providing health insurance coverage for their employees must continue to make health insurance available for an ex-spouse for a period of three years after the divorce.

You and your ex-spouse will need to negotiate in mediation how your insurance premiums will be paid once you are divorced. We recommend that, in order to ensure that payments are made

and your insurance is kept in force, you agree to be responsible for the payments, or that you make the payments and arrange to be reimbursed by your ex-spouse. If your ex-spouse is paying alimony, she can pay more alimony for the applicable period so the reimbursement can be tax deductible as alimony.

## Question 2

### I signed a prenuptial agreement before marriage. How will that affect what I can get in the divorce settlement?

It depends on the terms of the agreement. There still remain issues to negotiate, however, and, under limited circumstances, a court might find the agreement invalid because of fraud or unconscionability. Rather than letting a court decide, we would encourage you to negotiate changes with the help of the mediator.

*If you both agree to revise the terms.* If you want to revise the terms of the prenuptial agreement, you can only change those terms if both of you agree to do so. This might happen, for example, if circumstances have changed significantly since you signed the agreement, or in the case of a long marriage, where you both concur that the agreement is no longer relevant. Any revisions would become part of your negotiated separation agreement.

*If other issues must be negotiated.* Usually prenuptial agreements are limited to details concerning spousal support and property to be divided in the event of divorce. Other issues such as future parenting arrangements must be negotiated at the time of separation.

*If you want to nullify the entire agreement.* There are several factors that must be considered:

1. Do you have the potential of becoming a public charge? If you have been in a long marriage and feel you will be unable to support yourself, the situation must be quite extreme for the court to nullify the agreement. You must be so limited in your potential earning power—even with additional education—that you could risk ending up on welfare.

2. Was the agreement signed under coercion? Was it signed too
close to the wedding date or without your own attorney's
advice?

If you go to court, the risk is that after extensive and costly liti-
gation, the judge can still rule either way. Mediation is an appro-
priate alternative if both you and your spouse agree to give it a
try.

Remember, you can sue anyone for any reason, but it is likely to
be costly in terms of time, money, and emotional energy. We rec-
ommend you use mediation to resolve your disputes.

## Question 3

### How do we divide our debts?

Some of the questions you'll want to consider in evaluating debts
in divorce mediation are:

- Who owns each asset?
- Who has benefited from the asset?
- Who is liable for each debt (mortgages,
  credit cards, vehicles)?
- Who is most able to pay?
- Were the debts incurred before or during
  the marriage?
- Is there any security or collateral for the
  debt (such as the house or the car)?
- Are there future financial obligations (child
  support, alimony)?
- Are there potential future liabilities (taxes due,
  tax audits for prior joint filings)?

If there is a significant amount of debt to be considered in mak-
ing your divorce agreement, we recommend consulting with a pro-
fessional financial planner. The issue of who can be held responsi-
ble for debts incurred during the marriage varies according to the
state in which you live.

Frequently, if a debt from which you both benefited was incurred during the marriage, you will both be considered responsible for the debt. In some cases, if one of you incurred the debt and the other spouse did not co-sign, the nondebtor spouse may not be considered responsible. In community property states, however, you are, in principle, liable for your spouse's debts, including personal and business debts, even if you didn't co-sign to guarantee the debt.

The exception is that the separate property of one spouse is probably not liable for *premarital* debts of the other. Your husband, for example, may have debts to his former wife. You have a better chance to protect your assets if you have kept your assets in a separate account and didn't mix them with other marital assets or pay marital expenses from that account. (See Question 2 in Chapter 5: What is the difference between marital property, separate property, and transmuted property?)

Who benefits most from the assets attached to the debt and who is most able to pay the debt are primary considerations in making a settlement. If you are the one most able to pay, you may trade off, for example, by assuming responsibility for a debt and paying less alimony. Or, if one spouse is in debt because of business reverses, the couple may choose to give the nondebtor spouse the majority of the marital assets as equitable distribution. This protects the assets and keeps them in the family.

Whenever possible, a divorcing spouse's promise to make payments to the former spouse in the future should be secured by some form of collateral, and there should be a written contract to guarantee the debt. You can agree in mediation about the security or trade-offs, and then work out the details with an attorney knowledgeable about debts and bankruptcy.

When you and your spouse separate, in order to protect yourselves from being liable for any more debts incurred by your spouse during the period when the settlement is being negotiated, all joint accounts and credit cards should be closed, and creditors should be notified in writing that you are not responsible for each other's additional debts.

See also Questions 6–8 about bankruptcy.

## Question 4

**If, in our negotiations, my spouse offers to be responsible for our debts in return for paying less support, what should I consider in deciding whether to accept?**

The first consideration is whether your spouse can afford to pay the debts. The second is whether you can afford the trade-off.

Remember, this will be an agreement that binds the two of you, but it will not bind creditors. If your spouse files for bankruptcy or fails to pay marital debts or debts for which you co-signed, you may be held responsible for payment.

If your spouse makes this offer, will he or she agree to provide additional security? For example, a lien on the business or an insurance policy or some other collateral may provide reimbursement for debts you might have to pay if your spouse's situation changes. Also, in the event of bankruptcy, this may put you near the top of the list to get paid.

You will want to establish in your mediation agreement that your spouse is paying the debts in exchange for paying less support. This is important because the bankruptcy court is less likely to discharge those debts—and thereby possibly make you responsible—if it can be established that the obligation to pay them was taken on in lieu of support payments.

## Question 5

**My parents loaned us money. Who has to pay it back?**

A loan from parents to adult children is often made informally, without anyone signing anything. You and your spouse may disagree whether it was a loan or a gift. Who had the *obligation* to pay it back may differ from who agrees in *mediation* to pay it back.

If it was an informal loan, you will have to negotiate who repays, and a starting point for determining who repays could be the purpose of the loan. If the loan was for something that can't be sold (so that repayment can come from the proceeds), such as a

vacation, the debt is just another negotiable item in mediation. If you shared in the vacation, you may decide to share in the responsibility to pay it back.

If the loan was to buy an asset that you decide not to sell, such as a house, the one who keeps the asset would usually agree to assume the responsibility for the attached debt, unless you used the debt as a trade-off.

If one or both of you *did* sign an agreement to repay, whoever signed is responsible for repayment, unless you negotiate a different arrangement and your parents agree to the new terms. For example, you can negotiate in mediation that one of you agrees to repay the loan in exchange for the right to live in the house for a certain period of time after the divorce.

## Question 6

### Should I file for bankruptcy before or after we mediate the agreement?

Timing is important. If you have a choice, and your creditors will not force you into *involuntary* bankruptcy, it is usually advisable to mediate your separation agreement and obtain your divorce *before* filing for bankruptcy.

The reason is that, although alimony and child support obligations are not dischargeable in bankruptcy, property obligations can be discharged. So if your alimony and child support agreement includes property and debt arrangements, you may run into a problem when you file for bankruptcy unless this arrangement has been clarified and included in the final divorce decree. In this way, the Bankruptcy Court is more likely to agree that the financial arrangements in lieu of alimony or child support are nondischargeable.

Also, if you file for bankruptcy first, the Bankruptcy Court must approve any financial agreements involving property or debts *prior* to their approval by the divorce court. Since these two courts have different interests, your financial arrangements could be rejected if you filed for bankruptcy first. By all means, consult

with your mediator and a bankruptcy lawyer about the best timing for your bankruptcy action.

## Question 7

**My spouse plans to file for bankruptcy. How can I
be sure the financial arrangements we agree to in
mediation will be worth anything?**

You must negotiate an agreement that takes into account bankruptcy law. Generally, people file for bankruptcy either to *discharge* (eliminate) most of their debts and get a fresh start, or to arrange a plan to pay creditors, some of them only partially. Both alimony and child support are exempt from discharge by the Bankruptcy Court, which means your spouse *must* make those payments despite filing for bankruptcy. Since marital property may not be protected, it is important to get as much as possible of your share of the marital assets at the time of divorce and before filing for bankruptcy.

Property distribution should be made before or at the time of divorce. Otherwise, creditors may claim the property at a later time and you may lose it. You must consult with a bankruptcy attorney so that you can be certain that the distribution will not be interpreted as a *fraudulent transfer* and that the judge's legal findings include appropriate language from the mediated separation agreement. In this way, the Bankruptcy Court is more likely to agree to your financial arrangement.

> After you agree to financial arrangements in mediation, it is important to have your specific alimony/property/debt agreements made part of the divorce judge's "legal findings" so that the Bankruptcy Court will accept your agreement.

Since alimony and child support cannot be touched by creditors, couples often make clear in their agreements *which* property being distributed and *which* payments scheduled to be made after the divorce are in place of or part of alimony or child support, (for example, money from the sale of the house, payment of credit card debts, or school tuition).

## Question 8

### Should I file for bankruptcy when my soon-to-be ex-spouse does?

You should discuss this with your mediator and with a bankruptcy attorney.

In the event you have too many separate assets, you may not be able to file for bankruptcy. In other instances you may simply not want to lose credit-worthiness.

In making your decision, be aware that in most states, unless you both file, creditors can go after the one who did not file but did co-sign, or who will be assumed to be responsible because the debt was incurred during marriage. You must carefully weigh the option of filing, since the downside to any bankruptcy is a loss of credit-worthiness for a significant period of time.

## Question 9

### When we complete our separation agreement, do we need new Wills or any other new documents?

You will need a new Will at the time of your divorce. You may make financial commitments in mediation that will continue after your death. Also, there may be specific amounts of money or particular items that you want to leave to specific family members. Part of your settlement negotiations may be that you forgive a debt owed to you by your former spouse if you predecease him or her, and you would want to put that in your Will as well.

### Important Documents to Revisit

You will want to revise or change names or titles on the following:
- Bank accounts, safe deposit boxes
- Deeds (house, condominium)
- Insurance (life, health, vehicle)

- Leases (house, apartment, co-op, automobiles)
- Loans, lines of credit, credit cards
- Mortgages
- Pensions and other retirement accounts
- Stocks, bonds
- Vehicle titles
- Wills, Living Wills, Powers of Attorney

In addition, you may need to change your beneficiaries and name a new executor to distribute your estate. Even if you intend to keep your former spouse in your Will, you must confirm your intent to do so. Otherwise, your bequest to your spouse might be invalid.

Similarly, other related documents should be reviewed.

- If your former spouse was named for decision-making purposes in your Living Will and/or your Power of Attorney, these too should be changed or confirmed by newly executed documents.

- The beneficiaries on insurance policies and retirement accounts cannot be changed by your Will, so you may need to change these as well. In fact, your spouse may need to sign a waiver so that you can change beneficiaries on your retirement accounts. This will be part of your mediated agreement.

## Question 10

### If I agree to certain parenting arrangements now, can I change them in my Will?

No matter what parenting arrangements you agree to or what you put in your Will, if you die while your children are young, your former spouse (unless proven unfit) will become the guardian of your children.

You can, however, provide in your Will that someone else will be guardian of any money or property you want your children to

160

inherit, or you can create trusts for them and name a trustee other than your former spouse.

When you mediate your separation agreement, you can also negotiate *in advance* for your relatives' and friends' visitation rights in the event of your death, so that people you and your children know will be in contact with them on an ongoing basis.

## Question 11

**I was in an automobile accident while we were married, and the court may order that they pay me a considerable sum of money for my injuries after the divorce. My ex-spouse wants part of it. Is that fair?**

Whether it's fair or not, a portion of the personal injury award *may* be considered a marital asset or defined as marital income. In some jurisdictions, you may be able to keep the entire award for yourself.

If you are working in mediation to determine whether the personal injury award should be considered a marital asset or marital income in your particular situation, these are some of the questions to consider:

- Will the award be for lost wages, which might be considered income for child support purposes whether it is received before or after the divorce?
- Will the award be a "structured settlement" for disability, that is, to be paid out by an annuity over a period of time (more likely to be interpreted as income)?
- Will the annuity name both of you as beneficiaries?
- Is the award for repayment of medical expenses paid out of marital funds or for other expenditures or purchases made with marital funds in anticipation of the award?
- Will part of the award be specifically allocated for loss of marital services during the marriage?

If some of these questions cannot be answered until after your divorce, you may either plan in your separation agreement for each contingency, or agree to return to mediation after your case has been settled and you know the amount of your award.

# CHAPTER 9
## Unmarried and Gay/Lesbian Relationships

Overview

1: What if we aren't legally married?

2: How is common-law marriage legally defined? If we meet that definition, can we mediate an agreement that will be enforceable through the court?

3: We're unmarried and we don't live in a common-law state now, but we did in the past. Can we mediate our separation?

4: I thought we had a common-law marriage, but now that we're separating I have found out that we can't meet the requirements. My spouse says there's nothing to talk about. Is that true?

5: What should we include in our mediated separation agreement about property and partner support if we're not married?

6: We have children but we never married, and now we are splitting up. Can we use mediation to provide for our children in the future?

7: How would bankruptcy affect our separation agreement if we aren't married?

8: Who gets our house? My lover bought it, but I completely rebuilt it.

9: I'm going to tell my spouse that I'm gay and I want a divorce. How is that going to affect the settlement?

10: I'm a lesbian, and after our divorce I plan to live with my lover. How will this affect custody and visitation?

11: I recently told my spouse that I am a transsexual. Can we use mediation to get divorced?

12: I have been in a lesbian relationship for years, and now we are splitting up. What rights and obligations do I have?

13: My lesbian partner gave birth to our child and we agreed that the child would have two mothers, but now that the relationship is over, she wants me out of the picture. What can I do?

## Overview

The issues addressed in this section are rather complex, and we urge you to carefully read the questions throughout the book that relate to your specific situation. In this chapter, we address some of the issues concerning *unmarried heterosexual couples* who have been living together and want to separate and may or may not be living in states that recognize common-law marriages; and *gay men, lesbians,* and *transsexuals* who have either been living in a same-sex relationship or who are legally married and seeking a divorce.

In all of these situations, we encourage mediation because property settlements and support arrangements may be necessary, and state divorce laws often do not apply.

### Common-law Marriages

We have been consulted by separating heterosexual unmarried couples who are shocked to discover that there is no such thing as a common-law marriage in their state. The original purpose of legalizing common-law marriages was to offer couples the protections and benefits of legal marriage when it was difficult to get married because of the long distances clergy would have to travel to perform weddings. In recent years, with the increasing number of couples living together without necessarily intending to get married, most state laws have been changed and no longer recognize common-law marriage. See also Question 2: How is common-law marriage legally defined?

In this chapter, we explore ways to establish that you have a common-law marriage and tell you where it may be recognized. If you can establish a legal marriage, you will have to follow all the rules of the state concerning divorce, and you will be able to use mediation to reach a settlement.

## Unmarried Heterosexual Couples
## Who Do Not Have Common-law Marriages

We encourage mediation for unmarried couples who do not have common-law marriages because courts are seldom available to them to resolve issues through litigation. You should be aware, however, that even if you have a written contract with each other about property and/or support issues, some judges might void the contract if one of the partners petitions the court to have it invalidated, interpreting it as a contract for sexual services.

The good news is that as long as you act in good faith, your contract will remain as you intended, and in many jurisdictions it will be considered an acceptable basis for the purpose of settling property and support issues. Subjects covered in these contracts might include loans, family gifts, the purchase of homes and furniture together, the responsibility for debts, and repayment to one of you for giving up a career to move. See Questions 4–6.

## Gay/Lesbian Issues

Although in 1996 the Defense of Marriage Act severely limited benefits to same-sex domestic partners, each year thousands of same-sex couples continue to exchange vows in religious ceremonies performed by sympathetic clergy.

Currently, lawsuits are under way in several states to determine whether same-sex couples have the right to marriage licenses, civil marriages, and specific domestic partnership rights. At the same time, in the last few years, at least 28 states have prohibited gay/lesbian marriages. See Questions 12 and 13.

If you or your spouse are divorcing because one of you is changing lifestyles, there may be emotional as well as legal issues to consider. This may be a time when one or both of you are suffering from feelings of abandonment, betrayal, and anger, which may create barriers in making the best financial and parenting plans for the future. Mediation will be particularly helpful for you since you can address both the emotional and legal aspects of your separation. See Questions 9–11.

## Children

Married or not, if you have children and you and your partner are *both* recognized as the legal parents of your children, your state's child support guidelines will be available to use as a basis for your financial and parenting arrangements. However, you will probably still need to negotiate all your other financial issues through private mediation. If only one of you is the legally recognized parent, things are more complicated. See Question 6.

Our conclusion is that for an unmarried couple who is ending a relationship, the best way to proceed is almost always to use mediation. In addition to reading this chapter, we encourage you to read the other parts of this book, since you will have many similar issues to resolve in mediation.

### Question 1

### What if we aren't legally married?

Mediation is always available, whether or not you are legally married, in order to help you resolve money and custody issues. In a long-term relationship, couples frequently become quite intertwined financially, and they need to resolve property issues equitably. You may have some entitlement (based on local regulations about unmarried partners) to health insurance or to other benefits. Your mediator will know about the situation in your area.

If you have children and your partner will not agree to mediation, depending on whether one or both of you are recognized as the legal parents of your children, either as the biological parents or by way of adoption, the laws in your state concerning child custody and child support will be available in the event you must sue. Your rights and responsibilities with respect to all other issues depend on why you aren't considered legally married, and this chapter discusses several possible situations.

You should know that if you do not have a legal marriage, alimony and equitable distribution of property will not be protected in bankruptcy proceedings. Since the protections in

divorce laws do not extend to unmarried couples, the applicable tax laws might also transform what you intended as alimony or equitable distribution of property into taxable gifts. On the bright side, you are not obligated to pay each other's debts, which might be the case in some states if you were married.

> Although Washington State does not recognize common-law marriages created in that state, it does recognize "meretricious" relationships of heterosexual couples. So in Washington, if you have lived together in a heterosexual relationship that was like a marriage, you can divide your assets according to equitable distribution as if you had been married.

Although you may have few legal rights and obligations, mediation allows you to negotiate the same terms as a divorce would provide.

## Question 2

**How is common-law marriage legally defined? If we meet that definition, can we mediate an agreement that will be enforceable through the court?**

The majority of states no longer recognize common-law marriage, and where it is legally recognized common-law marriage is strictly defined, although the definition varies from state to state. The term refers to a relationship in which an unwed heterosexual couple has lived together as husband and wife for a specific period of time required by the common-law state in which they live.

If you need to go to court to prove that you *held yourselves out* as married, here are some of the things you might have done that would help the court decide in your favor:

- Did you intend to be known as husband and wife?
- Did you act as though you were married?
- Did you live together? (always required)
- How long did you live together? (states vary on time required)

- Did you introduce yourselves to others as husband and wife?

- Did your lease indicate that you were husband and wife?

- Did you sign a hotel register as husband and wife?

- Did you receive mail as the spouse?

- Did you register with any tax, voting, or other authority as married?

- Did your bank account indicate that you were married?

- Did your utility bills indicate that you were married?

- Did you represent yourself to your employer as married?

Here is a list of some of the states that are currently common-law states or have been within the recent past.

| | |
|---|---|
| Alabama | Oklahoma |
| Colorado | Pennsylvania |
| Georgia | Rhode Island |
| Idaho | South Carolina |
| Iowa | Texas |
| Kansas | Utah |
| Montana | District of Columbia |
| Ohio | |

If you meet your state's requirements, you will be considered legally married. That means you will have to get a divorce to finalize your settlement about property, children, and estate matters. Whether or not your common-law marriage is recognized by your state, you will be able to mediate the terms of separation, child support, and division of property.

## Question 3

**We're unmarried and we don't live in a common-law state now, but we did in the past. Can we mediate our separation?**

If the two of you want to mediate, there is nothing standing in your way. While some states don't accept common-law marriages made within their own state, you may be able to establish your marriage

in your current state by proving that you used to live in a common-law state and met that state's requirements for a common-law marriage. The court in your state may recognize the laws of the other state for purposes of dividing assets and granting a divorce, and then you will be able to mediate and enforce your agreement in the state where you currently live.

This is true even if the state where you formerly lived has changed its laws and no longer recognizes common-law marriages. For example, Ohio stopped recognizing common-law marriages in 1991, but if you lived together there in 1990, your marriage may be recognized for the purpose of getting a divorce.

New York recognized a common-law marriage where the couple visited Pennsylvania for 16 days over a period of several years, and told family members in Pennsylvania they were married. In other instances and in other states, it will be much more difficult to establish a common-law marriage.

## Question 4

**I thought we had a common-law marriage, but now that we're separating I have found out that we can't meet the requirements. My spouse says there's nothing to talk about. Is that true?**

Even though you don't have the rights of a spouse, you can mediate an agreement to resolve financial and parenting arrangements—but both of you must agree to mediate. See Questions 5–8.

## Question 5

**What should we include in our mediated separation agreement about property and partner support if we're not married?**

You will want to negotiate the same issues as you would in any separation agreement. If you live in a state that recognizes common-law marriages and you meet the state's definition, there will

be guidelines to follow. Otherwise, you are under no obligation to provide support, but you can work with your mediator to make a private agreement.

### Ask yourself:

- How do we want to divide our property?
- What are the monetary and nonmonetary contributions each of us has made?
- Has one of us stayed home to take care of the house?
- Has one of us moved so that the other could improve his or her business or career?
- Have there been large gifts from either of our families or to each other?
- Do we have large debts? Who is responsible for what portion of the debts?
- Do we have debts to family members or to each other? Should these debts be repaid or forgiven?
- If we have been in a long-term relationship, does one of us have fewer monetary resources and need some kind of support and for how long?
- Are both our names on the mortgage or lease? Can we sign the title over? If both our names must remain on these documents, who is responsible for payments?
- Which of us gets the car?

You will want very definite language in your agreement concerning mediation and binding arbitration, because the courts will not be accessible to enforce the partner-support part of your agreement.

During your mediation, it will be important to consult a tax expert, since the IRS does not recognize nonmarital relationships and could interpret the property part of your settlement as subject to gift taxes, and the support part of your settlement as sub-

ject to income taxes. Your tax expert will assist you in clarifying the terms in your agreement so that you won't pay unnecessary taxes.

## Question 6

### We have children but we never married, and now we are splitting up. Can we use mediation to provide for our children in the future?

If both of you have been legally defined as the parents of the children (on the birth certificate, through adoption proceedings, or DNA testing) it will be easier to negotiate and enforce parenting arrangements and child support.

You will find the child support guidelines helpful in your negotiations even if only one of you is the legal parent or if you are a same-sex couple. If you choose not to use the guidelines, you can mediate a private agreement in which the legally recognized parent agrees to the terms of visitation, custody, and child support. This agreement will describe the *understanding* between the two of you, but if it is later challenged by the legally recognized parent, the courts do not have to enforce it. The courts usually expect the legal parents to support the children.

## Question 7

### How would bankruptcy affect our separation agreement if we aren't married?

Since you don't have the protections of marriage—which would ensure that alimony would still be paid (not dischargeable) in the event that your former spouse filed for bankruptcy—you must proceed cautiously. If your former partner files for bankruptcy, *even if you have a written contract*, you may lose your claim to the financial settlement on which you have already agreed.

Our recommendation is that any debts your partner owes you be secured by property not vulnerable to the bankruptcy process.

This makes it more likely that your agreement will not be nullified by the Bankruptcy Court. Check with a bankruptcy attorney about the best course of action in your state.

## Question 8

### Who gets our house? My lover bought it, but I completely rebuilt it.

You need to work this out in mediation. If your partner holds title to the house and you go to court without a written agreement, it will be costly and, *at most*, you might get reimbursement for the time you spent rebuilding the house.

Is your former lover planning to sell the house? In mediation you can explore ways to divide the proceeds. Perhaps you can agree to a percentage of the profit from the sale. Some of the factors to negotiate in mediation include determining the value of the house, deciding on a minimum sale price, and deciding whether you will have an option to buy or a right of first refusal when the house is sold.

If both you and your former lover want to continue living in the house, this is an issue you will need to mediate. If he or she holds the title to the house, you may need to negotiate a trade-off or payment for your contribution to the value of the house so that it's possible for you to move elsewhere.

It's important in negotiating these issues to understand that you will not have the tax advantages of a married couple who transfer assets when they divorce. For example, as an unmarried couple, if you transfer assets at the time you separate, you may be subject to gift taxes or possible capital gains taxes. If one of you trades your interest in the house for payments to be made over a period of time, you may be subject to income taxes. Always consult with your mediator and your tax adviser about the best way to transfer assets or receive income.

∽∘∽

## Question 9

**I'm going to tell my spouse that I'm gay and I want a divorce. How is that going to affect the settlement?**

Your being gay *shouldn't* affect the settlement if you use mediation, since you remain in control of the decision-making process. If you litigate, however, the judge may have negative attitudes about homosexuality, which could jeopardize your visitation with your child and possibly your financial arrangements.

In mediation, you can agree to use no-fault grounds. If you litigate, and you or your spouse uses fault grounds, the laws in your state may limit property division and payment of alimony. In some states the definition of marital fault includes such grounds as abandonment (physical or sexual), adultery, frivolous waste of marital assets, or fraud. Some of these may be applicable to your situation, so clearly mediation would be the better approach. See also Question 1 in Chapter 11: What are fault and no-fault grounds for divorce, and how will the choice of grounds affect our settlement?

## Question 10

**I'm a lesbian, and after our divorce I plan to live with my lover. How will this affect custody and visitation?**

You need information before you begin mediation. Mediation is a good way to develop parenting arrangements that ensure quality time with your children. If you let a judge decide about access to your children, there might be limitations you would find unacceptable.

When custody and visitation are litigated, some states treat homosexual relationships and heterosexual relationships equally, and in those states there would have to be significant proof that your relationship is harmful to your children before custody or visitation would be denied to you by the court. Other states, as well as some individual judges who reflect local or personal atti-

tudes, might be inclined to deny or limit custody or visitation without proof of harm. In a recent Georgia ruling, the judge refused permission for a lesbian mother to visit with her young child in the presence of her female partner.

Inform yourself about court decisions in your community concerning gay/lesbian parents to get an idea what your bargaining position would be if you went to court. Check with local gay/lesbian centers, web sites, or lawyers known to be helpful to gays and lesbians. With this information you will be in a better position to mediate.

## Question 11

### I recently told my spouse that I am a transsexual. Can we use mediation to get divorced?

You certainly can. In fact, given that the courts and some judges are not always sympathetic to transsexuals, mediation is the better option. Just as we would encourage you to seek a mediator with expertise in any area that's especially important in your situation (complex finances, a family business), here we would encourage you to choose a mediator with a mental health background who would be able to understand, anticipate, and work out the emotional issues with you and your spouse.

We have encountered emotional issues in these circumstances that can make negotiation difficult. One or both parties is usually angry at the start, and feelings of betrayal and rejection are common. The transsexual partner may feel angry that his or her sexual identity is not accepted and that his or her fitness as a parent is being questioned. One or both partners may also feel guilty or fearful about the same or different issues. This can lead to inflexible demands, a power imbalance, or an impasse.

Addressing the underlying concerns of both of you when you begin mediation will be important. For example, in negotiating parenting arrangements, you will both need to express your concerns about visitation arrangements, and the mediator will help you create a plan with which both of you can be comfortable. It

will be helpful to talk about the stereotypes and myths concerning transsexual parenting, and you may need to reassure your spouse that the usual boundaries between parent and child will be observed.

We offer some examples below from our mediation practices. While we are aware that these stories sound stereotypical and controversial, they are true stories.

Dolores did a mediation with a couple in which the wife had been supporting her transsexual husband throughout their five-year marriage. Shortly before the beginning of the mediation, she refused to provide further support. In mediation the couple reached an impasse until their unspoken fears were explored.

Both were angry. The husband believed that by refusing to continue to support him, she rejected his sexual identity. But through mediation he learned that her real concern was about continuing to make support payments, not about his identity, which she had grown to accept. Once he understood her, they were able to negotiate a settlement in which he continued to receive support, but for a limited time.

If there are children, mediation offers a much better chance to create a more reasonable solution than a potentially unfriendly and unpredictable legal system.

Carol had a postdivorce consultation with a couple in which the issue was that the transsexual husband had begun permanently cross-dressing as soon as the divorce decree was issued. He insisted that the children address him by a female name, and he frequently left his lingerie hanging in the bathroom when the children visited. His former wife had come to accept his cross-dressing and thought he had a right to his sexual identity, but she was concerned about the effect of his more recent actions on their two young children. She wanted to negotiate some boundaries for the children's visits with him, and threatened to go to court to limit visitation. The father realized an unsympathetic judge might take away some of his visitation rights, and he agreed to work out some new rules in mediation.

Carol also encouraged the couple to consult with a child therapist and included additional language in their agreement provid-

175

ing that if they had future parenting disputes, they would return to the therapist as well as to the mediator.

## Question 12

**I have been in a lesbian relationship for years, and now we are splitting up. What rights and obligations do I have?**

Although you have been living together in a committed relationship, at this time your relationship is not recognized as legal. A "palimony" suit is not an option, since no state at this time recognizes palimony suits.

You may have some entitlement—based on local regulations about unmarried partners—to health insurance or to a rented apartment (your mediator will know about the situation in your area). With a few exceptions, however, the more accurate question is, what rights and obligations *don't* I have?

You are *not* obligated to pay each other's individual debts, which you might be if you were married. If your partner had a child during your relationship, you are also *not* obligated to pay child support. However, you may want to negotiate some child support in exchange for visitation or partial custody in order to ensure your continued role in the child's life. Also see Question 6: We have children but we never married, and now we are splitting up. Can we use mediation to provide for our children in the future?

Your only real option is to negotiate a separation agreement, which can be signed and enforced as a contract. Issues covered in this contract might include loans, family gifts, the purchase of homes and furniture together, the responsibility for debts, and repayment to one of you for giving up a career to move. Also see Question 5, which provides information about property and partner support in your circumstances.

Since the less-moneyed partner will not be eligible for benefits based on the other partner's Social Security, if one of you is older and/or has less income and property, in your mediated agreement you can negotiate some form of support or a division of property to provide some security for the future.

Whether the courts will recognize your agreement depends on the laws of your state, but the two of you can honor the agreement. Your mediator and tax adviser will assist you in creating an appropriate settlement that will best serve the financial interests of each of you.

## Question 13

### My lesbian partner gave birth to our child and we agreed that the child would have two mothers, but now that the relationship is over, she wants me out of the picture. What can I do?

This is a painful situation for all concerned. Although laws in this area are being challenged in several states, unless you legally adopted the child, at the time of this writing your relationship has no legal standing. Mediation is your best bet so that you can try to negotiate an agreement in order to spend time with the child. Agreements about custody and visitation in lesbian/gay relationships provide for an *understanding* between the couple, but if the agreement is challenged by one of the involved parties, the court can decide the agreement is not in the child's best interests and ignore it.

Since you have no legal right to visitation, you might try to make the prospect of your visits with the child attractive to your former partner. You might offer to arrange a brief visit at a time that is particularly appealing to her, perhaps so she can work late, be free to take a class, or do something else for which she'd need a baby-sitter. You might also want to discuss child support, since taking some responsibility for the child comes along with visitation.

If your former partner seems to be immovable and limits your contact with the child, keep in mind that the situation may change as things between the two of you settle down. Stay in touch with the child with cards, letters, phone calls, e-mail, and any other noncontroversial way. Finally, consider discussing the situation with a therapist, since working through some of the emotions may help you develop a practical plan with your former partner.

# CHAPTER 10
## Court-Ordered Mediation

Overview

1: How does court-ordered mediation work?
2: Who will be our mediator in a court-ordered system?
3: What are some of the questions we should ask our court-ordered mediator?
4: How much will we have to pay?
5: How long does court-ordered mediation take?
6: If we use court-ordered mediation, will our child meet separately with the mediator?
7: What if we don't come to an agreement while in court-ordered mediation?
8: How will negotiations be affected if our court-ordered mediator is required to make recommendations to the court?
9: What if we don't agree with the mediator's recommendation?
10: We live in a state where mediation is court-ordered, but we don't want to participate. How can we avoid it?
11: I have moved away from the state where my spouse and children still live, and we are arguing over visitation. Now I'm required to appear there for court-ordered mediation. Do I have to show up?
12: My spouse gets violent and I'm afraid to go to court-ordered mediation. Can I get out of it?

## Overview

Court-ordered mediation has been initiated in many states primarily as a way to reduce the amount of court time spent in resolving disputes about child-related issues in divorce cases. Court-ordered mediation is quite different from private mediation, and the differences could have a significant impact on your final agreement. In some states, like California, court-ordered mediation is a well-established practice used by thousands of couples each year; in New York, on the other end of the spectrum, it is in the experimental stage.

Similarly, the procedures in court-ordered mediation programs differ from state to state, and within a state there may be several different programs operating in different jurisdictions. In some areas, for example, parent education groups are part of the program.

In some states, if you choose to go to court to contest custody or visitation, the judge *must* order mediation through the court program; in other states, individual judges *may* order mediation. Every kind of court-ordered mediation, however, offers couples a chance to negotiate a settlement out of court but with court-imposed rules and limitations.

Contact a local mediator or your state or local mediation organization (see Resources) in order to find out if there are court-ordered mediation programs in your area, and to get a general idea of whether these services might work for you.

### Question 1

### How does court-ordered mediation work?

In contrast to private mediation, court-ordered mediation is limited, with few exceptions, to certain aspects of the divorce settlement (usually only parenting arrangements, but sometimes also

including child support). The court chooses your mediator from a pool of mediators who may or may not be court employees. Although you may sometimes to able to refuse the mediator chosen for you, or to request a mediator with expertise in a particular area, in general your input is limited.

You may prefer to use private mediation instead of participating in the court-ordered program, but if you can't come to an agreement about parenting arrangements, in some states you may still be required to meet with a court-ordered mediator. And although attorneys are not required to do so, they may attend your court-ordered mediation sessions, something that is seldom done in private mediation. All of your remaining issues, such as division of property, alimony, debts, and taxes will usually be resolved separately either through private mediation or litigation. Only a few states, such as Maine, mediate property settlements and other issues through court-ordered mediation.

A very limited number of sessions will be allowed to resolve certain issues in court-ordered mediation. You may then decide to continue the process with a private mediator or you may decide to litigate. In some programs, your sessions with the court-ordered mediator may remain confidential; in others, the court-ordered mediator or another neutral person assigned by the court may make evaluations or recommendations to the judge concerning custody and visitation, using what has transpired in the court-ordered sessions to justify his or her recommendations. This will mean that what was said in those sessions may not be totally confidential, and you should keep this possibility in mind when you participate in court-ordered mediation.

Also, it is usual for the court-ordered mediator to meet separately with your children, and in a few states the mediator is *required* to do so. Based on that meeting, the mediator may disagree with the arrangements you have just negotiated and may make different custody recommendations to the judge, again using observations of you and your spouse during mediation to formulate the recommendation.

This is a broad outline of how court-ordered mediation generally works. It has advantages and limitations, which are discussed

in more detail later in this chapter. Check with a mediator in your area to make sure you are clear about the local rules before you begin the process.

## Question 2

### Who will be our mediator in a court-ordered system?

Your mediator may be a court employee, a private mediator who accepts court assignments, or a volunteer. The majority of court-ordered mediators will have graduate degrees in fields such as social work, psychology, or law.

You may object to the court if you feel your mediator has a conflict of interest with you, and, in some jurisdictions, if the mediator pool is large enough, you may even be able to request a mediator familiar with issues specific to your situation (such as your child's disability), or you may be able to request someone who can conduct the mediation in a language other than English, if that would be preferable to you.

## Question 3

### What are some of the questions we should ask our court-ordered mediator?

Ask if there are any conflicts of interest, such as a prior relationship with one of you, which might limit the mediator's ability to be neutral and unbiased. If your court-ordered mediator is required to report back to the judge who assigned you to mediation, what is the extent of confidentiality about what took place during the mediation process? What are the rules about meeting individually (caucusing) with each of you? Will the mediator be meeting with your children?

In addition, you will want to know whether your mediator will simply facilitate discussions between you and your spouse or whether the mediator will have a role in actually *deciding* your parenting arrangements. Does the mediator make recommenda-

tions or evaluations to the court, and, if so, what effect will those recommendations or evaluations have on your future parenting arrangements? What would the consequences be if you refuse to mediate, and what are your alternatives if you drop out of the mediation process because you are dissatisfied?

## Question 4

### How much will we have to pay?

Often your fees for court-ordered mediation are lower than for private mediation. Your fees may be based on your income, or in a few instances, the mediators may be volunteers and your mediation may be free. Check with a local mediator (see Resources) to find out what the arrangements are in your area. Also, ask what the local procedure is if you are unable to complete the settlement within the court-imposed time limits, but wish to continue with mediation at your own expense.

## Question 5

### How long does court-ordered mediation take?

Since it is usual for only child-related issues to be mediated, the court generally allows for only one or two sessions. If the mediation is going well and you feel you need a few more sessions, you may be able to arrange to continue at your own expense, or your mediator may be required to make a recommendation to the court based on the completed sessions.

## Question 6

### If we use court-ordered mediation, will our child meet separately with the mediator?

In many—but not all—court programs, your mediator would be *required* to meet separately with your child. What happens in

those meetings varies significantly based on each mediator's particular approach, but the purpose of the meeting is to help the mediator understand what would be an appropriate parenting arrangement for your child.

One mediator, for example, told Dolores that she *never* asks the child to choose which parent he or she wants to live with. Instead, if the child is young, she explores what the child likes to do best with each parent. If the child is an adolescent, she explores the child's important activities. This helps her get a feel for the child's relationship with each parent, and, if the parents can't agree, she will use these insights in her recommendations to the court.

If the mediator is not required to meet with your child, you and your spouse may work out the arrangements with the mediator without involving the child, or there might be some form of home visit or other attempt to evaluate the child's needs more directly.

## Question 7

### What if we don't come to an agreement while in court-ordered mediation?

If you and your spouse can't work out an agreement with the mediator, your mediator or another neutral party appointed by the court to review the mediator's report may make a recommendation to the judge, who will then decide custody and visitation issues for you. Your preferences will have less impact on the decision than if you had worked out the terms in mediation.

In other instances, your mediator may provide an evaluation rather than a recommendation to the judge, or may simply report that you have been unable to come to a decision. If recommendations are not required in your state, you have the option of continuing by arranging for private mediation, or you may choose to litigate.

The advantage of mediation is that you have more control over the outcome, even if the mediator must report to the judge. Most judges will go along with a sensible arrangement to which you have both agreed in mediation.

## Question 8

### How will negotiations be affected if our court-ordered mediator is required to make recommendations to the court?

You should ask before you begin the mediation whether your court-ordered mediator will serve as an impartial guide to assist you with your negotiations, or whether he or she may be required to make recommendations to the court about your case. This varies from jurisdiction to jurisdiction.

If you litigate in California, for example, some courts' decisions concerning the custody and visitation aspects of your divorce action may be based primarily on the court mediator's recommendation. In this case, you may want to be cautious about what you say during the mediation sessions, since confidentiality is clearly limited. Your mediator may have to explain the reasons for the recommendation, which would in all likelihood mean some discussion of what went on in the mediation sessions.

While negotiating, keep in mind that the mediator will be forming an impression of how you relate to your child and whether you seem to have the ability to be an effective co-parent. Under these circumstances, if you are seeking joint custody, you will obviously not want to continuously argue with your spouse during the mediation sessions.

## Question 9

### What if we don't agree with the mediator's recommendation?

This will vary depending on the jurisdiction in which you file for divorce. Sometimes you can appeal the mediator's recommendation, but mediators have told us that few appeals result in changes in the judge's decision.

If you do appeal, you or your attorney may be able to cross-examine the mediator. If so, you will want to show that when you

negotiated, you did so in a cooperative manner, and that your proposed parenting arrangements are in the best interests of your child and not proposed in anger or to compete with your spouse for parenting time.

## Question 10

### We live in a state where mediation is court-ordered, but we don't want to participate. How can we avoid it?

Even though you live in a court-ordered mediation state, it does not mean that all divorce cases must be mediated. Generally, you may avoid court-ordered mediation if you begin private mediation or reach an agreement on child-related issues before the date you are scheduled for court-ordered mediation. Also, if there is a history of domestic violence, current mental illness, active substance abuse, or other problematic circumstances, sometimes mediation can be avoided.

In some states, if you appear for the required number of sessions, often only one or two, you will have met the requirements of the court. Under some circumstances, even though you don't want to mediate, you may decide that this is the easiest path. However, if your state requires your mediator or another neutral individual to make a recommendation regarding custody, you must proceed with caution to avoid creating the impression that you are uncooperative.

## Question 11

### I have moved away from the state where my spouse and children still live, and we are arguing over visitation. Now I'm required to appear there for court-ordered mediation. Do I have to show up?

If your spouse files for divorce in a distant state and you both can agree on parenting issues prior to the date of the required mediation, you would in all likelihood be excused from the process.

If you are not in agreement, consult with the court mediation office or your attorney. In some states, if you live far away, you may be able to establish that it would be a hardship to appear, but you will still need to negotiate with your ex-spouse in some alternative way, of course.

Your divorce cannot be granted until appropriate living and visiting arrangements for your children have been approved by the court. Your children need to know when they will be spending time with each of you in the future, so that they can feel assured that you both have a permanent place in their lives.

## Question 12

### My spouse gets violent and I'm afraid to go to court-ordered mediation. Can I get out of it?

If there has been violence or abuse, by all means contact either your lawyer or the court-mediation office to find out whether you can avoid court-ordered mediation, and what your alternatives might be.

In many jurisdictions, under these circumstances, you may be excused from the court-ordered program. In other jurisdictions there are special procedures for working with couples in which domestic violence has been an issue. Sometimes each spouse has a private screening interview to assess the risk involved and to determine whether it would be appropriate to proceed.

If mediation is used, depending on the particular court program, some of the special arrangements in use are separate waiting rooms for each spouse; security guards; and planned, separate departures from the sessions. A co-mediation team may be assigned to work with you, or you might have "shuttle" or alternating individual sessions with the same mediator.

# CHAPTER 11
## Additional Issues

Overview

1: What are fault and no-fault grounds for divorce, and how will the choice of grounds affect our settlement?

2: Is there a waiting period to obtain a divorce?

3: We live in separate states but we want to mediate. Is that possible?

4: My spouse wants an annulment. What are the reasons for an annulment and how will that affect mediating our agreement?

5: I need a Get for a religious (Jewish) divorce or I won't be able to remarry in synagogue. How will we work this out?

6: I want to change my name after we are divorced. How can I do that?

7: When we were planning a family, we had our fertilized eggs frozen. Now my husband doesn't want me using them with a new spouse. Can we negotiate who gets them?

This section answers some nonfinancial, general questions related to procedures for getting a divorce, such as grounds, waiting periods, legal annulment, religious annulment, Jewish divorce, name change, and the ownership of frozen preembryos.

Every situation brings unique details and nuances to mediation that must be addressed. We encourage you to consult with a mediator when you decide divorce is inevitable, so that you can negotiate an agreement that meets your special needs.

## Question 1

**What are fault and no-fault grounds for divorce, and how will the choice of grounds affect our settlement?**

Are you sitting down? Almost one-third of the states don't even allow fault as grounds for divorce, regardless of whether the reason is adultery, desertion, or anything else. Things have really changed in the past few years, away from the concept that it is necessary to officially blame someone if a marriage doesn't work out.

The *grounds*, or legally acceptable reasons, for divorce vary from state to state. Most states have some form of *no-fault* divorce, which takes into account the complex, interactive nature of relationships and the difficulty of proving that only one person was responsible for the problems in a marriage. Some of the no-fault grounds in your state may be incompatibility, irreconcilable differences, or irretrievable or irremediable breakdown of the marriage.

Another form of no-fault divorce is a legal separation. Most states also allow a couple to separate for a period of time, and to use that separation as grounds for the divorce. This does not mean that one person simply moves out. In order for the separa-

tion to establish legal grounds for divorce, it usually must begin with the signing of a separation agreement. This is a legal document including all the terms of the separation that were worked out with your mediator.

Approximately two-thirds of the states still allow *fault* grounds. Fault grounds in your state may include some of the following: abandonment, constructive abandonment (refusing to have sex with your spouse for a specified period of time), adultery, attempted murder, confinement in prison, habitual drunkenness or use of addictive drugs, incurable insanity, physical or mental cruelty, impotence, and infection with a venereal disease.

Even if one of you is the "guilty" spouse, that does not mean you can't agree to a fair settlement. In most divorces, decisions about alimony or property division are made without regard for who was at fault. Sometimes fault sways the court on custody decisions, but unless there is child abuse, it rarely affects visitation rights.

In Georgia, the no-fault ground is that the marriage is irretrievably broken; in Pennsylvania there must be an irretrievable breakdown; and in Texas the ground is called insupportability. In Ohio there may be a no-fault dissolution of the marriage, rather than a divorce.

**Warning:** In Virginia and in some other states, if you have filed for a no-fault divorce and are living separately but are still legally married, you can be sued for divorce on the basis of adultery if you move in with a new partner after the separation but before the divorce is final.

No matter which grounds you use, you will still need to negotiate an agreement in mediation concerning your children, property, taxes, debts, and other issues of importance to you.

See also Question 4: My spouse wants an annulment. What are the reasons for an annulment and how will that affect mediating our agreement?

∽

## Question 2

### Is there a waiting period to obtain a divorce?

Whether or not you mediate, there are several waiting periods you will want to ask your mediator about. They are:

*1. Residency requirements:* Almost every state has a minimum period of time you must live in the state before filing for divorce. This time period ranges from six weeks to one year.

*2. Legal separation:* Some states permit divorce if you live apart for a specified period of time. This time period ranges from six months to five years.

*3. Grounds—limitations on time to file:* Some grounds are only effective if there has been a significant period of time since the ground occurred. For example, in New York, abandonment can only be used as a ground if a year has passed since the abandonment commenced. On the other hand, if the ground for divorce takes place too long prior to filing for divorce, it may not be applicable. In New York, if the ground is cruel and inhuman treatment, the cruel treatment must have occurred less than five years before you commence divorce proceedings.

*4. Court calendar:* The time it takes the court to issue a final divorce decree varies in each geographical area and at different times of the year, depending on how busy it is in that particular court.

If there is a reason you must divorce quickly, be certain to inform your mediator and the attorney filing for divorce. They may be able to assist you in expediting the process. A colleague of ours explained to a sympathetic judge that an immediate divorce was necessary for a client who met the residency requirements, and, because of unusual circumstances, the judge granted the divorce on the spot.

༭ঙঃৎ

## Question 3

### We live in separate states but we want to mediate.
### Is that possible?

Frequently spouses move to different states before they get divorced. In this situation you will need to take a look at each state's laws to decide in which state you want to mediate and file for divorce.

Both of you must be willing to attend the mediation sessions, and one of you must meet the residency or other requirements for obtaining a divorce in that state. Residency requirements (the period of time you must live in the state in order to be eligible to file for divorce there) range from none at all to one year, with the average being six months.

If one of you must travel a long distance to the other state to participate in the mediation, your mediator can arrange for several mediation sessions over a span of a few days, or for sessions lasting several hours and spaced further apart as needed. You can mediate how to share the travel expenses.

## Question 4

### My spouse wants an annulment. What are the reasons
### for an annulment and how will that affect mediating
### our agreement?

First, let's clarify whether you are referring to a legal annulment in place of divorce or a religious annulment in addition to divorce. In either case, you may be agreeing that your marriage was invalid, but the reasons for its invalidity and the legal consequences of the annulment may differ considerably.

### Legal Annulment

Generally, legal annulments are obtained because the marriage is *invalid* for one of a variety of reasons. While each state has its

own set of legal reasons for a civil annulment, they usually include bigamy, failure to ever sexually consummate the marriage, incest, or mental incompetence or underage at the time of the marriage.

If you obtain a legal annulment, it is as though the marriage never existed. You should proceed with caution because this would affect property and support rights, and you would mediate your agreement as though you were never married. See Chapter 9 for a full discussion of mediating as an unmarried couple.

## Religious Annulment

In some religions, a religious annulment is required if the divorced individual intends at some time in the future to remarry within the church. For example, as part of their divorce negotiations, Catholic spouses sometimes discuss religious annulments in mediation since, in the American Catholic Church, annulments are now obtained with some frequency.

If your spouse is seeking a religious annulment, it would be advisable to agree in your mediated agreement that you will cooperate in obtaining a religious annulment *subsequent* to your divorce being granted. That way, you would be assured that any ground your spouse uses to obtain the religious annulment would not affect your rights with respect to the civil divorce. You can agree in mediation that you will sign any documents that your spouse may need for the annulment. Of course, you cannot promise your spouse that there will be a religious annulment; only the particular church can determine whether your spouse will qualify.

## Question 5

**I need a Get for a religious (Jewish) divorce or I won't be able to remarry in synagogue. How will we work this out?**

Your husband must agree to obtain the Get, and this can be negotiated in mediation and included in your separation agreement. You and your spouse will negotiate about who will pay the

expenses involved and the time frame for obtaining the Get. Also, you both must agree to appear before the rabbi at the appointed time. This too should be part of your separation agreement.

## Question 6

### I want to change my name after we are divorced. How can I do that?

You may have adopted your husband's surname when you got married, but you weren't legally obligated to do so. If you wish to return to using your maiden name after the divorce, ask your mediator to indicate that the separation agreement should include a provision that you have the right to take back your maiden name.

On the subject of names, in 1995 New Jersey's highest court ruled that the custodial parent has the right to choose the child's surname, according to what is in the best interests of the child.

Don't forget to notify all companies and government agencies you do business with that you have changed your name, and, where necessary, have new documents issued in your new name.

## Question 7

### When we were planning a family, we had our fertilized eggs frozen. Now my husband doesn't want me using them with a new spouse. Can we negotiate who gets them?

There are few court decisions and only one state law (Louisiana) regarding the disposition of stored preembryos or frozen sperm. Since most fertility clinics require you to sign a contract that provides for what is to happen to the unused embryos in the event of divorce, this document is the first place to look. So as long as you meet the requirements of any contract you have with your fertility clinic, you will probably be able to decide in mediation about who gets the preembryos.

In one Tennessee case, the court's view was that both parties must agree how to divide or dispose of the fertilized frozen eggs. The court reasoned that if the eggs were used (and a child was born), both parties would be responsible. Since that placed an involuntary obligation on the ex-spouse who didn't want them used, the court ruled that the party who wanted to avoid their use had veto power. In that case, however, the court added that if the woman had no other way to become pregnant, that might be a consideration in giving the eggs to her.

In New York, a similar case is being appealed. When it was first litigated, the lower court held that only the woman could decide. Two courts, two views. In Louisiana, the only state with laws on this issue, you will be required to make the embryos available to other couples for implantation if neither of you wants them.

Since the two of you plan to agree through mediation, you will be able to make your own decision as to the disposition of the fertilized eggs.

# Resources

A. Mediation Information Resources and Web Sites

B. Decisions to Be Made in Mediation

C. Sample Memorandum of Understanding

D. Membership Standards for AFM Practitioner Members and AFM Approved Consultants

E. State-by-State Directory of Mediators

# RESOURCES

## A. Mediation Information Resources and Web Sites

### Resources

**Academy of Family Mediators**
5 Militia Drive
Lexington, MA 02173
Telephone: (617) 674-2663
Fax: (617) 674-2670
E-mail: afmoffice@mediators.org
Web site: www.mediators.org

**American Arbitration**
 **Association**
140 West 51st Street
New York, NY 10020-1203
Telephone: (212) 484-4000
Fax: (212) 307-4387
Web site:www.adr.org

**American Bar Association**
**Dispute Resolution Section**
740 Fifteenth Street, NW
Washington, DC 20005-1009
Telephones: (202) 662-1681
(800) 285-2221
Fax: (202) 662-1032
Web site: www.abanet.org

**Society of Professionals in**
 **Dispute Resolution**
1621 Connecticut Avenue, NW
Suite 400
Washington, DC 20009
Telephone: (202) 265-1927
Fax: (202) 265-1968
E mail: spidr@spidr.org
Web site: www.spidr.org

### Web Sites

*All sites listed are preceded by* http://

www.ConflictNet.org
www.DivorceHelp.com
www.DivorceInfo.com
www.DivorceInfoSystems.com
www.Divorce.Net.com
www.DivorceSource.com/search/
 semediation.html
www.Divorce-Without-War.com

www.mediate.com
www.mediators.org
www.mediationNOW.com
www.spidr.org

## B. Decisions to Be Made in Mediation

## I. Assets

**Property Distribution**

Equitable distribution or
  community property state
Marital property
Separate property
Transmuted property

**Real Estate**

Leased apartment (for
  purposes of valuation)
Co-operative apartment
House or condominium
  Who occupies until sale
  Who pays
    Mortgage
    Common charges
      (if any)
    Taxes
    Utilities
    Insurance
    Repairs
  Sale
    When (Immediate or planned
      future date)
    Arrangements if you rent
    Selling price (how to deter-
      mine)
    Division of proceeds
    Option to buy
    Expenses of sale
    Capital gains tax
    Transfer tax

**Business Interests**

Valuation
Contribution of other party
Division of value (lump sum,
  payout, or both)
Buy/sell agreement

**Retirement Funds**

List type(s) of plan and
  trustee(s)
  Valuation
  Vested or not
  Division of Value

**Professional Licenses and
  Degress**

When obtained
Valuation
Contribution of other party

**Personal Property**

Who has title
Who will keep
  Vehicles
  Cash
  Jewelry
  Collectibles
  Pets
  Household furniture
  Family photographs
  Bank accounts
  Stocks, bonds, tax shelters, etc.
  Inheritances, trusts

## II. Debts and Liabilities
In whose name is the debt
Who pays
   Credit cards
   Car loans
   Bank loans
   Pension or life insurance
     loans
   Credit line
   Mortgage
   Family loans

Bankruptcy
   Is it a possibility
   Who may declare

## III. Support
Alimony or maintenance
   Amount
   Time of payment
   Duration
   Tax consequences
   Future increases or decreases
   Health insurance
Life Insurance
   Amount
   Type
   Beneficiary
   Trustee for children
   Duration

## IV. Other Financial Issues
Taxes
   Refunds
   Money owed
   Penalties

File jointly or separately
Mediation fees
Legal fees
   Who pays

## V. Children
Parenting plan
   Type of custody arrangement
   Which decisions need mutual
    consent

Access or visitation
   Weekends/weekdays
   Telephone calls
   Holidays and long
    weekends
   School recesses/
    summer vacations
   Birthdays (yours and theirs)
   Other special occasions
   Notice of changes
   Expenses of missed visits
   Special needs

Geographic restrictions
   Foreign travel
   Relocating with children
   Travel costs

Access to records
   Doctors, dentists, etc.
   Schools and teachers
   Notifications
    Addresses and phone
    numbers

Illnesses and accidents
Children's whereabouts

Grandparents' visitation

Child support
   Child support
      guidelines
   Amount
   Who pays
   Time of payment
   Future increases or
      decreases

Conditions of emancipation
   Age
   College
   Marriage
   Living away
   Employment

Additional expenses
   College or private school
      tuition
   Summer camp/activities
   Extracurricular activities
   Child care

Medical decisions
   Who provides insurance
   Who files insurance
      claims
   Who pays uncovered
      expenses
   Dental
   Prescriptions
   Eyeglasses
   Contact lenses
   Elective procedures
   Psychotherapy
   Orthodontia

# RESOURCES

## C. Sample Memorandum of Understanding

**Your Memorandum of Understanding may vary considerably from this sample. Each Memorandum is unique since the terms included depend upon the facts involved in each couple's marriage. Once the Memorandum of Understanding has been drafted, an attorney will prepare the legal Separation Agreement based on the information provided in the Memorandum. Sometimes lawyer/mediators do not draft a Memorandum, but proceed directly to draft the Separation Agreement. In any event, each spouse is strongly encouraged to have the Separation Agreement reviewed independently.**

This Memorandum of Understanding is being written as a result of mediation with _____ and as preparation for a Separation Agreement. This is not intended as a legal document, will remain unsigned by the parties and serves the purpose of putting in writing the goals, intentions, and attitudes of the couple, "Wife" and "Husband," who have been living apart for one year. They now seek a separation agreement and a divorce. The couple has been advised and has agreed to each see their own attorneys before they sign any agreement. They have also been informed as to the New York State Child Support Standards Act.

Wife and Husband were married on_____. Their son, _____, was born on_____. Wife resides in a rental apartment at_____. Husband resides in a rental apartment at_____. This couple is seeking a legal separation and divorce, and they have chosen to engage in mediation in order to minimize adversarial positioning, which they feel would not be in their or their child's best interests. They wish to define for themselves what constitutes the equitable division of their property and to determine together any decisions related to support payments. They intend to share involvement with their child. They have expressed their wish to remain cooperative with each other

and flexible in their future involvement and interactions and to resolve future differences with each other directly and if necessary by returning to mediation or arbitration.

## I. Name

The parents agree that they will not, at any time and for any reason, cause their son to be known or identified or designated by any name other than _____. In no event will the name of their son be changed nor will he be adopted without the express prior written consent of both parents.

## II. Custody

Provided that the terms of this Paragraph II are met, the parents agree that the mother will have sole custody until their son commences high school, and the father will have sole custody thereafter, throughout the period their son is attending high school. This arrangement will be effective provided that the mother does not move from the New York City Metropolitan Area until their son completes the fourth grade of elementary school. In the event the mother seeks to move before their son completes the fourth grade, the parents will return to mediation, and if that fails, to arbitration or any legal remedy available to them.

## III. Visitation

### A. Within the Greater New York City Metropolitan Area:

During the period both parents live within the Greater New York City Metropolitan Area ("Metropolitan Area"), defined as within the five boroughs of New York City, the sole visitation obligation of the noncustodial parent will be as follows:

1) *Alternating Weekends*—The noncustodial parent will pick up their son at school on Friday, at the end of the school day, and return him to the custodial parent at 6 P.M. on Sundays.

2) *One Afternoon/Evening During the Week*—The noncustodial parent will have access from the end of the school day to 9 P.M.

3) *Holidays*—In the event the parents live within the Metropolitan Area, the parents will alternate access on Christmas and Thanksgiving.

4) *Son's Birthday*—The mother will have access in even-numbered years and the father in odd-numbered years.

5) *Parents' Birthdays*—Each parent will have access on their birthdays.

6) *Summer, Spring, and Winter Vacations*

Summer—The noncustodial parent will have the option of a one- or two-month visitation period each summer, commencing any date after the son's school year ends. The noncustodial parent will provide one-month notice as to the commencement date and length of the visitation.

Spring and Winter Vacations—The noncustodial parent will have a minimum of one week and a maximum of two weeks during each Spring and Winter Vacation. The noncustodial parent will notify the other parent 30 days prior to the vacation as to the dates and length of visitation.

## B. In the Event Both Parents Do Not Reside In The Metropolitan Area:

At the commencement of each school year, the custodial parent will provide a school calendar to the noncustodial parent.

The noncustodial parent will have the following visitation rights at any location, other than the residence of the custodial parent, chosen by the noncustodial parent:

1) *Summer, Spring, and Winter Vacations*—The same periods as provided in Paragraph A (6) apply.

2) *Christmas*—The parents will alternate Christmas Days, the mother having access in even-numbered years and the father in odd-numbered years. The noncustodial parent will always have visitation rights commencing the day after Christmas Day.

3) *Thanksgiving*—The noncustodial parent may choose to have visitation rights during Thanksgiving week. The noncustodial parent agrees to notify the custodial parent 30

days prior to Thanksgiving as to whether the noncustodial parent will take the Thanksgiving visitation.

4) *Transportation Costs*—For the first four years subsequent to their son's move from the Metropolitan Area, if the mother is the custodial parent, she will pay for two round-trip air fare tickets for the son to visit the father. For any additional visitation periods described in this Memorandum, the parents agree to pay pro rata shares, according to gross income, for round-trip air fare for their son or for the visiting parent. During all visitation periods, the noncustodial parent will pay the land and vacation costs.

The parents agree that when their son attains the age of 10 he may fly alone on visitation trips within the United States. The parents agree that until their son is 14, he cannot fly outside the country without a parent or without another responsible adult accompanying him. Any adult accompanying their son on trips outside the United States, other than the noncustodial parent, must be approved by the custodial parent.

## IV. Friends Visitation

After their son's eighth birthday, each year he will visit one week each with his father's friends _____ and _____. Transportation costs will be paid by the father so long as he is alive. Thereafter, the costs will be paid by the mother.

## V. Grandparents Visitation

The child will visit a minimum of one week each year with the maternal and the paternal grandparents. Costs will be paid respectively by the mother and by the father.

## VI. Geographic Limitations

Except as provided in this Memorandum, it is the agreement of both parents that there will be no limitation on locations for residence of the custodial parent nor on residence or location for vis-

itation when the son visits the non-custodial parent. This includes locations outside the United States.

## VII. Death of Parent/Guardianship

In the event of the death of either parent, then the other parent will provide the sole and exclusive physical residence for their son. The parents agree that they will appoint no guardian for their son other than the other parent by Will during the lifetime of the other parent.

## VIII. Decision Making

The parents agree that they will speak to each other on the first calendar day of each month for purposes of sharing long-range planning for their son in regards to his education, special events, and general welfare.

## IX. Access to Records

The parents agree that they will each make schools, doctors, etc., aware of their wish for the other parent to be given full access to all information and decisions.

## X. Emergency Notification

There will be consultation on invasive medical treatment and procedures. However, where emergency situations occur in which there is no time for consultation with the other parent, the parent present can make sole decisions. The parent will then inform the other at the earliest possible time of the circumstances and the decisions.

## XI. Child Support

### A. Amount

The parties have been advised of the provisions of the Child Support Standards Act ("CSSA"). Pursuant to the Act, as more fully set forth below, the parents have agreed that subsequent to either parent leaving the Metropolitan Area, child support will consist of the noncustodial parent's pro rata share of 17% of the first $80,000.00 of their combined income.

Before the formula is applied, the parents will make the following deductions from income: FICA taxes actually paid, New York City or Yonkers income or earnings taxes actually paid, and nonreimbursed employee business expenses.

The 17% will be divided between the parents based on their portion of the combined income, and the noncustodial parent will pay his or her pro rata share monthly to the custodial parent.

For the purposes of this Memorandum, the parents' annual income will be as defined in the New York State CSSA.

The noncustodial parent will transmit a copy of his/her tax return no later than April 30th of each year. At that time payments will be adjusted up or down according to the CSSA, as the same may be amended from time to time.

The parents understand that the child support obligation is not taxable to the custodial parent or deductible by the noncustodial parent.

### B. So Long As Both Parents Live in the Metropolitan Area:

1) *Child Support*—Pursuant to the CSSA, the father's monthly child support obligation is $700.00, as it will be adjusted in May of each year.

2) *After-School Programs and After-School Child Care*—The parents agree that if the father attends school part or full time, he will not be responsible for costs of their son's after-school program or after-school child care until _____. If the father does not attend school or commencing on _____, whichever occurs first, he will pay one-half of the cost of both or $200.00 monthly, whichever is less.

### C. After Either Parent Moves from the Metropolitan Area:

After either parent moves from the Metropolitan Area, the noncustodial parent will pay 17% of his/her income, as defined by the CSSA. If the noncustodial parent moves to a foreign country, he/she will pay 17% of his/her income or the amount he/she paid the year prior to the move, whichever is greater.

In addition, at such time as the custodial parent leaves the Metropolitan Area, provided that their son participates in an after-school program, the non-custodial parent will pay half of the cost of the program, or $200.00 each month, whichever is less, and, in addition, if the custodial parent attends school, a maximum of $50.00 each month for after-school child care during such period.

## XII. Emancipation

For purposes of terminating child support, emancipation will be defined as their son's marriage, attaining the age of 22, or completion of undergraduate college, whichever occurs first.

## XIII. Health Insurance and Medical Costs

Each parent will be responsible for his/her own health insurance.

Until emancipation, the father will provide insurance for their son so long as he is eligible on his policy. If their son is no longer eligible, his mother will provide the insurance on her policy. If their son is not eligible for insurance on either parent's policy, the cost of insurance will be shared on a pro rata basis, according to income. Similarly, out-of-pocket expenses will be split pro rata.

The parent paying for the insurance will receive the reimbursement, if any, from the insurance company.

If not covered by insurance, pro rata payment for elective procedures such as orthodontia, cosmetic surgery, and psychotherapy are subject to prior written agreement. If there is no agreement, the parent incurring the expense will pay it.

## XIV. College Fund

Commencing with the execution of the Separation Agreement, the custodial parent will contribute annually a minimum of $1,000.00 toward a college fund. After their son attains the age of 18 and commences college, the 17% child support paid by the noncustodial parent will be paid to the college fund. The college fund obligation will terminate upon their son's emancipation. There are no other parental obligations with respect to payment of college costs.

## XV. Taxes

The parties have been filing separately for the past three years. Each party will be responsible for payment or penalties with respect to his/her individual return.

The parent who can recover the most will take the head of household, the dependent exemption, and the day care deduction. The savings will be prorated between the parents according to their income, and the parent taking the deduction will pay the prorated share to the nondeclaring parent.

The parents understand that child support is neither deductible by payor nor taxable to recipient.

## XVI. Life Insurance

Until their son's emancipation, each parent will carry a minimum of $100,000.00 term life insurance naming their son as beneficiary and the other parent as trustee. This minimum amount will not be changed by the birth of other children to either parent.

## XVII. Spousal Maintenance

The spouses agree there are to be no Spousal Maintenance payments made between them.

## XVIII. Division of Assets

### A. Personal Property
Furniture and other personal property have been divided prior to the signing of the agreement.

### B. Real Property
There is none.

### C. Retirement Funds
The father commenced employment with _____ on _____. He has no vested pension rights from this or prior employment. Currently, he has received no credits toward a pension fund.

The mother has been employed by _____ for approximately two years. She has no vested pension rights.

Both parents agree that their son will be named the beneficiary of any present or future pension funds, and that neither party

seeks to share in any benefits or distributions from each other's funds.

## D. Professional Licenses

Neither party seeks an equitable distribution with respect to their professional licenses.

## XIX. Debt Obligations

Each party will be solely responsible for his/her individual school loan. The mother will be responsible for the approximately _____ owed by her, and the father will be responsible for the approximately _____ owed by him.

Each spouse will be solely responsible for her/his individual credit cards. The mother owes approximately _____ to _____. The father owes approximately _____ to _____ and approximately _____ to _____.

## XX. No Smoking Clause

Neither parent will smoke when their son is visiting or in his/her custody. In the event either parent has a roommate, such roommate will be permitted to smoke only in the roommate's room.

## XXI. Future Disputes

The parties agree to try to resolve future disputes with each other directly. Should they be unable to do this, they agree to return to mediation. Should mediation fail, they agree to submit their differences to arbitration under the rules of the American Arbitration Association, and to accept the arbitrator's findings as final and binding. They agree that, if the arbitrator finds one of the parties has violated the agreement, the arbitrator may assign the costs of the arbitration against that person. If there is no such finding, the parties will share equally the costs of arbitration and/or mediation.

## XXII. Disclosure of Financial Information

Both parties to this agreement have fully disclosed information as to current earnings and assets. They have each provided the prior three years' income tax forms, a statement of assets and liabilities, and current paystubs.

## XXIII. Legal Fees

Each party will pay his/her own legal fee in connection with the Separation Agreement and with a subsequent divorce.

## XXIV. Confidentiality

In a separate document, _____ and _____ agreed that all communications between each other and the Mediator come within the rules of evidence, which exclude from court or arbitration any disclosures made with a view toward settlement. Accordingly, they agreed that they would not call the Mediator or any consultant brought in by the Mediator as a witness in any court or arbitration to testify regarding any aspect of the mediation. The documents exchanged will remain confidential and nondisclosable until such time as they become part of the final, signed Separation Agreement.

# D. Membership Standards for AFM Practitioner Members and AFM Approved Consultants

## AFM Membership Categories

### General Member

Applicants for General Membership must have completed a minimum of 30 hours of training in mediation skills or possess demonstrated experience in mediation.

### Practitioner Member

Applicants for Practitioner Membership must meet all of the mediation experience/skills and training requirements detailed below:

**Mediation Experience Requirements:**
A. Possess a minimum of two (2) years of experience as a mediator.
B. Complete a minimum of 250 hours of face-to-face mediation and have mediated at least 25 cases.
C. Submit sample memoranda (preferred), case reports, or other documentation from two (2) cases. All identifying information about clients must be deleted from submitted material. An additional four (4) memoranda may be requested by the Academy.

**Training Requirements:**
D. Completion of 60 hours of mediation training as follows:
1. Completion of a minimum of 30 hours of an integrated generic family mediation training or a 40-hour integrated divorce training program. Approved Academy training programs of 30 hours or 40 hours fulfill this basic training requirement. Non-approved training applied to fulfill this requirement must include the following core areas and a minimum of six (6) hours of role-playing:
   - Information-gathering skills & knowledge
   - Relationship skills & knowledge
   - Communication skills & knowledge
   - Problem-solving skills & knowledge
   - Ethical decision-making skills & knowledge
   - Professional skills & knowledge
   - Introduction to conflict resolution theory
   - Family system & development

212

- Domestic violence issues
- Legal context (substantive knowledge)
- Interaction and conflict managements skills and knowledge

2. A minimum of two (2) hours of training in domestic violence issues (may be included in core training);
3. Additional training to fulfill the hours of training required beyond the basic training may be met through attendance at Academy Conference Workshops and Institutes and at Academy Approved Training Programs and Workshops. This additional training may include up to 10 hours of training through related graduate academic programs;
4. A minimum of four (4) hours of consultation with an AFM Approved Consultant. Consultation is available at AFM Conferences and through AFM Approved Consultants.

E. Agree to complete a minimum of 20 hours of continuing education every two (2) years after fulfilling the requirements above.

## AFM Approved Consultant

Those interested in applying to become AFM Approved Consultants should request a separate application form which details *all requirements*. The following is a *partial* listing of the requirements for becoming an AFM Approved Consultant:

The applicant must have been a Practitioner Member of the Academy for at least one (1) year preceding the application and have at least five (5) years of experience as a mediator, having completed a minimum of 1,000 hours of face-to-face mediation and have mediated at least 100 cases (including the hours and cases used in applying for Practitioner Membership). In addition, the applicant must have completed the AFM Consultation Institute within two (2) years preceding the application and have a minimum of six (6) additional hours (beyond those required for Practitioner Membership) of case consultation with an AFM Approved Consultant. The applicant must also submit additional materials for consideration (details available from AFM).

Academy of Family Mediators
5 Militia Drive • Lexington, MA 02173 USA
Voice: (617) 674-2663 • Fax: (617) 674-2690
E-mail: afmoffice@mediators.org • Web site: www.mediators.org

Copyright © 1996, The Academy of Family Members. All rights reserved.
No portion of this document may be reproduced without written permission of the Academy.

## E. State-by-State Directory of Academy of Family Mediators Practitioner Members, AFM Approved Consultants, and Professional Organizations of Mediators

The following is a state-by-state list of qualified mediators who have given us permission to let you know they are available. In states where we have no individual listings, we have listed mediation organizations; they are a source of local information and often provide referrals on request.

All of the mediators listed are practitioner-level members of the Academy of Family Mediators. Practitioner Members have met the extensive experience and training requirements of the Academy.

Some of the mediators are also Consultants, and their listings are followed by the letter C. Practitioners may choose to qualify as Consultants, which allows them to provide AFM approved consultations for continuing education.

### Alabama

Lee Borden, J.D.
Alabama Family Law Center
3280 Morgan Dr.
Birmingham, AL 35216
(205) 979-6960
(205) 979-6902 fax
Lee@divorceinfo.com
C

Luther E. Kramer, M.Div.
219 Grove Ave.
Huntsville, AL 35801
(205) 534-2560
(205) 536-5508 fax

### Alaska

Kathleen G. Anderson
The Arbitration & Mediation Group
PO Box 240783
Anchorage, AK 99524
(907) 345-3801
(907) 345-0006 fax
tamg@alaska.net

Glenn E. Cravez, J.D.
421 W. First Ave.
Suite 250
Anchorage, AK 99501
(907) 276-3370
(907) 276-8238 fax
pgcravez@alaska.net

Mary Ann Dearborn, M.S.W.
Dearborn Family Mediation
HCOI Box 6123
Palmer, AK 99645
(907) 746-3853
(907) 746-1134 fax

Drew Peterson, J.D.
4325 Laurel
Suite 255
Anchorage, AK 99508
(907) 561-1518
(907) 562-0780 fax
C

214

## Arizona

Joy B. Borum, J.D.
7520 E. Second St.
Suite 3
Scottsdale, AZ 85251
(602) 945-8909
(602) 945-1971
(602) 949-8814 fax
jmediator@aol.com
C

Linda Brewster, Ph.D.
Divorce Mediation Center
7520 E. Second St.
Suite 7
Scottsdale, AZ 85251
(602) 994-8787
(602) 941-2650 fax

Shari M. Capra, J.D.
340 E. Palm La.
Suite 275
Phoenix, AZ 85004
(602) 271-4244
(602) 271-9308 fax

Clarence Cramer, M.A.
Cramer & Associates Dispute
  Resolution Services
561 W. Spur Ave.
Gilbert, AZ 85233
(520) 723-3077
(520) 868-7354 fax
mediator@primenet.com
C

Jeannine P. Dashiell, M.A.
1130 E. Missouri Ave., #206
Phoenix, AZ 85014
(602) 870-0053
jdashiell@juno.com
C

Linda Devoy, J.D.
ACCORD Mediation Services
177 N. Church Ave.
Suite 200
Tucson, AZ 85701-1117
520 628-7777
520 623-5074 fax

Gordon B. Giles, J.D.
Divorce Mediation Center
7520 E. Second St.
Suite 7
Scottsdale, AZ 85251
(602) 994-8787
(602) 941-2650 fax

Marlene Joy, Ph.D.
10900 N. Scottsdale Rd., #201
Scottsdale, AZ 85254
(602) 948-2635
(602) 948-8163 fax
MJOYPHD@aol.com

S. Terry Lee, J.D.
Private Forum
2342 S. McClintock Dr.
Tempe, AZ 85282
(602) 829-0494
(602) 784-4996 fax
abutler@doitnow.com
C

John P. Moore, J.D.
1300 E. Missouri
Suite A-100
Phoenix, AZ 85014
(602)266-3800
(602) 266-0466 fax
P.Moore@worldnet.att.net

# RESOURCES

Suzanna A. Norbeck, J.D.
1807 E. Hale
Mesa, AZ 85203
(602) 649-9970
C

Allison H. Quattrocchi, J.D.
Family Mediation Center
7520 E. Second St.
Scottsdale, AZ 85251
(602) 949-9511
(602) 949-8814 fax
mediation@goodnet.com
C

Ann Jordan Remers, J.D.
5022 E. Calle Guebabi
Tucson, AZ 85718
(502) 529-8610
(502) 529-8610 fax

Oliver Ross, J.D., Ph.D.
Out-of-Court Soultions
3420 E. Shea Blvd.
Suite 219
Phoenix, AZ 85028
(602) 953-5216
(602) 953-5316 fax
mediate@primenet.com

Russell Schoeneman, Ph.D.
1840 E. Warner Rd.
A105-106
Tempe, AZ 85284
(602) 838-3303
(602) 838-2659 fax
r_schoenman@juno.com

Judith M. Wolf, J.D., Ph.D.
Arizona Mediation Institute
2525 E. Camelback Rd.
Suite 710
Phoenix, AZ 85016
(602) 852-5565
(602) 852-5560 fax
mediate710@aol.com

Karen Yandell, A.C.S.W., C.I.S.W.
1357 E. Chilton Dr.
Tempe, AZ 85283
(602) 839-8713
(602) 506-3296 fax

## Arkansas

Frances D. Still, A.C.S.W., L.C.S.W.
Resolutions Mediation Service
114 N. 14th St.
Fort Smith, AR 72901
(501) 785-3004
(501) 648-3454 fax
efstwo@IPA

## California

Nancy A. Adams, M.A., M.F.C.C.
550 N. State St.
Suite 4
Ukiah, CA 95482
(707) 468-7871
(707) 467-0121 fax
nadams@pacific.net

Hal D. Bartholomew, J.D., C.F.L.S.,
  F.A.A.M.L.
Bartholomew, Waznicky,
  & Molinaro, L.L.P.
1006 Fourth St., 8th Floor
Sacramento, CA 95814
(916) 443-2055
(916) 443-8287 fax
hal@divorcepage.com

Anne C. Bernstein, Ph.D.
2955 Shattuck Ave.
Suite 12
Berkeley, CA 94705
(510) 549-0598
(510) 843-2205fax
anneberns@wrightinst.edu

Janelle Burrill, J.D., L.C.S.W.
2277 Fair Oaks Blvd.
Suite 275
Sacramento, CA 95825
(916) 646-6500
(916) 646-1176 fax

Ronald L. Cameron
Dispute Resolution Center
2100 Goodyear Ave.
Suite 11
Ventura, CA 93003
(805) 985-1967
(805) 985-2449 fax

Margaret Dale, M.A., M.F.C.C.
Sonoma Mediation Services
PO Box 770
Sonoma, CA 95476
(707) 938-0523
(707) 539-6555 fax
SOMEDIATE@aol.com

Joyce C. Dickey
Family & Divorce Mediation
  Services
101 Gregory La, #49
Pleasant Hill, CA 94523
(510) 689-2326
(510) 825-4106 fax
ldickey@earthlink.net

William A. Eddy, L.C.S.W., J.D.
160 Thorn St.
Suite 2
San Diego, CA 92103-5691
(619) 291-9644
(619) 692-4061 fax
eddylaw@ixpres.com

Alice Houghton Esbenshade, M.F.C.C.
226 E. Canon Perdido #I
Santa Barbara, CA 93101
(805) 966-1212
(805) 966-1212 fax
ALICE@silcom.com

Jay Folberg, J.D.
University of San Francisco
School of Law's Dean's Office
2199 Fulton St.
San Francisco, CA 94117
(415) 422-6304
(415) 422-6433 fax
FOLBERGJ@usfca.edu

Nancy J. Foster, J.D.
Northern California Mediation
  Center
100 Tamal Plaza
Suite 175
Corte Madera, CA 94925
(415) 927-1422
(415) 927-1477 fax
njfoster@ncmn-mediate.org
C

Carol A. Gefis, J.D.
LegalEase Mediation & Legal Services
7700 Irvine Center Dr.
Suite 730
Irvine, CA 92618
(714) 748-0100
(714) 453-7393 fax

Tom Hicks, M.A.
Resolution Resources/Resolve
  Divorce Mediation Service
2211 Blucher Valley Rd.
Sebastopol, CA 95472
(707) 824-9024
(707) 824-9036 fax
thicks@igc.apc.org

Faith Jansen, J.D.
540 Lennon La.
Suite 290
Walnut Creek, CA 94598
(510) 274-0900
(510) 274-0364 fax

Althea Lee Jordan, J.D.
Jordan & Miller
385 Sherman Ave.
Suite 1
Palo Alto, CA 94306
(650) 325-8800
(650) 325-8837 fax

Joan B. Kelly, Ph.D.
Northern California Mediation
  Center
100 Tamal Plaza
Suite 175
Corte Madera, CA 94925
(415) 927-1422
(415) 927-1477 fax
jbkelly@ncmc-mediate.org
C

Pamela S. Lane-Garon, Ph.D.
California State University
Fresno, CA 93740-8025
(209) 278-0320
(209) 292-4875
garon@sirius.com
C

Helene Linker, M.A., J.D.
Custody Resolution & Family
  Mediation Center
PO Box 21469
Oakland, CA 94620
(510) 595-1680
(510) 595-1680 fax

Mimi E. Lyster
1125 Neilson St.
Albany, CA 94706
(510) 524-8320
(510) 526-8431 fax
mlyster@vdr-solutions.com/mimi.l
C

Hedy McAdams, J.D.
467 Hamilton Ave., #8
Palo Alto, CA 94301
(415) 325-3371
C

Ruth Dickerson McGough, J.D.
2145 Donald Dr., #3
Moraga, CA 94556
(510) 376-0766
(510) 361-9676 fax

Michele McInaney, J.D.
Law and Mediation
540 Bird Ave.
San Jose, CA 95125
(408) 279-1481
(408) 292-7181 fax

Nina Meierding, J.D.
Mediation Center for Family Law
857 E. Main St.
Ventura, CA 93001
(805) 643-3543
(805) 653-6107 fax
meierding@aol.com

Lacy N. Moes, J.D.
735 State St.
Suite 633
Santa Barbara, CA 93101
(805) 966-7844

Stephen W. Penn, J.D., M.S., M.B.A.
16360 Monterey Rd.
Suite 120
Morgan Hill, CA 95037
(408) 776-1525
(408) 778-5447 fax
SPENNLAW@aol.com

Chip Rose, J.D.
4340 Scotts Valley Dr.
Suite J
Scotts Valley, CA 95066-4541
(408) 438-1604
(408) 439-0703 fax
crose@igc.org

Steven Rosenberg, J.D.
591 Redwood Hwy.
Suite 2275
Mill Valley, CA 94941
(415) 383-5544
(415) 381-4301 fax
C

Duane Ruth-Heffelbower, M.Div., J.D.
Mediation Associates/Center for
  Peacemaking & Conflict Studies
1717 S. Chestnut Ave.
Fresno, CA 93702
(209) 455-5840
(209) 252-4800 fax
duanerh@fresno.edu

Michelle D. C. Samis, L.M.F.C.C.
Child Custody Mediation
3065 Porter St.
Suite 102
Soquel, CA 95073
(408) 475-3661
(408) 475-6669 fax

Donald T. Saposnek, Ph.D.
Family Mediation Service
6233 Soquel Dr.
Suite E
Aptos, CA 95003
(408) 476-9225
(408) 662-9056 fax
afmdsaposnek@igc.org

Patsy K. Schiff, J.D.
Attorney & Mediator
1409 28th St., #210
Sacramento, CA 95816-6404
(916) 457-2850
(916) 457-7035 fax

Michael Scott, L.M.F.C.C.
Family Mediation Service
333 Church St.
Suite B
Santa Cruz, CA 95060
(408) 423-0521
(408) 427-2935 fax
Michael@DivorceInfosystems.com

Susan Stahl, M.F.C.C.
66 Bovet Rd., #300
San Mateo, CA 94402
(650) 572-2600 ext 123

Dianne Thomas, M.A., L.M.F.C.C.
60E Third Ave.
Suite 302
San Mateo, CA 94401
(650) 349-0461
(650) 401-7424 fax
Diathom@aol.com

Clarence D. Walters, M.A.
2277 Fair Oaks Blvd.
Suite 190
Sacramento, CA 95825
(916) 920-9429
(916) 923-9723 fax

Suzanne Foster Winslow, L.C.S.W.
820 Bay Ave.
Suite 208
Capitola, CA 95010
(408) 476-0704
(916) 791-6787
(916) 791-6797 fax
GOLDCNTRYM@aol.com

### Colorado

Christine A. Coates, M.Ed., J.D.
2737 Mapleton Ave.
Suite 103
Boulder, CO 80304
(303) 443-8524
(303) 442-2345

Larry D. Dragon, M.A.
The Mediation Center of Colorado
1512 Grand Ave., Suite 218
Glenwood Springs, CO 81601
117 Aspen Airport Business Center
Suite 301
Aspen, CO 81611
(970) 945-7370
(970) 945-7281 fax
ldragon@mediate.com
C

Janet R. Eaton, J.D.
524 S. Cascade Ave.
Suite 2
Colorado Springs, CO 80903
(719) 636-5123
(719) 636-2077 fax
jeaton@pcisys.net

Mary Margaret Golten
CDR Associates
100 Arapahoe Ave., #12
Boulder, CO 80302
(303) 442-7367
(303) 442-7442 fax
mmgolten@mediate.org

Katherine S. Head, L.C.S.W.
The Center for Solutions
3665 Cherry Creek Dr. N.
Suite 250
Denver, CO 80209
(303) 329-3435
(303) 299-5572 fax
K-shead@worldnet.att.net

Jane Irvine, M.A.
Irvine Associates
8174 S. Holly St., #178
Littleton, CO 80122
(303) 771-7909
(303) 290-1020 fax
irvine@ecentral.com

Albert L. Landa
Office of Dispute Resolution
1123 Custer Ave.
Colorado Springs, CO 80903
(719) 633-6680
(719) 633-6680 fax

Michael J. Maday, M.S.W.
102 S. Tejon St.
Suite 1100
Colorado Springs, CO 80903
(719) 471-0970
C

Bernard Mayer, Ph.D.
CDR Associates
100 Arapahoe, #12
Boulder, CO 80302
(303) 442-7367
(303) 442-7442 fax
bmayer@mediate.org

Joan McWilliams, J.D.
McWilliams Mediation Group Ltd.
 Dispute Resolution Services
1775 Sherman St.
Suite 2825
Denver, CO 80203
(303) 830-0171
(303) 830-8422 fax

Martin D. Meltzer, M.A., L.P.C.,
 N.C.C.
6920 S. Holly Circle
Suite 190
Englewood, CO 80112-1065
(303) 721-9779
(303) 721-7350 fax
mmeltzer@du.edu

Steven Meyrich, J.D.
100 Arapahoe Ave., #14
Boulder, CO 80302
(303) 440-8238
(303) 938-9703 fax
stevenM659@aol.com

Nancy Cohen Nowak, M.A., L.P.C.
6966 S. Spruce Dr. W
Englewood, CO 80012
(303) 771-5424
(303) 741-3828 fax

Elaine O'Reilly, M.S., L.P.C.
Colorado Couseling Associates, Inc.
8703 Yates Dr., Suite 105
Westminster, CO 80030
(303) 430-9550
(303) 430-5306 fax

John A. Rymers, M.A.
1805 S. Bellaire St.
Suite 301
Denver, CO 80222
(303) 759-5103
(303) 757-4225 fax
C

William Schwartz
Family Mediation Group
709 Clarkson St.
Denver, CO 80218
(303) 322-3080
(303) 321-9473 fax
schwartz@csn.net

Thomas H. Smith, Ph.D.
1336 Northridge Ct.
Boulder, CO 80304
(303) 444-0181
thsmith@concentric.net

Arnold L. Swartz, L.C.S.W.
Arnold Swartz & Associates
720 Kipling St., #200
Lakewood, CO 80215
(303) 237-4828
(303) 232-3892 fax
AFMASWARTZ@igc.apc.org
C

221

# RESOURCES

## Connecticut

Barbara D. Aaron, J.D.
Whitehead & Aaron
241 Main St.
Hartford, CT 06106-8002
(860) 241-7797
(860) 241-7744 fax

Mary Ann Carney, M.Ed.
Mediation & Training Center
35 Cold Spring Rd.
Rocky Hill, CT 06067
(860) 644-6308
(860) 721-5792 fax
CARNEYMA@juno.com
C

Resa Fremed, Ed.D.
New England Counseling
  & Mediation
898 Ethan Allen Hwy.
Ridgefield, CT 06877
(203) 431-4957
(203) 431-7984 fax
C

Roberta S. Friedman, J.D.
383 Orange St.
New Haven, CT 06511
(203) 776-9002
(203) 787-3259 fax

Kate W. Haakonsen
Brown, Paindiris and Zarella
100 Pearl St.
Hartford, CT 06103
2252 Main St.
Glastonbury, CT 06033
(860) 522-3343
(860) 659-8292 fax
KATEBPS@aol.com

Mary G. Marcus, Ph.D.
Center for Divorce Mediation
10 Wall St.
Norwalk, CT 06851
(203) 854-9394
(203) 454-0404 fax
MGMPHD@aol.com

Walter Marcus, J.D.
Center for Divorce Mediation &
  Alternative Dispute Resolution, Inc.
The Trolley Barn
10 Wall St., PO Box 326
Norwalk, CT 06852
(203) 854-9394
(203) 454-0404 fax
ZWMZ@aol.com
C

Linda L. Mariani, J.D.
Linda Mariani & Associates, L.L.C.
83 Broad St., PO Box 1630
New London, CT 06320
(203) 443-5023
(203) 443-8897 fax

Bonnie C. Robson, M.Ed., J.D.
Family Law Mediation Service
200 Retreat Ave.
Hartford, CT 06106
(860) 545-7358
(860) 545-7045 fax

Leslie D. Strong, Ph.D.
46 Overlook Rd.
Glastonbury, CT 06033
(860) 633-6176
(860) 657-3531 fax

Georgia Von Schmidt, J.D.
PO Box 146
Darien, CT 06820
(203) 656-4777
(203) 656-4777 fax
G.VonSchmidt@juno.com

Carol Widing, M.Ed., J.D.
Attorney at Law
Mediated Divorce Services
56 E. Main St.
Suite 4
Avon, CT 06001
(860) 678-8401
(860) 678-8223 fax

### Delaware

Jolly Clarkson-Shorter, M.C., N.C.C.
PO Box 5686
Newark, DE 19714-5686
(302) 738-9702
clarkshort@aol.com

### District of Columbia

Peter R. Maida, Ph.D., J.D.
6242 29th St. NW
Washington, DC 20015
(202) 362-2515
(703) 528-9894 fax
pmaida@aol.com
C

### Florida

Joseph W. Davis, C.P.A., C.F.P.
Davis, Monk & Company
4010 N.W. 25th Pl.
Gainsville, FL 32606
(352) 372-6300
(352) 375-1583 fax

Iris B. Di Gennaro, J.D.
6526 Via Rosa Dr.
Boca Raton, FL 33433
(561) 391-6818

Phyllis Dorian, M.A.
3147 Hyde Park Dr.
Clearwater, FL 34621
(813) 787-9627
(813) 787-9627 fax
ISCHOENBERGER@aol.com

Gregory Firestone, Ph.D.
2901 W. Busch Blvd.
Suite 707
Tampa, FL 33618
(813) 933-7655
firestoneg@aol.com

Peter T. Gianino, J.D.
The Law Offices of Grazi,
  Gianino & Cohen
217 E. Ocean Blvd.
Stuart, FL 34994
(561) 286-0200
(561) 286-4789 fax

Donald R. Gilette, J.D., Ph.D.
Family Mediation Center
1006 N. Armenia
Tampa, FL 33607
(813) 877-1210
(813) 876-5966 fax

Diane R. Godard, Ph.D.
28471 U.S. 19 North
Suite 514
Clearwater, FL 34621
(813) 785-1820
(813) 786-1916 fax
DianeGodard@ij.net

# RESOURCES

Nancy W. Gorman, J.D.
609 Park Circle
Bradenton, FL 34207
(941) 753-4025
(941) 753-4025 fax
ednancy@bhip.infi.net
C

Florence Kaslow, Ph.D.
Kaslow Associates, PA
128 Windward Dr.
Palm Beach Gardens, FL 33418
(561) 625-0289
(561) 625-0320 fax
C

Melvin A. Rubin, J.D.
Law Offices of Melvin A. Rubin
111 Majorca Ave., #A
Coral Gables, FL 33134
(305) 446-4345
(305) 446-4978 fax

Lee A. Schreiber, J.D.
Thompson & Schreiber, PA
3949 Evans Ave.
Suite 206
Fort Myers, FL 33901
(941) 936-5225
(941) 936-2542 fax

Daniel K. Warner, J.D.
Mediation Center of Jacksonville
4741 Atlantic Blvd.
Suite C
Jacksonville, FL 32207
(904) 399-4113
C

## Georgia

Robert Berlin, J.D.
Decision Management Associates
3081 Revere Ct.
Atlanta, GA 30340
(770) 458-7808
(770) 455-7272 fax
dma-adr@mindspring.com

Kay A. Giese, J.D.
The Mediation Center, Inc.
PO Box 1626
1090 S. Milledge Ave.
Athens, GA 30605
(706) 369-0360
(706) 543-8453 fax
mediatr1@aol.com
C

Daniel E. Gulden, J.D., L.L.M.
4820 Longchamps Dr. NE
Atlanta, GA 30319-1032
(404) 847-9529
(404) 847-9529 fax
DGADR@aol.com

Timothy Keim, C.F.P.
7848 Princess Ct.
Jonesboro, GA 30236
(770) 603-0506
(770) 473-0075 fax
timk@ibx.net

Marti Kitchens, M.A.
7193 Douglas Blvd., #103
Douglasville, GA 30135
(770) 942-9361
(770) 947-9840 fax
C

Lemoine D. Pierce, M.Ed., J.D.
School for Dispute Resolution
PO Box 2372
Decatur, GA 30031-2372
(404) 373-4457
(404) 377-4244 fax
C

Ted F. Simon
Divorce Mediation of Cobb County
670 Village Trace Bldg. 19-a, #100
Marietta, GA 30067
(770) 980-0988
(770) 977-6795 fax
CTSIMON@aol.com

## Idaho

Crete Brown, M.S.W., C.P.M.
Heartland Wellness Center
303 N. 12th Ave.
PO Box 4085
Pocatello, ID 83205-4085
(208) 234-1099
(208) 234-1100 fax

Frances H. Thompson, J.D.
Thompson Mediation Services
116 E. Third St.
Suite 201
P.O. Box 8489
Moscow, ID 83843-0989
(208) 882-6856
C

Wendy W. Werth, M.Ed., L.P.C.
Werth & Werth Mediation
PO Box 985
Sun Valley, ID 83353
(208) 788-9781
(208) 788-5968 fax
werth@sunvalley.net

## Illinois

Peggy Beck, L.C.S.W.
Partners in Transition
3330 Old Glenview Rd.
Wilmette, IL 60091
(847) 256-2300
beck@ameritech.net

Brigitte Schmidt Bell, J.D.
53 W. Jackson Blvd.
Suite 702
Chicago, IL 60604
(312) 360-1124
(312) 360-1126

Sara E. Bonkowski, Ph.D., L.C.S.W.
Myrtle Burks Center for Clinical
  Social Work
450 Duane St.
Glen Ellyn, IL 60137
(630) 469-2000
(630) 469-0452 fax

Lynn A. Gaffigan, J.D.
53 W. Jackson Blvd.
Suite 702
Chicago, IL 60604
(312) 360-1124
(312) 360-1126 fax

Pat Gay, M.S.
PO Box 4322
Fairview Heights, IL 62208
(618) 261-1417
FFXTO2B@prodigy.com

Don C. Hammer, J.D.
202 N. Center St.
Bloomington, IL 61701
(309) 828-7331
(309) 827-7423 fax
dhammer@dave-world.net
C

225

## RESOURCES

Judy L. Hogan
115 Cambell St.
Suite 100A
Geneva, IL 60134
(630) 232-1886
(630) 232-1890 fax
C

Carp Jacob, L.C.S.W.
Family & Legal Social Services
2234 Asbury Ave.
Evanston, IL 60201
(847) 866-6231
(847) 866-6718 fax
LJACOB@igc.apc.org
C

Earl B. Jann, Ph.D.
Affiliates in Mediation
633 Skokie Blvd.
Suite 400A
Northbrook, IL 60062
(847) 564-9900
(847) 480-0156 fax
me_d_ate@aol.com

Jerald A. Kessler, J.D.
1950 Sheridan Rd.
Suite 110
Highland Park, IL 60035
(847) 433-2323
(847) 433-2349 fax
jakessler@igc.apc.org

William A. London, J.D.
3712 N. Broadway, Box 407
Chicago, IL 60613
(773) 472-7673
(773) 975-0145 fax

Lynn Joan Elizabeth Massaquoi,
L.C.S.W., B.C.D.
360 E. Randolph Dr., #1001
Chicago, IL 60601
(312) 240-1267
(312) 240-1385 fax

Bruce P. Mindrup, M.A., L.C.P.C.,
L.C.S.W.
Mediation Services of Mid-Illinois
106 Goodrich St.
Jerseyville, IL 62052
(618) 498-4911
(618) 498-4921 fax
brucem@gtec.com

Margaret S. Powers, L.C.S.W., M.A.
415 W. Golf Rd., Suite 22
Arlington Heights, IL 60005
1165 N. Clark St., Suite 314
Chicago, IL 60610
(312) 943-2155 ext 6
(847) 670-0036 fax
mspowers09@aol.com

Debra Sudduth, J.D.
1906 Oakwood Ave.
Bloomington, IL 61704
(309) 664-0556
(309) 662-8821 fax
SUDDUTH331@aol.com

Burton I. Zoub, J.D.
155 N. Michigan Ave., #600
Chicago, IL 60601
(312) 938-0011
(312) 938-8541 fax
C

## Indiana

Association of Independent
  Mediators
300 N. Michigan Ave.
South Bend, IN 46601
(219) 288-5100
(219) 288-5511 fax

Indiana Association of Mediators
6100 N. Keystone
Indianapolis, IN 46220
(800) 571-0260
(317) 571-0260

## Iowa

Steve Sovern, J.D.
Eells & Sovern Law Offices, PLC
1921 51st St. NE
Cedar Rapids, IA 52402
(319) 393-1020
(319) 393-4000 fax
ssovern@compuserve.com

## Kansas

Gary Kretchmer
Domestic Court Services
1255 E. 119th St.
Olathe, KS 66061-5140
(913) 324-6937
(913) 782-3297 fax
gary.kretchner@jocors.com
C

Doug Morphis, D.Min.
Counseling & Mediation Center
334 N. Topeka
Wichita, KS 67202
(316) 269-2322
(316) 269-2448 fax

## Kentucky

Rose T. Colley, M.S., M.Ed.
410 W. Chestnut, Suite 628
Louisville, KY 40206
(502) 581-1961
(502) 581-9832 fax
justsolution@igc.apc.org

Peggy Parsons, M.Ed., L.P.C.
2 Dortha Ave.
Florence, KY 41042
(606) 525-1487
(606) 525-7811 fax

## Louisiana

Laura Prosser Davis, J.D.
The Mediation Center
7737 Old Hammond Hwy.
Baton Rouge, LA 70806
(504) 926-0776
(504) 926-0021 fax

Nell I. Lipscomb, M.S.W., J.D.
317 Jefferson Heights Ave.
Jefferson, LA 70121
(504) 838-6100
(504) 838-9555 fax

Edith H. Morris
1515 Poydras St.
Suite 1870
New Orleans, LA 70112
(504) 524-3781
(504) 561-0228 fax

## Maine

Cushman D. Anthony, J.D.
120 Exchange St.
Suite 208
Portland, ME 04101
(207) 775-3091
(207) 775-7078 fax
MAINEMEDI8@aol.com

# RESOURCES

Jacqui Clark, M.P.A.
Mediation & Facilitation Resources
11 King St.
Augusta, ME 04330
(207) 622-1429
(207) 626-3318 fax
C

## Maryland

Robert H. Barshay, J.D., Ph.D.
9 Old Stage Ct.
Rockville, MD 20852
(301) 322-0560
(301) 468-2344
(301) 322-0549 fax
RB2@pgstumail.pg.cc.md.us

Lili Bermant, M.Ed.
The Concordia Systems Group
11029 Seven Hill La.
Potomac, MD 20854
(301) 983-8707
(301) 983-8737 fax
CONCORDIA@mediate.com

Aza Howard Butler
PO Box 538
801 Dairy Rd.
Parkton, MD 21120
(410) 887-6578
(410) 887-3288 fax

Sarah Childs Grebe, M.Ed., M.A.
Family Center for Mediation &
  Counseling
3514 Plyers Mill Rd., Suite 100
Kensington, MD 20895
(301) 946-3400
(301) 946-3400 fax
Sarahgrebe@aol.com
C

Diane L. Halvorsen, M.S.W.
8018 Quarry Ridge Way
Bethesda, MD 20817
(301) 469-9637
(301) 469-9637 fax
artemisi@ix.netcom.com

Susan Leslie Kelly, L.C.S.W.-C.
111 S. Cross St.
Chestertown, MD 21620-1513
(410) 778-1506

Sara Dunham Kraskin, J.D., MBA
Chevy Chase Metro Bldg.
2 Wisconsin Circle, #700
Chevy Chase, MD 20815
(301) 654-4040
(301) 652-2148 fax
Kraskins@erols.com

Carl D. Schneider, Ph.D.
Mediation Matters
1500 Highland Dr.
Silver Spring, MD 20910
(301) 565-8284
(800) 905-2221
(301) 565-8285 fax
cdschneider@conflictnet.org
C

Phyllis B. Simon, M.P.A.
Family & Child Associates
414 Hungerford Dr., #240
Rockville, MD 20850
(301) 340-2060
(301) 984-3325 fax

Susan Sulami, J.D.
Lifebridge Family Mediation
7104 Exfair Rd.
Bethesda, MD 20814
(301) 215-7933
(202) 966-6806 fax
LBRIDGE@erols.com

Elizabeth B. Tong, J.D.
108 N. Washington St.
Easton, MD 21601
(410) 822-5993
(410) 822-5993 fax

Bertram I. Weiner, M.P.A., J.D.
Bertel Counseling & Mediation
  Service
11408 Fairoak Dr.
Silver Spring, MD 20902
3801 Connecticut Ave. NW
Suite 100E
Washington, D.C. 20008
(301) 593-7744
(301) 593-3921 fax
bertel@erols.com
C

## Massachusetts

S. Tracy Fischer, J.D.
99 Washington St.
Salem, MA 01970
109 Highland Ave.
Needham, MA
(978) 745-0590
(978) 744-5151 fax

John A. Fiske, L.L.B.
Healy, Fiske & Woodbury
189 Cambridge St.
Cambridge, MA 02141-1279
(617) 354-7133
(617) 354-5830 fax

Diane Neumann, M.A., J.D.
Divorce Mediation Services
650 Worcester Rd.
Framingham, MA 01702
(508) 879-9095
(508) 879-9099 fax
divorcemed@aol.com
C

Gail L. Perlman, M.S.S., J.D.
Dispute Mediation, Inc.
369 Pleasant St.
Northampton, MA 01060
(413) 585-0977
(413) 585-0999 fax
CLARKPERL@aol.com
C

Les Wallerstein, M.A., J.D.
1620 Massachusetts Ave.
Lexington, MA 02173-3826
(781) 862-1099
(781) 861-8797 fax
lwaller@tiac.net

Janet B. Weinberger, M.S.W., J.D.
206 Windsor Rd.
Newton, MA 02168
(617) 965-4432
(617) 527-3536 fax

Catherine Woolner, M.A.
The Mediation & Training
  Collaborative
393 Main St.
Greenfield, MA 01301
(413) 774-7469
(413) 774-7460 fax
collaborative@juno.com

Barbara C. Younger, M.Ed., J.D.
152 R Main St.
Wenham, MA 01984
(978) 468-2226
byounger@shore.net

## Michigan

Elizabeth S. Bishop, Ph.D.
Arbor Psychological Consultants
1565 Eastover Pl.
Ann Arbor, MI 48104
(734) 741-8844
(734) 741-9038 fax

Beverly Clark, M.A., J.D.
Mediation Works
440 E. Congress
Suite 4R
Detroit, MI 48226-2917
(313) 961-4440
(313) 961-5830 fax

Gary L. Marsh, C.S.W., A.C.S.W.
Ann Arbor Mediation Center
330 E. Liberty, #3A
Ann Arbor, MI 48104
(313) 663-1155
(313) 663-0524 fax

M. Brady Mikusko, C.S.W.
415 N. Main St.
Ann Arbor, MI 48104
(313) 747-8240
(313) 747-8226 fax

Mary F. Whiteside, Ph.D.
Ann Arbor Center for the Family
2300 Washtenaw Ave.
Suite 203
Ann Arbor, MI 48104
(313) 995-5181
(313) 995-9011 fax

Zena D. Zumeta, J.D.
Mediation Training &
  Consultation Institute
330 E. Liberty, #3A
Ann Arbor, MI 48104
(313) 663-1155
zzumeta@igc.org
C

## Minnesota

Herbert C. Kroon
PO Box 327
Mankato, MN 56002
(507) 625-3000
(502) 625-2002
HCKS@aol.com

Susan D. Mainzer, J.D.
Conflict Management Providers
3033 Humboldt Ave. S
Minneapolis, MN 55408
(612) 824-7664
(612) 824-6583 fax

Marilyn S. McKnight, M.A.
3800 W. 80th St.
Suite 850
Minneapolis, MN 55431
(612) 835-3688
(800) 760-7837
(612) 835-3689
EricksonMediation.com
C

Dawn Marie Mondus, J.D.
A Better Way Divorce Mediation
4916 Highway 61 North
White Bear Lake, MN 55110
(612) 426-1554
(612) 426-7858 fax

Katherine J. Nevins, Ph.D.
2590 Dellwood Ave.
Saint Paul, MN 55113-3210
(612) 636-3541
(612) 638-6001 fax
nevkat@bethel.edu

Dean A. Nyquist
Family Conflict Resolution Center
5637 Brooklyn Blvd., #200
Brooklyn Center, MN 55429
(612) 533-7272
(612) 533-3183 fax

Victoria Westfall
Applied Mediation Services
5001 W. 80th St.
Minneapolis, MN 55420
(612) 835-1151
(612) 835-1113 fax

## Missouri

Susan L. Amato, J.D.
130 S. Bemiston, #706
Clayton, MO 63105
(314) 862-0330
(314) 727-6782 fax
amato@anet-stl.com

Robert D. Benjamin, M.S.W., J.D.
Mediation & Conflict
 Management Services
8000 Bonhomme, Suite 201
St Louis, MO 63105
(314) 721-4333
(314) 721-6845 fax
rbenjamin@mediate.com
C

Terri Clinton Dichiser, J.D.
Jackson County Family Ct.
2729 Gillham Rd.
Kansas City, MO 64108
(913) 829-4972
(816) 881-6504
spuds@sprintmail.com

Julius Z. Frager, J.D., M.B.A.
Alternative Solutions, Inc.
13112 Piedmont Ct.
Maryland Hts, MO 63043
(314) 434-4200
(314) 434-2768 fax
Juliusz@worldnet.att.net
C

Alan E. Freed, J.D.
Paule Camazine & Blumenthal PC
165 N. Meramec, 6th Floor
St Louis, MO 63105
(314) 727-2266
(314) 727-2101 fax
alanfreed@stlcom.net

Mary Anne Kiser, M.A.
Kiser Counseling Service
411 Nichols Rd.
Suite 217
Kansas City, MO 64112
(816) 931-9912
(913) 764.5463
(816) 561-5352 fax

Kakie Love, M.S.
Families in Transition
5413 Dalcross Dr.
Columbia, MO 65203
(573) 443-7717
(573) 449-9505 fax
klove@trib.net
C

231

Lynn M. Malley, J.D.
200 N. Ninth St.
Suite A
Columbia, MO 65201
(573) 499-0748
(573) 499-4469 fax
lmalley@juno.com

Peter M. Schloss, J.D.
104 W. Kansas St.
Liberty, MO 64068
(816) 792-4242
(816) 792-0888 fax
PMSLAW@prodigy.net

ElGene Ver Dught, J.D.
Mediation Services of Missouri
3600 S. Noland Rd.
Suite A
Independence, MO 64055
(816) 836-4141
(800) 637-7511
(816) 836-4141 fax
ELGENE@aol.com
C

## Montana

Roy H. Andes, M.A., J.D.
210 N. Higgins Ave.
Suite 336
Missoula, MT 59802
(406) 728-7295
(406) 721-7364 fax
RoyHAndes@aol.com

Norman G. Lavery, Ph.D.
Common Quest Mediation
PO Box 3056
Missoula, MT 59806
(406) 549-1121
(406) 549-1121 fax
Commquest@aol.com

## Nebraska

Mediation Association Network
8552 Cass St.
Omaha, NE 68114
(402) 397-0330
(402) 558-1929 fax
llamberty@aol.com

Office of Dispute Resolution
State Capitol Bldg.
Room 1207
PO Box 98910
Lincoln, NE 68509
(402) 471-3148
(402) 471-2197 fax

## Nevada

Mediators of Southern Nevada, Inc.
333 N. Rancho Dr., #144
Las Vegas, NV 89106
(702) 631-2790
(702) 873-6371 fax
MaddyBlue@sol.com

## New Hampshire

New England Center Program on
  Consensus & Negotiation
University of New Hampshire
211 Thompson Hall
Durham, NH 03824
(603) 862-2051
(603) 862-4741 fax
jsv@hopper.unh.edu

New Hampshire Mediators
  Association
PO Box 7228
Concord, NH 03301-7228
(800) 783-9883
(603) 271-6607 fax
Nhmediator@aol.com

## New Jersey

Ralph Bean, Ph.D.
145 Wellington Ave.
Pleasantville, NJ 08232
(609) 484-9736
(609) 748-5515 fax
beanr@stockton.edu

Linda Fish, J.D.
157 Engle St.
Englewood, NJ 07631
(201) 567-0003
(201) 567-7809 fax

Ruth W. Friedland, J.D., L.L.M.
1107 Goffle Rd.
Hawthorne, NJ 07507
(973) 423-4200
(973) 427-5302

Bonnie Blume Goldsamt, J.D.
25 Pompton Ave.
Verona, NJ 07044
(973) 239-5900
(973) 857-1818
1 University Plaza
Hackensack, NJ 07601
(201) 487-1622

Sam Margulies, J.D., Ph.D.
The Group for Dispute Resolution
45 Park St.
Montclair, NJ 07042
(973) 783-5515
(973) 509-0308 fax

Douglas K. Schoenberg, J.D.
3 Beechwood Rd.
PO Box 113
Summit, NJ 07902
(908) 598-1766
(908) 598-1248 fax

Mary Vivian Fu Wells, L.C.S.W.
Wells Consultation Service
36 June Pl.
Matawan, NJ 07747
(732) 583-1620
(732) 583-5532 fax

## New Mexico

New Mexico Mediation Association
PO Box 82384
Albuquerque, NM 87198
(505) 266-6550
jhowarth@cabq.gov

## New York

Steven L. Abel, J.D.
2 New Hempstead Rd.
New City, NY 10956
(914) 634-4700
(914) 634-1675 fax
sabel@igc.apc.org
C

Barbara Badolato, C.S.W.
666 Old Country Rd., #705
Garden City, NY 11530
(516) 222-0101
(516) 745-5745 fax

Morna Barsky, C.S.W., M.S.
877 Lorenz Ave.
Baldwin, NY 11510
(516) 223-2025
19 W. 34th St., Penthouse
New York, NY 10001
(212) 947-7111
C

233

# RESOURCES

Adam J. Berner, M.A., J.D.
Law & Mediation Offices
525 W. 235th St., 5th Fl.
Riverdale, NY 10463
2112 Broadway
Suite 201
New York, NY 10023
(718) 601-1117
(718) 543-7260 fax
ajberner@aol.com

Susan J. Brown
319 N. Tioga St.
Ithaca, NY 14850
(607) 272-8837

C

Carol A. Butler, Ph.D.
60 W. 13th St.
Suite LB
New York, NY 10011
(212) 807-0008
(212) 675-7073 fax
cabutler@seetheotherside.com

Stacey Chaikin
Chaikin & Chaikin Mediation Center
 for the Family in Transition
450 Seventh Ave.
Suite 1408
New York, NY 10123
1129 Northern Blvd.
Manhasset, NY 11030
(212) 564-8887
(212) 594-5064 fax

Amy Carron Day, J.D.
Alliance for Mediation & Conflict
 Resolution, Inc.
440 Park Ave. S
9th Floor
New York, NY 10016
(212) 252-0005
(212) 252-1087 fax
acdmediate@hotmail.com

Julie Denny
Alliance for Mediation & Conflict
 Resolution, Inc.
32 W. 40th St., Suite 3B
New York, NY 10018
(212) 944-7416
(212) 944-7271 fax
14 Troutbeck Crescent
Armenia, NY 12501
(914) 373-9788
(914) 373-7092 fax
juliadenny@aol.com

Glenn E. Dornfeld, J.D.
Center for Family and Divorce
 Mediation
111 W. 90th St.
New York, NY 10024
(212) 673-2827
(212) 721-1012

Marc Fleisher, J.D.
98 Riverside Dr.
Suite 1B
New York, NY 10024-5323
(212) 595-0595
(212) 595-0760 fax
MFleish@brooklaw.edu

Mark William Fohs, M.S.,
  C.C.M.H.C., M.A.C
7445 Morgan Rd.
Liverpool, NY 13090
(315) 695-8683
mfohs@dreamscape.com

Nancy Gardner, C.S.W.
Alliance for Mediation & Conflict
  Resolution, Inc.
615 Broadway
Hastings-on-Hudson, NY 10706
(914) 478-7070
(914) 478-5148 fax
Ngardner@we-mediate.com
C

Diana B. Gittelman, J.D.
69 E. 89th St.
New York, NY 10128
(212) 426-2288
(212) 426-2277 fax
DGITTEL1863@aol.com

Lori Goldstein, J.D.
Family & Business Mediation
875 Ave. of the Americas
New York, NY 10001
(212) 594-4115
(212) 594-3955 fax

Lisa Gordon, J.D.
Albany Family & Divorce Mediation
  Center
16 Groesbeck Pl.
Delmar, NY 12054
(518) 439-6900
(518) 439-6900 fax
gordonl@crisny.org

Michael C. Haehnel
37 Prospect St.
Oneonta, NY 13820
(607) 432-9203

Kenneth H. Handin, M.A., C.A.S.
18 Seeley Dr.
Albany, NY 12203
(518) 453-6700
(518) 453-6733 fax
handin@stcath.org

Ronald W. Heilmann, C.S.W., B.C.D.
Mediation Network of Syracuse
1940 Valley Dr.
Syracuse, NY 13207
(315) 492-1082
rwheilma@mailbox.syr.edu
C

John W. Heister, Ph.D.
Mediation Center of Rochester
2024 W. Henrietta Rd., #5G
Rochester, NY 14623-1355
(716) 272-1990
(716) 272-1978 fax
heister@mediationctr.com
C

Dolly Hinckley
47 Round Trail Dr.
Pittsford, NY 14534
(716) 385-2648
(716) 381-4841 fax
C

Donna L. Huggins
2024 West Henrietta Rd.
Suite 5-G
Rochester, NY 14623-1355
(716) 272-1990
(716) 272-1978 fax
huggins@mediationctr.com

# RESOURCES

Kathy Jaffe, CSW
Rockland County Mediation Group
978 Route 45
Suite 107
Pomona, NY 10970
(914) 362-3543
(914) 362-1892 fax
RCmediate@aol.com

Susan Keiser, J.D.
PO Box 350
Livingston Manor, NY 12758
(914) 439-5550
(914) 439-5554 fax
SueKeiser@aol.com

Mark Kleiman, J.D.
Community Mediation Services, Inc.
89-64 163rd St.
Jamaica, NY 11432
(718) 523-6868 ext 248
(718) 523-8204 fax

Joanna Komoska, C.S.W., Ed.D.
Peconic Bay Mediation Services
355 Sebonac Rd.
Southampton, NY 11968
(516) 283-3981
(516) 287-6806 fax
jkomoska@hamptons.com

Julie Z. Kuhn, M.S., C.S.W.
499 N. Broadway, #J2
White Plains, NY 10603
(914) 478-1700

Carolyn Laredo, J.D.
978 Route 45
Suite 107
Pomona, NY 10970
(914) 362-3543
(914) 362-1892 fax
RCmediate@aol.com

Kathryn S. Lazar, J.D.
110 Route 82
Hopewell Junction, NY 12533
(914) 896-9651
Klazar@mhv.net

Barbara S. Levine, C.S.W.
2701 Rosendale Rd.
Niskayuna, NY 12309
(518) 377-2802

Jill Lundquist, C.S.W.
Mid-Hudson Divorce & Family
  Mediation Center
Wildey Rd., PO Box 23
Barrytown, NY 12507
(914) 471-7167
LBAZ@aol.com

Lorraine Marshall, M.B.A., J.D.
Law Offices of Lorraine Marshall
200 Mamaroneck Ave.
White Plains, NY 10601
(914) 428-1040
(914) 428-1595 fax
LMDIVMED@aol.com

Elizabeth H. Marvald, J.D.
Mediation Center of Rochester
2024 W. Henrietta Rd.
Suite 5G
Rochester, NY 14623-1355
(716) 272-1990
(716) 272-1978 fax

Helvi McClelland, J.D.
16 N. Goodman St., #113
Rochester, NY 14607
(716) 473-8723
(716) 473-7711 fax
C

236

John B. McCormick, M.A.
115 Marangale Rd.
Manlius, NY 13104
(315) 682-7706
(315) 682-7706 fax
jmccormick@juno.com

Marilyn A. Miller, J.D.
1221 E. Genesee St.
Syracuse, NY 13210
(315) 428-1221
(315) 425-7268 fax
MILLER@1221.com
C

Mary N. Miller, M.B.A.
43-31 223rd St.
Bayside, NY 11361
(718) 631-0156
(718) 631-0156 fax
MNMILLER@aol.com

Roberta G. Miller, C.S.W.
59 E. Monroe Ave.
Pittsford, NY 14534
(716) 586-0410
(716) 586-2029 fax

Kenneth Neumann
Center for Family & Divorce
  Mediation
111 W. 90th St.
Townhouse B
New York, NY 10024
(800) 61-DIVORCE
(212) 721-1012 fax
2 New Hempstead Rd.
New City, NY 10956
knewmann@igc.apc.org
azneumann@aol.com
C

Robert C. Niles, M.A.
51 Kenaware Ave.
Delmar, NY 12054
(518) 439-3404
rcnile@prodigy.net

Nancy Norton, C.S.W.
26 Quarry Rd.
Ithaca, NY 14850
(607) 272-0556
(607) 273-4692 fax
nnsandplay@aol.com

Emanuel Plesent, C.S.W., Ed.D.
340 A Willis Ave.
Mineola, NY 11501
354 Veterans Memorial Hwy.
Commack, NY 11501
(516) 747-1344
(516) 747-4489 fax

Sally Ganong Pope, M.Ed., J.D.
23 W. 73rd St.
New York, NY 10023
(212) 721-0770
(212) 721-0773 fax
C

Roger S. Reid, M.B.A., M.A.
Family Mediation Center
7000 E. Genesee St.
Building B
Fayetteville, NY 13066
(315) 446-5513
(315) 446-7324 fax
rsreid@syr.edu
C

Thom Roach
12 Main St.
Suite 12
Hamburg, NY 14075
(716) 649-1168

237

Ross T. Runfola, M.A., J.D., Ph.D.
Siegel, Kelleher & Kahn
Matrimonial Mediation Center
420 Franklin St.
Buffalo, NY 14202
(800) 888-5288
(716) 885-3369 fax

Vicki Lewin Ryder, M.S.
11 N. Goodman St.
Rochester, NY 14607
(716) 244-1600
(716) 244-4135 fax
vryder@juno.com
C

Jill Sanders-Demott, J.D.
91 Hillside Dr.
Mahopac, NY 10541
(914) 621-1231
(914) 621-1231 fax

Steve Scher, C.S.W.
82 Hart Blvd.
Staten Island, NY 10301
(718) 727-2901
SSCHER3@aol.com

Susan Whiting Shanok, N.C.Psy.A.,
 C.T.C.
324 W. 22nd St.
New York, NY 10011
(212) 242-4194
(212) 645-0392 fax

Elizabeth K. Shequine, J.D.
17 Collegeview Ave.
Poughkeepsie, NY 12603
(914) 471-2039
(914) 486-4080 fax

Sydell S. Sloan, M.A.
17-26 215 St.
Bayside, NY 11360
(718) 631-1600
(718) 423-0325 fax
SSSLOAN@aol.com
C

Dolores Deane Walker, C.S.W., J.D.
153 Waverly Pl.
Suite 1111
New York, NY 10014
(212) 691-6073
(212) 316-7627 fax
DWalkermed@aol.com

Howard Yahm, C.S.W.
Center for Family & Divorce
 Mediation
146 Willow Tree Rd.
Monsey, NY 10952
(914) 354-3158
(914) 354-4048 fax
yahmh@waonline.com
C

Diane Yale, J.D.
4465 Douglas Ave.
Riverdale, NY 10471-3523
(718) 601-6265
(718) 601-6455 fax
dyakejd@aol.com

### North Carolina

Judith Bobo, M.Ed.
Family Counseling & Mediation
108 W. Kime St.
Burlington, NC 27215
(919) 227-8412
(919) 227-8412 fax
C

J. Andrew Briggs, M.A.Ed.
A.D.C. North Carolina
916 Holland St.
Winston Salem, NC 27101
(910) 761-2092

Sarah V. Corley, J.D.
MediationWorks
22 South Pack Sq.
Suite 600
Asheville, NC 28801
(704) 253-1015
(704) 253-0886 fax

M. Susan Cox, C.C.S.W., B.C.D.
5111 Nations Crossing
Building 8
Suite 150
Charlotte, NC 28217
(704) 556-1798
(704) 525-7340 fax

Naomi S. Eckhaus, M.S.
Divorce Mediation Service
  of North Carolina
6119 Hathaway La.
Chapel Hill, NC 27514
(919) 942-6644
(919) 942-6644 fax
ECKHAUS@aol.com
C

Susan F. Green, C.C.S.W.
c/o Guilford Psychiatric Assn.
522 N. Elam Ave.
Greensboro, NC 27403
(910) 854-2391
rgsfg@aol.com
C

Wm. Michael Haswell, M.S.
The Executive Suites
2016 Cameron St., Suite 219
Raleigh, NC 27605
(919) 828-4011
(919) 832-2961 fax
I.MEDIATE.DISPUTES@juno.com

Jan Hood, M.S., M.Ed.
107 Stonehollow Ct.
Cary, NC 27513
(919) 461-0200
C

Claudia Kelsey, M.S.
Kelsey Mediation Practice
1105 S.E. Maynaro Rd.
Suite 140
Cary, NC 27511
(919) 859-4344

Jean Livermore, C.C.S.W.
Counseling Services
18 W. Colony Pl., #250
Durham, NC 27705
(919) 493-2674 ext 106
(919) 493-1923 fax

Margaret Jane McCreary, J.D.
112 Swift Ave.
Durham, NC 27705
(919) 286-3327
(919) 286-4303 fax
mardie.McC@aol.com

John K. Motsinger, Sr.,
  M.S.F.S., J.D.
204 W. Cascade Ave.
Winston-Salem, NC 27127-2029
(336) 723-5900
(336) 723-7711 fax
ccsc@igc.org
C

# RESOURCES

Celia O'Briant, M.Ed., N.C.C.,
 N.C.L.P.C.
2711-D Pinedale Rd.
Greensboro, NC 27408
(910) 282-0052
(910) 282-5845 fax

George L. Price
603 Surry Rd.
Chapel Hill, NC 27514
(919) 942-6937
(919) 942-6937 fax

Paul R. Smith, M.Ed., M.A., Ed.S.
481 Blue Heron Rd.
Suite B
Mars Hill, NC 28754
(704) 689-9416
(704) 689-3436 fax
psmith@madison.main.nc.us
C

## North Dakota

Glenn W. Olsen, Ph.D.
814 Thorndale
Crookston, MN 56716
(701) 777-3145
(701) 772-4393 fax
golsen@plains.nodak.edu

## Ohio

Janice A. Beaty, M.S.S.W., L.I.S.W.
Crittenton Family Services
6420 E. Main St.
Reynoldsburg, OH 43068
(614) 863-6631
(614) 863-8611 fax

Bette D. Eisenstein, L.I.S.W.
3 Commerce Park Sq.
23230 Chagrin Blvd., Suite 405
Beachwood, OH 44122
(216) 464-7555 ext.128
(216) 464-8733 fax

Martha Green
3436 Co. Rd. 959
Loundonville, OH 44842
(419) 994-5884

Jane R. Hill, L.I.S.W., CCDCIII
Jewish Family Service Association
24075 Commerce Park Dr.
Beachwood, OH 44122
(216) 292-3999
(216) 292-6313 fax
C

Kathleen P. Hoenie, M.S., L.S.W.
Family Matters Mediation Services
1520 Old Henderson Rd.
Suite 12A
Columbus, OH 43220
(614) 457-3177
(614) 442-5802 fax
KHOENIE@compuserve.com

Marya C. Kolman, J.D.
1231 E. Broad St.
Columbus, OH 43205
(614) 258-7777
(614) 258-3333 fax

Denise Herman McColley, M.Ed., J.D.
Maumee Valley Mediation &
 Dispute Resolution Services
331 W. Clinton St.
Napoleon, OH 43545
(419) 592-9289
(419) 592-6258 fax
dmccolley@igc.apc.org

Virginia Petersen, M.S.W.
Divorce Services Children's
  Hospital Guidance Centers
1704 Schrock Rd.
Columbus, OH 43229
(614) 794-2145
(614) 794-6599 fax
Vpetersen@aloha.chi.ohio-state.edu

Marty Ring
5751 Loudon St.
Johnstown, OH 43031
(614) 587-3035

Jim Rundle, L.I.S.W.
Crittenton Family Services
1414 E. Broad St.
Columbus, OH 43205
(614) 251-0103
(614) 251-1177 fax

Judith Thomas, Ph.D.
136 E. Broadway
Granville, OH 43023
951 High Street
Worthington, OH 43085
(740) 587-3367
(740) 587-1612
juditht@nextek.net

Paula J. Trout, J.D., M.B.A.
The Baristers Building
338 South High St.
Columbus, OH 43215-4546
(614) 628-0601
(614) 222-0536 fax
pjtrout@igc.apc.org

## Oklahoma

Carrie S. Hulett, J.D.
119 N. Robinson, #1100
Oklahoma City, OK 73102
(405) 232-3407

(405) 232-3461 fax
CSHulett@aol.com

Ann T. Riley, M.S.W., L.C.S.W.
110 N. Mercedes
Suite 400
Norman, OK 73069
(405) 366-6100
(405) 366-8702 fax

## Oregon

Joe Atkin
1050-G Crater Lake Ave.
Medford, OR 97504
(503) 776-9166
JATKIN@cdsnet.net

John C. Gartland, J.D.
Doyle Gartland Nelson
  & McCleery, PC
PO Box 11230
Eugene, OR 97440-3430
(541) 344-2174
(541) 344-0209 fax

Kathleen O'Connell Corcoran, Ph.D.
The Mediation Center
440 E. Broadway
Suite 340
Eugene, OR 97401
(541) 484-9710
(541) 345-4024 fax
Kcorcoran@conflictnet.org
C

Sheila Annette Dale, J.D.
PO Box 120
724 Oak Ave.
Hood River, OR 97031
(541) 386-6597
(541) 386-3960 fax
5DM48@aol.com

# RESOURCES

Pat Dixon, M.S.
Mediation Services
2695 12th Pl. SE
Salem, OR 97302
(503) 363-8075
(503) 391-5348 fax
p.dixon@juno.com
C

John C. Gartland, J.D.
Doyle Gartland Nelson
 & McCleery, PC
PO Box 11230
Eugene, OR 97440-3430
(541) 344-2174
(541) 344-0209 fax

Lois Gold, M.S.W.
Family Mediation Center
1020 S.W. Taylor, #650
Portland, OR 97205
(503) 248-9740
(503) 284-0194 fax
Forester@mediate.com
C

Joshua D. Kadish, J.D.
Meyer & Wyse
900 S.W. Fifth Ave., #1900
Portland, OR 97204
(503) 228-8448
(503) 273-9135 fax

Sara R. Morrissey, J.D.
777 N.E. Second St.
Suite E
Corvallis, OR 97330
(541) 752-7591
(541) 752-7594

Joel D. Palmer, M.S.
Joel D. Palmer Mediation Services
PO Box 2451
Corvallis, OR 97339-2451
(541) 753-8387
jpalmer@peak.org

John W. Reiman, Ph.D.
PO Box 474
Monmouth, OR 97361
(541) 753-4667
(541) 757-7601 fax
tty: (800) 877-8973
Jreiman@mediate.com

Linda R. Scher, J.D.
Johnston & Root
1500 S.W. First Ave.
630 Crown Plaza
Portland, OR 97201
(503) 226-7986
(503) 223-0743 fax
JnR1500@aol.com

Ingrid Slezak, J.D.
1020 S.W. Taylor
Suite 845
Portland, OR 97205
(503) 248-0938
(503) 248-0943 fax
ieslezak@aol.com

Cynthia Vander Sys, M.A.
1741 Wade Circle
Klamath Falls, OR 97601
(503) 884-7247
rose@cdsnet.net

## Pennsylvania

Winnie Backlund, M.Ed.
2331 Merel Dr.
Hatfield, PA 19440
(215) 822-8135
(215) 822-1020 fax
WGBACKLUND@aol.com
C

Edward Blumstein, J.D.
Edward Blumstein & Associates
1518 Walnut St., 4th Fl.
Philadelphia, PA 19102
(215) 790-9666
(215) 790-1988 fax
NNJM10A@prodigy.com
C

Susan V. Edwards, J.D.
28 Bridge Ave.
Suite 105
Berwyn, PA 19312-1770
(610) 725-0733
(610) 725-0736 fax
SVEesq@aol.com

Sara Lee Goren, M.S.W., J.D.
512 Bethlehem Pike
Fort Washington, PA 19034
(215) 283-9913
(215) 233-3049
(215) 283-9913 fax

Edward P. Hanna, D.S.W.
33 W. Lancaster Ave.
Shillington, PA 19607
(610) 796-8131
(610) 796-8131 fax
mediatorED@aol.com

Sherle Josephs, M.A.
Mediation Masters
134 W. Lyndhurst Dr.
Pittsburgh, PA 15206
(412) 441-9282
(412) 441-4282 fax
C

Nancy Van Tries Kidd, Ph.D.
Psychological & Mediation
 Resourses
173 Indian Hill Rd.
Boalsburg, PA 16827
(814) 466-6666
(814) 466-6699 fax

Don Stephen Klein, J.D.
Lehigh Valley Mediation, Inc.
1436 Hampton Rd.
Allentown, PA 18104
(610) 395-7933
(610) 706-4300
(610) 395-7109 fax
KLEIN@blankrome.com
C

Carrie C. Latman
2130 Penn Ave.
West Lawn, PA 19609
(610) 678-4410
(610) 678-5300 fax

Dana Rakinic, J.D.
Divorce Mediation Services
500 Old York Rd.
Suite 100
Jenkintown, PA 19046
(215) 885-2330
(215) 885-2260 fax

Fredric David Rubin, J.D.
9637 Bustleton Ave.
Philadelphia, PA 19115
(215) 677-9666
(215) 677-5131 fax
FSRUBIN@aol.com

Nancy Rohrer Sauder, R.N.
320 N. Duke St.
Lancaster, PA 17602
(717) 393-4440
(717) 284-2714 fax
nsauder@juno.com

Arnold T. Shienvold, Ph.D.
Central Pennsylvania Mediation
  Services, Inc.
2151 Linglestown Rd., Suite 200
Harrisburg, PA 17110
(717) 540-9005
(717) 540-1416 fax
ASHIEN@ipc.org
C

Judy Shopp, M.A., J.D.
Pennsylvania Council of Mediators
2935 Broxton La.
York, PA 17402
(717) 755-4224
(717) 840-1455 fax
jshopp@prodigy.com

Paul Wahrhaftig, J.D.
Mediation Masters
7514 Kensington St.
Pittsburgh, PA 15221
(412) 687-6210
(412) 687-6232 fax
crcii@conflictnet.org

Nanci Olivere Weber, J.D.
The Ben Franklin
834 Chestnut St.
Suite 206
Philadelphia, PA 19107
(215) 546-6556
(215) 574-0699 fax

Patricia B. Wisch, Ed.D.
Mediation Services
1601 Walnut St.
Suite 1424
Philadelphia, PA 19102
(215) 988-9104
(215) 204-3342 fax (c/o Yancy)
C

## Rhode Island

Bryna B. Bettigole, L.I.C.S.W., B.C.D.
29 Wilcox Ave.
Pawtucket, RI 02860
(401) 723-0353
(401) 722-1382 fax
C

## South Carolina

Mary L. Bryan, J.D.
1528 Blanding St.
Columbia, SC 29201
(803) 252-5905
(803) 748-9220 fax

Joyce W. Fields, Ph.D.
Family Mediation Services
817 Calhoun St.
Columbia, SC 29201
(803) 799-2323
(803) 799-8249 fax

Diane David Hamrick, Ph.D.
655 St. Andrews Blvd.
Charleston, SC 29407
(803) 571-2040
(803) 556-0701 fax
C

C.C. Harness, J.D.
177 Meeting St., PO Box 1808
Charleston, SC 29402
(803) 853-1300
(803) 853-9992 fax
cotton.harness@adnss.com

Diane R. Manwill, Ed.M., L.P.C.
2801 Bratton St.
Columbia, SC 29205
(803) 779-7295
ramdad@mindspring.com

Barbara Melton, M.Ed., L.P.C.,
  N.C.C., M.A.C
215 Calhoun St., Suite 306
Charleston, SC 29401
(803) 723-8002
(803) 723-0420 fax
bmelton@worldnet.att.net

F. Glenn Smith, J.D.
Family Mediation Service
817 Calhoun St.
Columbia, SC 29201
(803) 771-6107
(803) 799-8249 fax

Donna Willson Upchurch, Ph.D.
1403½ Calhoun St.
Columbia, SC 29201
(803) 252-1866
(803) 252-1177 fax

## South Dakota

J. Lee Berget, R.N., M.S., J.D.
2601 S. Minnesota Ave., Suite 105
Sioux Falls, SD 57105
(605) 331-2539
(605) 334-7047 fax
ccrm@igc.apc.org
C

## Tennessee

Richard Beckwith Adams, Ph.D., J.D.
1010 Burchwood Ave.
Nashville, TN 37216-3608
(615) 780-3632
(615) 256-4105 fax
mediate@WBTV.net

Lynn P. Barton, L.C.S.W.
4535 Harding Rd., #102
Nashville, TN 37205
(615) 269-4557

Gregory S. Davis, M.S.
4546 Newcom Ave.
Knoxville, TN 37919
(423) 579-1356
(423) 577-6684 fax
greg.s.davis@juno.com

Jack Redden, L.P.C., M.H.P.
4370 Fizer Cove
Memphis, TN 38117
(901) 763-3271
(901) 763-0001 fax
JACKREDDEN@juno.com

Jocelyn Dan Wurzburg, J.D.
5118 Park Ave., Suite 232
Memphis, TN 38117-5708
(901) 684-1332
(901) 684-6693 fax
jdwurzburg@igc.org

# RESOURCES

Mary Ann Zaha
Conflict Resolution & Mediation
  Services
100 Cherokee Blvd.
Suite 2004
Chattanooga, TN 37405
(423) 266-0477
(423) 752-1700 fax
MAZaha@igc.apc.org
C

## Texas

Laury Adams
Adam's Mediation & Financial
  Resource Center
800 Gessner, #252
Houston, TX 77024-4256
(713) 465-2347
(713) 468-4486 fax
Lauadams@aol.com

Michael R. Anderson, Ph.D.
308 S. Third St.
Harlingen, TX 78550
(956) 425-8077
(956) 425-8077 fax

Molly Bean, J.D.
2502 Barton Hills Dr.
Austin, TX 78704
(512) 476-3323

James L. Greenstone, Ed.D., J.D.
Leviton & Greenstone
222 W. Fourth St., #212
Fort Worth, TX 76102
(817) 882-9415
(214) 361-0209
(214) 361-6545 fax
Drgreenstone@juno.com

Bill T. Hagen, C.F.P.
16010 Barkers Pt.
Suite 215
Houston, TX 77079
(281) 870-8020
(281) 870-0850 fax

Carol May Hoffman, C.P.A.
Mediation Associates of Houston
4550 Post Oak Pl.
Suite 150
Houston, TX 77027
(713) 629-1416
(713) 629-1433 fax

Paula James, J.D., Ph.D.
2501 N. Lamar
Austin, TX 78705
(512) 476-3400
(512) 469-9867 fax
pjames@prismnet.com

Lynelle C. Yingling, Ph.D.
570 E. Quail Run Rd.
Rockwall, TX 75087-7321
(972) 771-9985
(972) 772-3669 fax
LYNELLEYINGLING@compuserve.com

## Utah

William W. Downes, Jr., J.D.
Winder & Haslam
175 W. 200th St.
Suite 4000
Salt Lake City, UT 84101
PO Box 2668
Salt Lake City, UT 84110
(801) 322-2222
(801) 532-3706 fax
w.downes@winhas.com

## Vermont

Nina Swaim, M.Ed.
Box 65
Sharon, VT 05065
(802) 763-2208
nina.swaim@valley.net

Ellen Bernstein, M.S.
S. Burlington, VT 05403
(802)860-8405

Susan Feldman Fay
A Mediation Partnership
41 Main St.
Burlington, VT 05401
(800) 564-6859
fay2med8@together.net

Sky Yardley
RD 1, Box 37A
Irasburg, VT 05845
(802) 754-8780
SKY@together.net

## Virginia

Helga K. Abramson, M.A.
Alexandria Mediation
1800 Diagonal Rd.
Suite 600
Alexandria, VA 22314
(703) 684-7677
(703) 684-7676 fax
abramson@igc.apc.org

Jerry Bagnell, M.Ed., M.S.W.
Divorce Mediation Service
6104 Holly Arbor Ct.
Chester, VA 23831-7760
(804) 768-1000
(804) 768-1010 fax
jbagnell@ix.netcom.com
C

Joe Beaty, L.C.S.W.
Agreements Unlimited
113 N. Park St., PO Box 208
Marion, VA 24354
(540) 783-7015
(540) 783-1077 fax
jbeaty@agreements.org

Emily M. Brown, L.C.S.W.
Key Bridge Therapy & Mediation
  Center
1925 N. Lynn St., Suite 700
Arlington, VA 22209
(703) 528-3900
(703) 524-5666 fax
key-bridge-center@erols.com
C

C. Mark Dunning, Ph.D.
Commonwealth Mediation
3374 Flint Hill Pl.
Woodbridge, VA 22192
(703) 497-7870
cmdun@aol.com

Merri Hanson Eckles, M.A.
Peninsula Mediation Center
PO Box 7135
Hampton, VA 23666
(757) 595-0264
(757) 728-0192 fax
merrihe@aol.com
C

Kathryn Stoltzfus Fairfield, J.D.
205 W. Riverside Dr.
Bridgewater, VA 22812
(540) 828-6785
(540) 432-0953 fax
fairfijr@jmu.edu

# RESOURCES

Kathy J. Foskett, M.S.
Northern Virginia Mediation
 Service
6206 Sierra Ct.
Manassas, VA 20111
(703) 330-2476
(703) 335-5827 fax
75710.1710@compuserve.com

Linda D. Hale, M.S.C.M., M.A.
Institute for Conflict Management
3783 Center Way
Fairfax, VA 22033-2602
(703) 591-3800
(703) 352-7714 fax
ICMHALE@aol.com

Martha D. Hartmann-Harlan, J.D.
915 Kingsland Rd.
Richmond, VA 23231
(804) 795-9283
C

Tazewell T. Hubard, III, J.D.
125 St. Paul's Blvd.
Suite 201
Norfolk, VA 23510
(757) 627-6120
(757) 625-2161 fax

Vincent F. Kavanagh, Jr.
301 Linden Ct.
Sterling, VA 20164
(703) 437-4147

Mark R. Lohman, Ph.D.
1 Village Green Circle
Charlottesville, VA 22903
(804) 293-2499
(804) 977-2944 fax

Catherine L. Moore, L.C.S.W.
PO Box 7107
Richmond, VA 23221-0107
(804) 355-5944
(804) 355-9922 fax

Noel Myricks, J.D., Ed.D.
University of Maryland
2000 Golf Course Dr.
Reston, VA 20191-3802
(703) 716-0194
(703) 716-0193 fax

Judy S. Rubin, C.F.M.
Dispute Settlement Center
1208 Botetourt Gardens
Norfolk, VA 23517
(757) 625-2881
(757) 480-2555 fax
JSR291@aol.com

Joyce K. Sexton
PO Box 814
Richmond, VA 23218
(804) 763-2788
(804) 763-2788 fax
Rich-jaks@worldnet.att.net

Duke Turman, L.P.C.
Counseling Associates of Virginia
2807 S. Main St.
Blacksburg, VA 24060
(540) 552-1402
(540) 552-3428 fax

Robert L. Whittaker
Commonwealth Mediation Group,
 L.L.C.
8001 Franklin Farm Dr.
Suite 120
Richmond, VA 23229

(804) 285-2780
(804) 285-2766 fax
CmedG@aol.com

Robin Zelinger-Casway, L.S.W.
9401 Courthouse Rd.
Suite 201
Chesterfield, VA 23832
(804) 748-3250
(804) 748-5009 fax
1753 S. Dover Pt.
Richmond, VA 23233
(804) 741-4549
(804) 741-9539 fax
medi84ya@aol.com

## Washington

Jayne Bauer-Hughes, M.A., J.D.
101 Robert Bush Dr.
PO Box 337
South Bend, WA 98586
(800) 231-3422
(360) 875-5290 fax
AMICUS@willapabay.org

Susan Dearborn, Ph.D., M.C.
12505 Bel-Red Rd., #211
Bellevue, WA 98005
(206) 451-7940
(206) 324-4945 fax
sdearborn@igc.apc.org

C. Scott East, J.D.
Law Offices of C. Scott East, Inc., PS
11000 Main St.
Bellevue, WA 98004-6320
(425) 454-3006
(425) 454-3187 fax
LOCSE@aol.com

Richard M. Eberle, M.Div.
Eberle Mediation Services
10900 N.E. Eighth St., #900
Bellevue, WA 98004
(425) 454-0724
C

Mary J. Hatzenbeler, M.S.W.,
A.C.S.W.
316 E. Fourth Plain Blvd.
Vancouver, WA 98663
(360) 695-6188
(360) 737-7686 fax

Judith D. Jeffers. M.A., J.D.
601 Union St.
2600 Two Union Sq.
Seattle, WA 90101-4000
(206) 292-9800
(206) 340-2563 fax
jdjeffers@alo.com

Nancy Kaplan, M.S.W., B.C.D.
CRU-Conflict Resolution Unlimited
845 106th Ave. NE
Suite 109
Bellevue, WA 98004
(425) 453-5244
(425) 451-1477 fax
cru@conflictnet.org

Madeline Kardong
The Mediation Center of Spokane
628½ N. Monroe
Suite 304
Spokane, WA 99201
(509) 324-9052
(509) 326-8316 fax

# RESOURCES

Claire S. Reiner, J.D.
1015 Sixth St., PO Box 952
Anacortes, WA 98221-0952
(360) 293-0300
(360) 299-3917 fax
creiner@ncia.com

Barbara Rofkar, M.A.
Family Mediation & Counseling
  Services
119 N. Commercial, #560
Bellingham, WA 98225
(360) 671-6416
(360) 733-6253 fax
C

Candice Rosenberg, J.D.
Mediation Associates
495 Sudden Valley
Bellingham, WA 98226-4809
(360) 671-0816
(360) 671-9743 fax
mediator@pacificrim.net

Leslie J. Savina, J.D.
1112 108th Ave. SE
Bellevue, WA 98004-6839
(425) 451-0748
(425) 451-3109 fax

Sue A. Stipe, M.S.
33919 Ninth Ave. S, #201
Federal Way, WA 98003
(206) 467-1722 ext. 1489
AStipe6985@aol.com

Donnelly J. Wilburn, M.A., J.D.
2815 130th Pl. NE
Bellvue, WA 98005
(425) 883-0237
(425) 453-8452
(206) 637-9541 fax

## Wisconsin

Rita Costrini-Norgal, B.A., S.W.
51 S. Main St.
Janesville, WI 53545
(608) 757-5549
(608) 363-1822
(608) 757-5516 fax
RITAC@CO.RO.WI.US
C

Rebecca E. Greenlee, M.S.S.W., J.D.
P.O. Box 5086
Madison, WI 53705-5086
(608) 238-7122
(608) 238-9606 fax
greenlee@execpc.com

# Index

# About the Authors

**Carol A. Butler, Ph.D.**, is a divorce and business mediator and an individual and couples psychotherapist in private practice. A clinical supervisor, Butler is Adjunct Assistant Professor in the Department of Applied Psychology at New York University. She is a Practitioner Member of the Academy of Family Mediators and a member of the Society of Professionals in Dispute Resolution (SPIDR) and of other international, state, and local professional organizations. Butler lives and works in New York City.

**Dolores Deane Walker, M.S.W., J.D.**, is a psychotherapist and attorney, specializing in mediation. Previously Director of Negotiations for a New York City mayoral agency, she is a Practitioner Member of the Academy of Family Mediators, a Board member of the Family and Divorce Mediation Council of Greater New York, a member of the Family Section of the New York State Bar Association, and admitted to practice before the Federal District Court: E.D., S.D., and the U.S. Supreme Court. Walker, a former resident of Texas, Oklahoma, and Michigan, now lives and has a private practice in New York City and offers workshops about the emotional and legal aspects of divorce mediation.

KETCHER PUBLIC LIBRARY

METUCHEN PUBLIC LIBRARY

3930500146?558

METUCHEN PUBLIC LIBRARY
480 Middlesex Ave.
Metuchen, NJ 08840